TORONTO

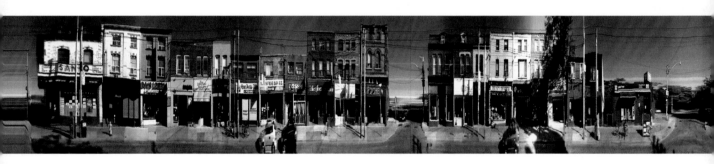

To the memory of Richard Bradshaw 1944–2007

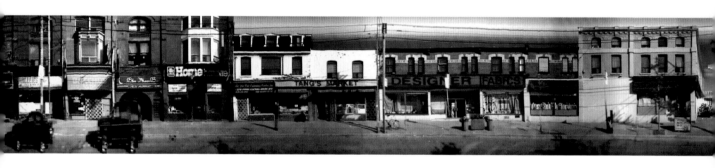

TORONTO

A CITY BECOMING

EDITED BY

DAVID MACFARLANE

KEY PORTER BOOKS

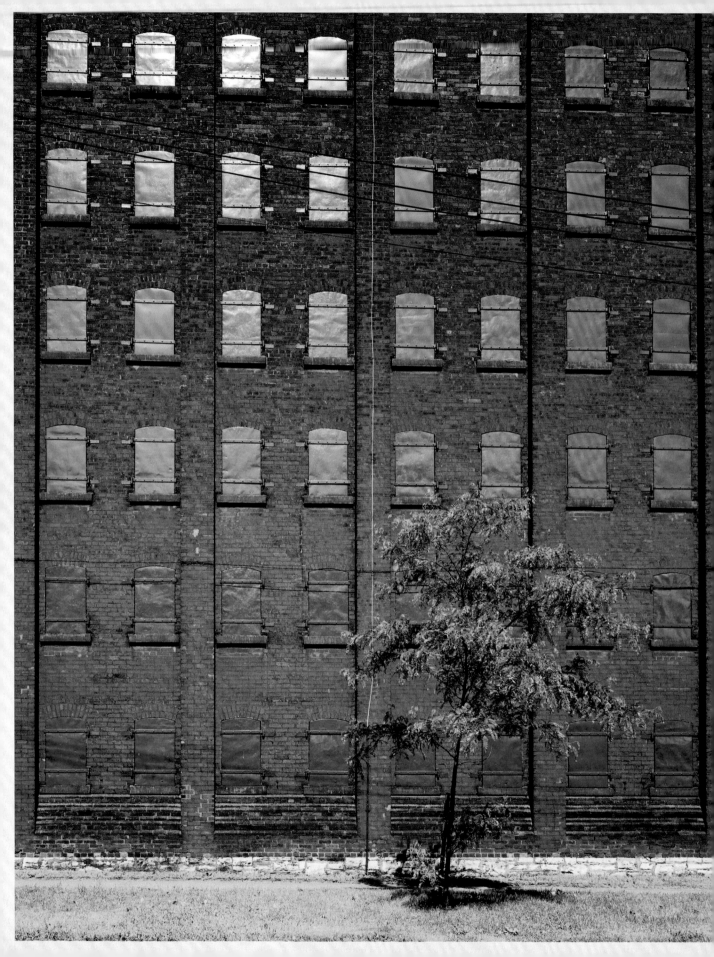

TABLE OF CONTENTS

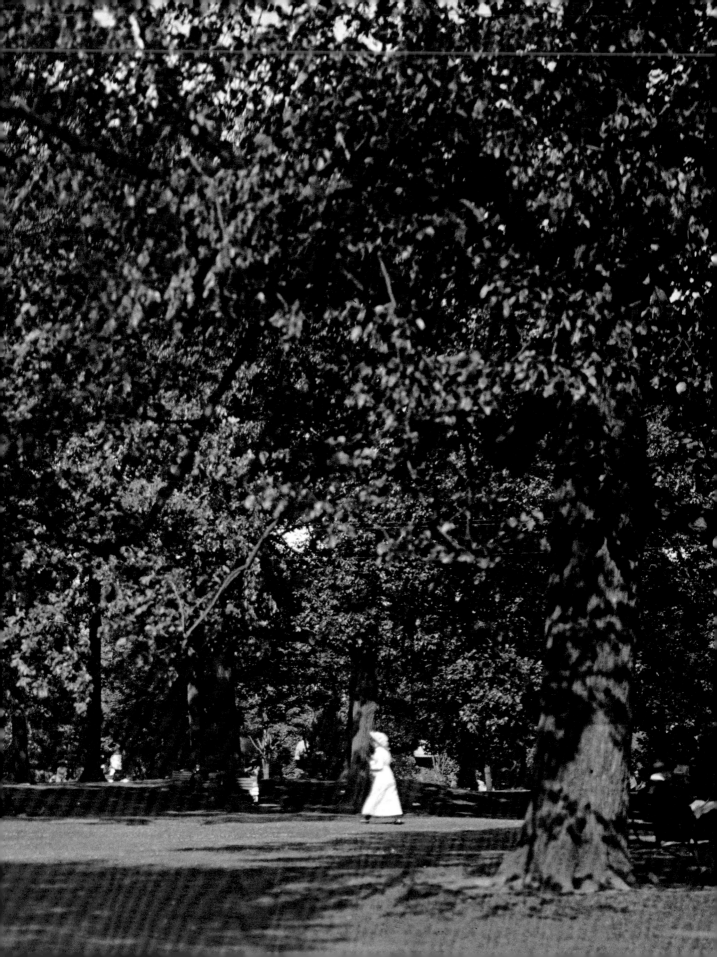

INTRODUCTION

OUR HOUSE IS TALL, AND NARROW, and made of brick that, like much of the red, Victorian fabric of Toronto's downtown, was quarried and kilned beside the Don River. The Don Valley, one of the largest of the many ravines that wind their hidden way below the grade of Toronto's streets and sidewalks, used to be a dramatic fall of wilderness between the city and what would become its eastern flank. Today there are bike paths and hiking trails, and the valley is popularly known as the home of a long-neglected river and a desperately overused highway. But toward the end of the nineteenth century, it had a kind of shire-like peacefulness. There were a few mills along the willowed banks, a few small settlements, winding dirt roads, swimming holes, and, rising from the chimneys of the brick works, the curling smoke of a growing city's requisite industry.

Our home was built in 1887 by a developer—a gentle precursor to the condominium builders whose glass-lofted towers are so changing the face of Toronto today. He built our house on the corner of what is still a surprisingly quiet downtown street. He lived here, but used his residence as a model for the houses he offered to build for purchasers of the various lots he owned along the block. He must have done well—judging from the number of nearly identical houses I pass as I head eastward, on my daily walks through the University of Toronto.

FACING PAGE: CITY OF TORONTO ARCHIVES SERIES 372, SUB-SERIES 52, ITEM 54
PREVIOUS PAGE: DAVID KAUFMAN; GOODERHAM-WORTS DISTILLERY STORAGE
WAREHOUSE, JUNE 1984

We live only a few blocks from the downtown campus. As a result, the sidewalk that runs directly along the western edge of our property, just beyond our garden fence, is well-used. So is the scruffy alley directly to our south. This must be one of the few areas in the city where there are more shoes than tires going by.

But it is the fact that we are on a corner that distinguishes us from most downtown Toronto houses. We have good light. We have exposure on the south, north, and west sides—something that many of the city's tall, narrow, semi-detached Victorian houses cannot boast. But this also means that we are not tucked away. We have no mystery to our back.

There are backyards in the downtown—behind modest and grand houses alike—that are secret groves. Like the city's ravines, they are not obvious to outsiders. They have always been one of the things I like best about Toronto, but my affection for them always feels private. It's as if they are too modest an attraction to mention. There must be visitors to Toronto who never guess at their presence—who, having taken in the destinations that are listed in the tourism brochures in their hotel rooms, wonder why anyone thinks of this city as being other than ordinary.

That might be because they do not know that Toronto's neighbourhoods are where the city's real beauty lies. Or because they have not been told where to slip from the street level of neighbourhoods, down to the cool, wooded other-world of the ravines—the hidden places that the distinguished writer, Robert Fulford, has called the "shared subconscious of the municipality" and that the architect, John van Nostrand, a contributor to this book, calls the "Other Places."

The city's hidden downtown gardens have the same effect. Behind their rickety fences, under their canopy of maples, beside their shadows of lilac

and bridal wreath, they reveal an aspect of Toronto's personality that is not at all apparent in the Eaton Centre or on the observation deck of the CN Tower. Often, the gardens feel old-fashioned—which is another way of saying that they naturally reach back into the brambled generations of the city's history. In fact, as a Torontonian, I often think of the city's most popular tourist destinations as impostors—institutions that have been pretending so stridently to be the city that they have almost obscured what the city really is.

More so than in most other cities, tourists aren't privy to what the people who live here know about this place. Torontonians seem to be reticent about these things—a civic shyness that is not without its charm, as the author and professor Richard Florida notes in these pages—but that sometimes undermines our ambitions and that tends to keep private the deepest pleasures we take in our city.

No one is likely to tell out-of-town visitors that they should make a point of watching the sun set at the end of College Street on a late-winter evening as a snowstorm is clearing. There is no song, or poem, or accumulation of repeated opinion that lets tourists in on the fact that the streaked purple sky behind the tower of the Bellevue fire station is a beautiful sight. Nor does anyone advise them to stroll up and down the streets of the most ordinary and unpicturesque neighbourhoods in order to see, at first hand, what the *Globe and Mail* city columnist, John Barber, calls in his essay, the triumphant experiment of Toronto.

The term "world class" used to be trotted out by gung-ho journalists, bureaucrats, businessmen, and politicians whenever the subject of the Olympics, or an NFL football franchise, or the domed stadium's retractable roof came up—at least, it was so-trotted until the groans of embarrassed

Torontonians became too loud. But Toronto's real relationship to the world is apparent, not in what is usually a cavernously empty sports facility, but at modest meeting places such as the corner of Vaughan and Oakwood: in the Nova Era Bakery, the Eritrean Orthodox Church, the Istanbul Bazaar, the York Italian Hunting and Sports Association, the Mt. Zion Bible College, the Oakwood Baptist Church, the Brazilian sports bars, the Chinese grocery stores, the Portuguese grocery stores, and the Caribbean grocery stores. No tourist will likely be told that the "world-class" place to be in Toronto is the perfectly ordinary park adjacent to Riverdale Farm in Cabbagetown on a perfectly ordinary Sunday afternoon in June, where Pakistani families and Jamaican families and Nigerian families and Ukrainian families and Indonesian families and Chilean families can be seen picnicking, playing, strolling, relaxing.

In reality, there is nothing ordinary about this. In a Toronto park, many are enjoying freedom from sectarian strife and violent crime, freedom from poverty and disease and environmental degradation, freedom from political oppression and class injustice. This spectacularly unspectacular scene— the snoozing Dad, the romping kids, the women chatting at the picnic tables—is freedom that an enormous percentage of the Earth's population would give anything to share. And this is what is so very odd about Toronto these days: a scene that, at first glance, seems as unremarkable as a pleasant Sunday afternoon, takes on global dimensions when cast against the invisible, distant, and often horrifying context that created it.

Toronto is a big city, but it is not revealed in its big places, so much as in its quirky ones. Not that those of us who live here articulate this very successfully to those who don't. No one is likely to suggest to tourists that they drop by a bar

that is as tiny, as eccentric, and as off the beaten path as the one Ian Pearson writes so lovingly of in this collection. The demolition of Regent Park, as recorded by photographer Scott Johnston, and the disappearing Toronto, as captured by David Kaufman, are not on many must-see lists. Visitors will not, for the most part, learn about the city by reading *uTOpia*—the surprising and surprisingly abundant collections of essays about Toronto that Siobhan Roberts contemplates in this, another collection. A city's history is part of every tourist's visit to London or Chicago or Beijing, but visitors to Toronto come and go by the millions without ever hearing a word spoken about Robert Baldwin—a historical figure, who, so John Barber argues, has played a role in the creation of contemporary Toronto that is as significant as it is uncelebrated.

To some considerable extent, tourists will entirely miss the point of Toronto because they are not told stories we hardly tell ourselves. Figuratively as well as literally, they are rarely given the opportunity to sit up late in back gardens that seem a world away from the bright, noisy city that presides out front.

Downtown gardens are about illusion. This is especially true in Toronto. Large or small, they conjure something that isn't rural exactly, isn't pastoral exactly, but that is tucked away and slightly anarchic. Toronto's private, modest little gardens—higgledy-piggledy or obsessively manicured, blowsy and overgrown, or trimmed and precise—are the unregulated expressions of individuals in a city of individuals. They somehow stand in opposition to the super-sized gas stations, the stingy sidewalks, the architectural blunders, the swaths of concrete, the screech of subways, the nasty winters, and the week-in, week-out regimen of work that is so frequently Toronto's most obvious presentation.

In a city that often seems bleak, there is something subversive about these little green patches of flower beds and vegetables and bushes and trees. In their way, they are "off the grid"—to use John van Nostrand's term—which may explain why they are so removed from the city's boosterish and frequently idiotic public swagger. The booming, hectoring, profoundly irritating commercial voices that won't let baseball fans alone for a between-batter instant at a Blue Jays game, find their very opposite in the tinny little radios that are playing in the secret backyards where, for generations, Torontonians have cut the grass, or done the weeding, or had a beer, while listening to the ball game.

But a secret place is not a possibility where my family and I live. In our downtown, corner back garden, you can read a book by the light of a streetlamp. You can smell the cigarettes and (with un-American frequency) the marijuana of people on their way to the College Street bars. The bounce of basketballs and the gravelly rush of longboards interrupt our conversations. For the duration of about a dozen steps—the length, more or less, of our back property—passing discussions are clearly, sometimes regrettably, audible.

Cars park just a few feet beyond our fence: their stereos, their slammed doors, their not-always co-operative ignitions, and their (insert string of expletives) alarms are a presence in our lives. When we eat outside on a summer evening, our table is as close to the curb as a fire hydrant would be. As a result, there is nothing abstract about our objections to idling cars and trucks. The solid, eight-foot-high wooden fence is a barrier, but it can't make us feel farther away from the street than we are. Our garden is never capable of pretending that it is anywhere other than exactly where it is.

In fact, the only time the back of our house gives way to illusion is early in the morning. We have large windows that look out, to the south, over our garden, and I sometimes sit there with coffee as the sun is coming up. To the southeast are alleys, garages, and the unpainted brick backs of old houses. There are fire escapes, sheds, and parked cars. There are trash cans, bits of old bicycles, a rusted refrigerator door, scraps of lumber, concrete blocks, graffiti, sewer grates.

But this is not my view. Not at all. Our fence and the roofs of two of my neighbours' garages cut off the scrappy, dusty reality of what I'm looking at. From where I sit, there isn't a split garbage bag, broken sherry bottle, rusted-out hibachi, or old tire in sight. What I see for the most part are the trees that are there—the upper branches of trees that grow between the parking pads, the sway-backed sheds, and the old chain-link fences. The distance between the far trees and the closest ones, the range in size from high old maples to ironweed, the shafts of morning light, all conjure a pleasant hallucination. They convey the impression that I am not looking over an undistinguished maze of asphalt and trash and parked cars. Early in the morning, the trees and the generosity of space between them create the illusion that my view is of a leafy common garden.

This *trompe-l'oeil* happened without effort on my part. Subconsciously—or, perhaps, simply in the pre-caffeine dreaminess of waiting for the hot water to bubble up through the coffee I routinely buy a few blocks away in Kensington Market—I transposed memories of civic gardens I have known onto what I can't quite see. There is a bit of Paris's Bois de Vincennes in my imaginary landscape—or at least that's where I think the pond and the paths and the footbridge come from. And there's some of Greenwich Village's

MacDougal-Sullivan Gardens in the civilized enclosure that I like to pretend is there. Most of all, there is a common garden in London that works its way into my invented park, a view that I knew very well for a year—long before Hugh Grant and Julia Roberts arrived on the scene—when I lived at the back of the second floor of a rooming house in Notting Hill.

This is an occupational hazard of being a Torontonian. Indeed, it is the initial stage of what underlies many of the essays in this book. For years, Torontonians squinted at what was, and imagined what might be. Why couldn't we have wider sidewalks? Why was it necessary to tear down so many lovely old buildings and raise so many ugly ones? Does the flow of automobile traffic always have to be a municipal priority? Why can't we have water clean enough for us to swim at our beaches? And for years, all this squinting and imagining was thought to be the stuff of fantasy by the grey, sober, practical, business-like, and decidedly dull presence that seemed to loom over the city. A beautiful waterfront? A thriving artistic community? Imaginative architecture? An opera house? Until quite recently, these were viewed as the most impractical and frivolous pipedreams—much like the sleepily imagined common garden that I sometimes think I see from the back of my ordinary, red brick home.

I AM STANDING ON THE shoulder of the Don Valley Parkway, not far from the abandoned kilns that more than a hundred years ago produced the bricks for the houses along our street. It's as good a place as any from which to consider the City of Toronto.

There are views that are more complete. Looking at the city from Centre Island, for instance, on a calm, blue summer's afternoon, or from the window of a night flight approaching Pearson as the glittering skyline banks into view like a backdrop to the opening of a television news program: these are both views that are more comprehensive than the towers that I see rising from a river valley's bank of trees.

I'm sure that on a clear day the CN Tower affords a more panoramic view than the gravel siding on which I'm standing. From way up there the view would be not only of Toronto, but of the fading-to-infinity expanse of what is known as the Greater Toronto Area. This is the Toronto that *National Post* reporter Peter Kuitenbrouwer describes in his essay in this book, and the regional economic powerhouse that Richard Florida addresses in his.

Looking at Toronto from the CN Tower would compel me to consider the tracts of suburbs and office towers, housing developments and industrial parks, strip malls and freeways, rail lines and airport, factories and sidings, storage units and apartment complexes, hydro lines and warehouses, arid intersections, and distant, windblown bus shelters that, in reality, represent Toronto more accurately than the older core of the city that is the Toronto with which I am most familiar—and that I can see, rising to the south, from the side of the Don Valley Parkway where I am standing. But to look out over this grey, flat sprawl would require my doing what many Torontonians, myself included, prefer to leave to tourists: I'd have to go up the CN Tower. And one has to draw the line somewhere.

Or, possibly, an incomplete view of the city, such as the one I'm considering now, is entirely appropriate because the impulse to try to see Toronto in any kind of entirety may be misguided to begin with. In a city that

has the flux of immigration as its most obvious defining characteristic (more than 40 per cent of all immigrants to Canada settle in Toronto), it's possible that the city is not to be found in a long and impressive view. Perhaps the real Toronto is in the window of a little grocery store where handwritten signs advertise cow foot, goat fish, and coconut water. Or in the mobile health unit operated by the Immigrant Women's Health Centre—a refurbished RV that takes doctors and nurses to the factories and malls where immigrant women can be found in such numbers and in such a range of cultural and linguistic variety that translators for seventeen languages are required as part of the program. Perhaps Toronto is a tranquil block of modest homes where two black-dressed, white-haired women speak in Portuguese from porch to porch, across the street, as if chatting on a phone, and where the front flower gardens are so tiny and so carefully arranged they would not look out of place on a casket.

Perhaps in a city that is changing as constantly as Toronto changes, a partial view—this view from the side of a parkway, close to the old brick works—is the best we shall ever have. In his essay, Philip Preville sees the city in a single crosswalk. Perhaps the absence of an accepted myth of Toronto is because the city has come of age late enough and realistically enough to know, in its heart of civic hearts, that there is no such thing as a whole.

"ALL SLOPES TO BE ROUNDED and molded to existing ravines and tableland to provide Parkway character." So stipulated the report for the proposed Don Valley Parkway that was submitted to Fred Gardiner, the chairman of Metropolitan Toronto, by the engineering firm Fenco-Harris

in the autumn of 1955. It was one of many recommendations. All elevations of the proposed road would be above maximum flood levels (the report was released exactly one year after Hurricane Hazel). The bridges that would cross it would be rigid-frame concrete. The route would follow the most direct and economic line between the proposed Lakeshore Expressway (soon to be renamed the Frederick G. Gardiner Expressway) and the intersection of Sheppard and Woodbine. The "limited access [highway] with three lanes in each direction and interchanges at principal existing thoroughfares" would be designed "for safe travel at sixty miles per hour" and would be built for an estimated cost of $29 million.

But it was the idea of a road that would conform to the existing landscape and "blend into the existing expanse of Greenbelt"—a notion accepted by Metro Council when it proceeded with construction three years later—that would make the Don Valley Parkway different from the network of radial roadways of which it was intended to be a part.

The scheme to surround and intersect Toronto with a system of expressways was the brainchild of the City of Toronto, which was intent, in the immediate postwar years, on almost completely re-routing traffic flow within its borders. It envisaged construction of five limited-access, high-speed "superhighways," three crosstown and two north and south. The Spadina Expressway, the Scarborough Expressway, the Don Valley Parkway (DVP), a midtown expressway, and a crosstown expressway linking the DVP to Spadina—these were the mainstays of an overall transportation system that would, it was hoped, solve the city's traffic problems.

In those days, the steadily increasing traffic heading into the city had no place to go. It piled up at a few chaotic bottlenecks. Photographs from

the 1950s of rush hour on Lakeshore Boulevard and at the end of the Queen Elizabeth Way at the Humber River show traffic jams that look altogether contemporary. Among North American cities, only New York was more congested. Sixty-three per cent of the jobs in Metropolitan Toronto lay within two miles of Queen and Yonge, and nearly 130,000 vehicles poured into and out of the downtown core every weekday. So great was the increase in the volume of automobile traffic between 1945 and 1955 (it doubled), and so tangled were the traffic jams, that one journalist aptly called Toronto's ad hoc transportation plan the vain effort "to pour a gallon of cars into a pint of streets."

But the expressway plan was troubled from the very beginning. With great fanfare, the Yonge Street subway had opened in 1954, and almost as soon as it did there were those who argued that any money spent on new roads was money that wasn't being spent on public transit. They were right, we now know, but it took about half a century for this truth to become evident. Indeed, there are still those who, as if shoring up support for Toronto's small-town personality, continue to argue that public transit will never replace the automobile.

It was the proposed construction of the Spadina Expressway that galvanized the plan's opponents. The most passionate opponents of the proposal were people whose homes and properties were going to be directly affected, but the arguments for and against marked out the battleground for debates between communities and transportation planners for decades to come. It was Jane Jacobs who became the anti-expressway champion—her vision was perfectly suited to what her adopted hometown was beginning to dream it could become. The fight also underscored the deep divisions between suburban constituents of Metropolitan Toronto and the residents of the city's

core, a division that, as Peter Kuitenbrouwer notes in these pages, has not grown any less deep with the passage of time.

In 1971, when the Ontario government stopped the Spadina Expressway in its tracks, the expressway's supporters—mostly Metro politicians and members of the provincial legislature who represented constituencies of daily commuters—launched rear-guard attacks, but to no avail. The Spadina Expressway was reduced to the W. R. Allen Road, and with Spadina gone the rest of the scheme fell apart. The midtown and crosstown expressways were never seriously considered again.

But the Don Valley Parkway was different. Its construction caused almost no outcry. The can-do optimism of the 1950s still prevailed. The word "environmentalism" scarcely had a place in the public vocabulary. Smog was something American cities had. The river valley was practically wilderness, but its natural beauty was not, for many Torontonians, a cause to rally around— especially when it appeared to provide an easy solution to the city's increasingly irritating traffic problem. Don Mills Road might have been turned into an expressway, but not without the cost and disruption of considerable expropriation. As far as most Torontonians were concerned, the Don Valley itself was empty space waiting to be put to use.

The only neighbourhood that fell to the wrecker's ball was the Corktown area of south Cabbagetown, where buildings were bulldozed to make way for the Adelaide and Richmond Street links to the DVP. But unlike the neighbourhoods through which the Spadina Expressway was slated to pass, Corktown was neither well-organized nor affluent. The razed buildings of Corktown, like those in south Parkdale that were demolished to make way for the Gardiner Expressway, were thought to be a reasonable price to pay for relieving traffic congestion.

Richard White, an urban historian, argues that the acquiescence of Toronto's population to the construction of the Don Valley Parkway had its origins in a civic mood formed largely by the Canadian wartime experience. "There was a new acceptance of government intervention," he says. "The war had brought about vast increases in taxation, in government involvement in housing and food supply and prices, in labour relations. The legacy of the hand of government was pretty much accepted." It was in this spirit—"a new spirit of confidence" is White's description—that Toronto undertook its massive postwar projects. The Lakeshore Expressway (now the Gardiner Expressway) was built. Water and sewage infrastructure was laid in, opening vast suburban tracts to Toronto's postwar development. And the Don Valley Parkway got the green light.

The boom of postwar development transformed the city. Ironically, the 1971 decision to stop the expressways—a reversal, so expressway proponents argued, of the momentum that the postwar boom kicked into gear—had a similar defining effect, although it did not so much change the city as save it. What did change—as the "Stop the Spadina Expressway" buttons began to appear on more and more lapels, and as Jane Jacobs became a household name—was the city's vision of itself. The destruction of neighbourhoods in the name of progress was, finally, not a price Toronto was willing to pay. It might as well have ripped out its own heart. Toronto didn't just have neighbourhoods; it *was* neighbourhoods: backyards and ravines, modest blocks and unfancy skating rinks, quirky bars, like the one Ian Pearson describes, and the little art galleries that Sarah Milroy discovered when she first arrived here. Toronto began to think of itself as some place different. It was not Cleveland or Atlanta. Nor was it Paris or Rome. It was becoming Toronto. It still is.

The changes are taking place today—changes of governance, as described by political economist James Milway and urban geographer Meric Gertler; changes in spirituality, as described by John Allemang; changes in manners, as described by Tabatha Southey in her witty meditation on Toronto's new, self-centred coffee habits; changes in the kind of street crime that is now part of the city's life, as Andre Morrison and David Hayes outline in their sobering collaboration on Toronto's gangs; and the necessary environmental changes that member of the provincial legislature Peter Tabuns proposes in his timely essay. These have less to do with ramps and roads and sewers than the massive changes in vision that Toronto undertook a generation ago. They are, perhaps, less dramatic than the fight to stop an expressway—and to stop the idea that the expressway represented. But they are no less brave. And no less transformative.

I have already noticed, for instance, that when I tell my two children about the Toronto that I knew when I was their age—the handful of restaurants; the stuffy store clerks; the paucity of cheerful bars and intriguing art galleries, warehouse-like theatres; when I tell them of the archaic drinking laws; of the grim, buttoned-up Sundays, of the city's grudging attitude toward its own culture—they sometimes think I'm making things up. When we speak about the Toronto of not so very long ago, it's as if we are standing in a leafy common garden and I am asking my children to imagine that it was once a scrappy maze of back alleys and garages and sway-backed sheds.

THE SYLLABLES ARE USUALLY INDISTINCT. But if loosely defined, they are also evenly weighted—a perfect aural image, some might say, of the flatness of landscape and equilibrium of civil life that are characteristic of the city. In the great grey urban sprawl of 4.7 million people that presides over the northwest shore of Lake Ontario, we say more than "Trawna." But not much more. We don't want to be sloppy. But neither are we given to excessive displays of elocution. We don't want to get carried away.

It is Americans, oddly enough, who are sticklers when it comes to pronouncing the name of the fifth-biggest city in North America. (Only Mexico City, New York, Los Angeles, and Chicago are larger than Toronto.) Americans are most usually here for a baseball game, or a convention, or a business trip, or for what Torontonians fear might well be a dull family holiday. Approximately three million US citizens visit Toronto every year, and to be perfectly candid, we are not always sure why. Aside from the dwindling advantage of the exchange rate, and the fact that the chances of getting robbed, shot, or mugged are relatively slight, the attractions are a little mystifying. Torontonians will stare at a passing sightseeing bus with far more curiosity than that with which its occupants stare back at the uneventful cityscape of Toronto.

Nonetheless, the Americans come—an attraction that does not speak well of the excitements of upstate New York or the urban vitality of most American cities—and when they do, they Very Carefully Pronounce the name of the place they are visiting. "Toe-RON-Toe," they say, as if asking for directions to the washroom in a foreign language.

Why this should be so is a mystery. It hardly fits the freewheeling, unbuttoned image of slang-friendly Americans. Normally drawn to unfussy shortcuts of pronunciation—"Uh-huh," for "You are very welcome." And

"Ril'gud" for "I am quite well, thank you"—Americans approach the name of the capital of the province of Ontario as if under the strictest of instructions from Henry Higgins.

To a certain degree, this has to do with lack of familiarity. One has the sense that when it comes to saying the name of the city where the Rolling Stones often come to practice, where Mike Meyers grew up, where the World Series was won, twice, and where Joe Shuster lived when he was busy creating Superman, they somehow haven't had a lot of practice. We almost never make anyone's news but our own—a fact that we neither grieve nor celebrate. In a distinctly Canadian way, we observe, without much by way of comment, that when Americans speak of Toronto they often sound as if they are repeating a name that has only recently been brought to their attention. It's as if they're a little embarrassed to discover that the financial and cultural capital of the nation that is the largest trading partner of the United States has somehow gone unnoticed by them, and they've concluded that a cautiously correct approach to pronunciation is less likely to draw attention to this oversight.

Torontonians run just as strenuously against type. Reputed to be overly formal, unnecessarily polite, ploddingly cautious, obsessively law-abiding, and incapable of escaping the stodgy, persnickety strictures of British heritage, Torontonians are extremely relaxed when it comes to the name of their city. They may wait for a green light on a deserted street before crossing. They may honk like Grade 6 safety monitors if somebody tries to make an illegal left turn. They may nearly have a stroke if someone jumps a queue. And they may even, in certain demographically diminishing circles of the old WASP establishment, strongly disapprove of a white dinner jacket before May 24

or after Labour Day. But when it comes to talking about Toronto, they slide through the syllables of its name with all the attention to detail of a drunk falling down stairs.

When a Torontonian says "Toronto," every consonant and every vowel is usually touched upon, but with such subtlety it's hard to know where speech has ended and humming has begun. "Toronto" is an appropriately fair, suitably undemonstrative, aptly unprovocative kind of word—for Toronto is a very nice place. And that could be the problem.

An advertising executive recently suggested that the city *play up* its crime in order to overcome its wholesome but dull image. Aside from being nutty, and more than a little insensitive to the victims of a recent rash of shootings in the city, his suggestion perfectly illustrates the difficulty marketers and advertisers have with Toronto: it's impossible to touch down on one aspect of Toronto's civic character—its pride in being a place that is, for the most part, untroubled and safe—without ignoring another—its unhappiness at being almost universally perceived as dull. Toronto—the birthplace of Mary Pickford! The home of the Santa Claus parade! The site of Casa Loma! The city where the paint roller was invented! The city does not have a very exciting reputation, and while it is this reputation that allows Torontonians and visitors alike to feel comfortable at night on the city's downtown streets— no small civic achievement, as South African journalist William Saunderson- Meyer notes—it may be that this reputation seeps into the syllables of "Toronto" more than the city's frustrated marketers would like.

Most Torontonians have little interest in their city's history. This is not because they were any worse students in Grade 6 history classes than their counterparts in London, or Paris, or New York. It's just that for reasons that

are darkly peculiar to Toronto writers, filmmakers, and television producers, the city's history has only rarely crossed the line from school textbook to popular entertainment. Despite stories of duels, fires, plagues, wars, villains, eccentrics, and a first mayor who could hardly have been more colourful had he been dreamed up by a team of Hollywood screenwriters, Toronto's enthusiasm for its own past has, until recently, been tepid. The suggestion that Toronto might want to have a museum devoted to its history is a suggestion that has been frequently made by former mayor David Crombie, whose essay graces these pages. Perhaps nothing so exemplifies the shift taking place in Toronto's sense of itself than the fact that now, after years of only the slightest official interest, the city is paying attention to his idea.

Those few Torontonians who were paying attention in history class will tell you that the word "Toronto" is a First Nations word for "meeting place." This has a nice ring to it, particularly in light of Toronto's remarkably broad and pacific mix of races, cultures, religions, and nationalities. But, in fact, Toronto was the Huron name for the narrows between Lake Couchiching and Lake Simcoe about 150 miles north of the city. Through a series of seventeenth-century exploratory approximations, cartographical goofs, and careless assumptions that one northern lake was pretty much the same as another, the word "Toronto" was a regional generalization that gradually became erroneously specific. Toronto was the name given to the settlement on Lake Ontario that eventually became York and then (in rebellion against Lieutenant-Governor Simcoe's Python-esque enthusiasm for giving everything English names), Toronto again. Accustomed as we are to being described as nice but dull— "New York run by the Swiss," as the actor Peter Ustinov famously put it—it is nonetheless a little depressing to think that the most notable landmark

anywhere in the vicinity was a fishing weir between two lakes that is now a two-hour drive north of the city. Apparently, there was nothing worth mentioning here—a situation that, if you stand at the corner of Danforth and Victoria Park, or even at Yonge and Bloor, seems not to have changed a great deal. Which could explain the regrettable associations we have with the city's name.

"Toronto" does sound a little monotonous by the time you hit its third "o," but that's hardly out of character for a city that managed to keep *The Phantom of the Opera* running for ten years. As only Torontonians could, we have found a way to pronounce the name of our city without favouritism of any sort: we grant each syllable an equal absence of emphasis.

"QUITE HONESTLY," wrote a blogger on the Zeit.ca forum recently, "besides visiting relatives or attending a gay wedding, I'm not sure why anyone would want to come to Toronto." Knowing that this is a perfectly valid point of view is part of the odd business of being a Torontonian.

Toronto's weather in winter is often grey and forbidding, and this hurtling cold has the capacity, somehow, of exaggerating the prominence of the city's most brutal and brutally boring buildings. It has a way of widening the city's most inhuman intersections. It has a way of diminishing the city's fragile spirit. From the huddled, shivering perspective of Toronto in February, sidewalk cafés and evenings in back gardens seem not so much memories as improbable fantasies. Winter can be a blizzard of smallness, and for months it can turn the city into little more than a tunnel through which its citizens must pass, as quickly as possible, on their way from point of departure to point of arrival.

Even so, Toronto is a good deal less provincial than many cities. Winter or summer, a walk on any downtown street reveals the population's racial complexity. John Barber tells us that this complexity is the city's greatest blessing. Its restaurants are excellent, its music and art scenes lively—and this sophistication, as both Richard Florida and Meric Gertler point out, is a far more important asset than the city fathers of old ever imagined.

I am in my mid-fifties and when I was a student at the University of Toronto we used to go down to the sidewalk in front of the St. Charles Bar on Yonge Street on Halloween and laugh *at* the drag queens. One generation later, my children laugh *with* the drag queens at the Pride Day parade, and within that difference there lies a good part of the story of a city's transformation. Now, when anyone asks me what I like about Toronto, I reply that once, not long ago, in the very worst of February storms, I stopped my car at a downtown corner and watched an elderly gay couple, fighting the weather, leaning into one another. They were helping each other against the wind and the snow, picking their way over the ruts of difficult ice and, as I watched them, I surprised myself by starting to cry—tears of pride that I lived in a city that now makes these two gentlemen feel so comfortable with one another and so untroubled about being so publicly together. As Sarah Milroy points out in her contribution to this collection, those of us who live in Toronto are often surprised when we discover that we have fallen in love with a place that we once thought of as convenient, comfortable, and safe, but somehow unlovable. Milroy's heartfelt piece is the subtext to almost every essay in this book.

Even so, Toronto has its examples of small-mindedness—which isn't surprising. Small-mindedness, after all, is something that humans can almost always be counted upon to demonstrate, no matter how big the city or how

small the town in which they live. Toronto still resists the notion of spending adequate money on civic beauty and on support for the arts—as the former Canadian Opera Company's general director, the late Richard Bradshaw, points out in these pages.

Toronto's public transit system is decades out of date. (Toronto's embarrassing lack of a train to its airport always seems to me to have a snooty, mean-spirited undertone: if you can't afford a limo to the airport, so the nonexistent subway line seems to be saying, you shouldn't be travelling.) And—in the boom of condominium construction that is transforming the downtown—Toronto still builds towers that are not named after the neighbourhood they're in, or after a local landmark, or after a Toronto historical figure. Torontonians may not be all that provincial, but many of the people who develop condominiums in their midst must think they are: apparently, if you're interested in being really swank in Toronto, you can buy a unit in the French Quarter, or the Carlyle, or the Park Avenue, or the Rockefeller, or the Shangri-La.

All these shortcomings are hard to miss, and although they remain part of the weave of what comprises the complexity of Toronto, they are no longer primarily representative of the city's reality. Toronto has changed. It has changed enormously in the past forty years. Michael Awad's photography attests eloquently to this new reality. And more than ever before, it is changing now.

But still the old reputation persists. In the spring of 2006, I sat in a brasserie in Paris with French artist Michael Weston. I was surprised to learn that he had spent some time in Toronto in the 1960s. More surprised still (a typically Toronto reaction) to learn that he'd liked it. But even though he

A CITY BECOMING

had more association with Toronto than most Parisians, his sense of the city had never adjusted in the almost half-century since he heard Neil Young in Yorkville and sat in the Horseshoe Tavern on Queen Street and listened to country and western music for the first time. The success of the Toronto International Film Festival seemed not to have sunk in. The acclaim that attends Harbourfront's International Authors Festival seemed not to have registered. The reputation of Toronto's best restaurants had made no impression, apparently, in Paris. The fact that Toronto is perhaps the most multiracial and multicultural city on Earth, and that it remains more than relatively peaceful, had not broken through. (The Parisian suburbs were erupting with riots the day we spoke.) Toronto's openness to gays, its theatres and music scene, its new opera house and newly redesigned and expanded art gallery, the architectural seam-splitting of the Royal Ontario Museum, the wit of Will Alsop's Ontario College of Art & Design—these have not become known somehow. Weston asked me if it was still illegal to drink wine in a private garden and whether alcohol was still forbidden on Sundays—antique notions that my children, born in Toronto two decades after Weston left it, would have difficulty believing had ever been true.

But what is interesting about this out-of-date sense of the city is not so much that it persists, but why it does. For reasons that have something to do with the cautious, undemonstrative, circumspect, and relentlessly modest soul of this odd city, Torontonians have proven to be next to useless at presenting their city in its new light.

Its reputation for being boring, grey, and provincial persists to a considerable degree because Torontonians are either singularly inept at, or entirely uninterested in presenting a different view of themselves to the

world. Perhaps this is because they spend more time in the privacy of their gardens (legally sipping wine) than in the public of their city's streets.

Torontonians are overly modest about their city. They are inured to it being dismissed, often unfairly. Whenever the British press shows up, usually unhappily tagging along with some royal visit, it remains as predictably unimpressed with Toronto as it is stubbornly determined to ignore much beyond the horizons of their well-stocked hospitality suites. And Fleet Street is not alone in its disdain. A recent announcement in a Paris weekly of an upcoming concert by Broken Social Scene, an internationally successful Toronto-based band, made the comment, for no apparent reason, that it was a surprise that Toronto had a social scene, broken or otherwise.

But Torontonians are accustomed to such slights. They even take a certain pride in them. When Wyndham Lewis, the English artist and writer who spent several years in Toronto during World War II, was told by a Toronto matron that where he was living was not a very good address, he replied, "Madame, there are no good addresses in Toronto." And nobody other than a Torontonian would remember or repeat the story.

Like a person who loses an enormous amount of weight but is still stuck with the cruel nickname "Fatty," Toronto is shackled with clichés that are long out of date. As John Allemang points out in his essay, The City of Churches is an epithet that is about as apt now as Muddy York. Anyone who talks very much about how "neat" and "clean" Toronto is has obviously not been on Spadina Avenue very recently.

People who live in Toronto will say that they like it. They will say it's manageable. They will say that it is a good city in which to raise a family.

They will say that they couldn't live anywhere else in Canada—which, to a New Yorker, or a Londoner, or a Parisian, is probably faint praise indeed.

You might occasionally encounter people who have taken stock of Toronto's safety and civility, its good public schools, its liberal good-heartedness, its lively artistic scene, its remarkable racial harmony and exciting mixture of cultures, its openness to lesbians and gays, its fine restaurants, its slightly awkward, not always successful but nonetheless comforting instinct to be fair, and its livable, not-yet-exclusive downtown (not-quite-yet, as Linda McQuaig warns in these pages). You might find people who, like Mark Kingwell, believe that Toronto has arrived at a moment in its history at which it can look beyond image and fad and ask the rigorous and difficult questions that cities of any significance always need to ask of themselves.

These people have measured the truth of Toronto against the expense, or the difficulty, or the noise, or the danger, or the social and economic injustices of bigger, more famous urban centres. And sometimes their conclusion—a little calculated perhaps, a little dispassionate, it might be said—is that they wouldn't live anywhere else in the world. But you almost never hear anyone talk about Toronto being beautiful. More rare still is someone who thinks Toronto is a beautiful place and who speaks—openly, emphatically—about loving it here. But that, as these essays argue, is one of the many things that are changing. That is what is yet to come.

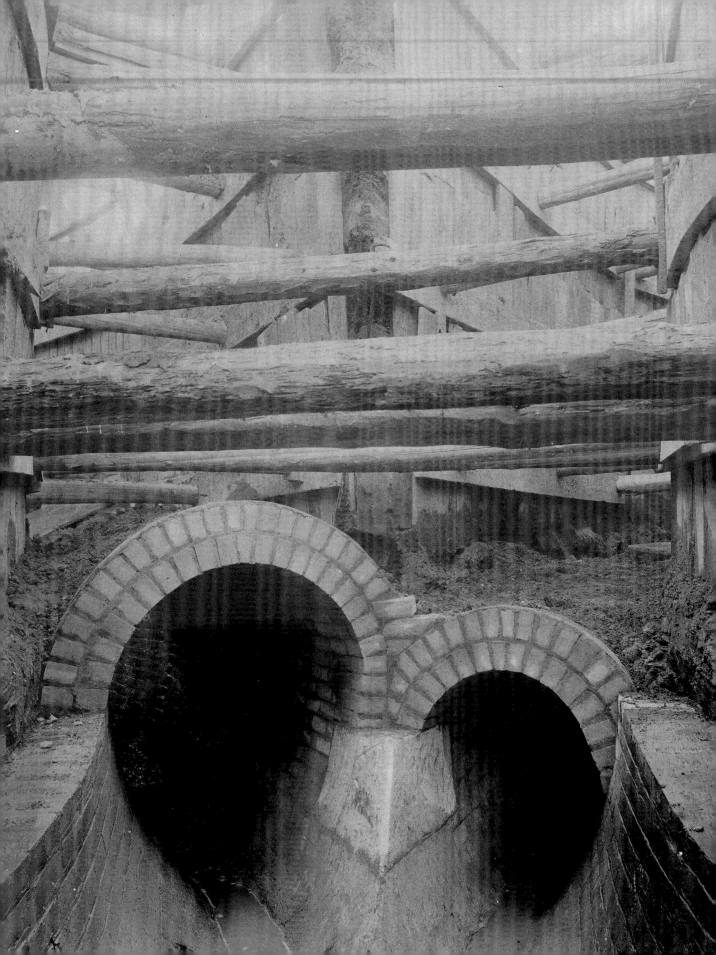

OF LOCAL INTEREST
DAVID CROMBIE

BOTH A GLOBALIZED ECONOMY AND THE ENVIRONMENTAL IMPERATIVE OF SUSTAINABILITY ARE CASTING TORONTO'S EVOLVING URBAN ECOLOGY INTO HIGH RELIEF, WRITES THE CITY'S FORMER MAYOR, DAVID CROMBIE. IT IS A TRANSFORMATION THAT TORONTONIANS ARE ONLY BEGINNING TO COMPREHEND.

R OBERT FULFORD, in writing the introduction to his book *Accidental City*, put his finger on a fundamental truth about building strong cities. "A successful city," he wrote, "fulfills itself not by Master Plans but through attentiveness to the processes that have created it—and an awareness of its possibilities. It achieves heightened identity by giving form to memory and providing new space for life."

Few can doubt that Toronto has made an extraordinary effort in the recent past to provide "new space for life." In the latter half of the twentieth century, the city opened its doors to human migration and transformed the composition of its population, recast its social institutions, retooled its urban infrastructure, revolutionized its economy, and rethought its role in the world.

Toronto has become the central player in an expanding region of continental and global proportion—a vast place that includes within its orbit cities, towns, villages, farms, forests, wetlands, and rivers. It must be said, however, that Toronto, despite some notable exceptions, has been far less successful in recognizing and celebrating the "processes that have created it." It too often has shown a remarkable indifference to heightening its identity through "giving form to memory." Nevertheless, whether celebrated or not, the history of a city is always at work. Through the power of its civic culture—its values, traditions, laws, public processes, institutions, and time-tested habits of mind and heart—a city uses its past to shape its future.

Several essential convictions drawn from the core of Toronto's own civic culture share an enduring quality. In the first place, Torontonians have always understood the primary importance of economic opportunity and the transformational power of the marketplace. This legacy is woven into the

city's civic culture, and endures as a belief that is so deeply ingrained we don't always see how fundamental it is. But Torontonians know that people must be free to pursue their material well-being for themselves and their families. This instinct should not be underestimated; it is a deep and universal need. It is why people come here and the reason they will stay.

Secondly, Torontonians have insisted on the central significance of place and community in human experience. Neighbourhoods are seen not just as physical places but psychic spaces where human personalities are formed and safely expressed; where identity is rooted and where the rudiments of survival and the lessons of life are learned and practiced. At the same time, the concept of community has persisted as an expansive one. Toronto plays a special role as global gathering place for human migration. An activity as simple as a walk on a Toronto street allows for greater understanding of the complex nature of the immigrant experience.

Thirdly, from the beginning, Torontonians have required that government carry a fundamental responsibility in the shaping of community. They have consistently demanded public investment in facilities and services to match the economic and social needs of the day. They have understood that the complete spectrum of basic community infrastructure—from health and education, to roads and communication, to libraries and recreational facilities—must be of good quality and open to all. These connecting tissues link private worlds and generations to one another, forming a platform for economic prosperity. They allow a widening of the circle of social justice and thereby foster civic peace.

Happily, in the past few years there has been a widespread and growing movement to restore vigour to these notions and to engage generally in the

restoration of cultural and natural heritage. We have witnessed an extraordinary reinvestment and rebuilding of our main cultural institutions and equally impressive activity in the regeneration of our rivers, creeks, watersheds, waterfronts, wetlands, and natural areas.

There has been an explosion of interest in neighbourhood health, histories, walks, and parks. Human diversity is celebrated through exhibits, festivals, diaspora dialogues, and engaging in public debate on the needs of new immigrants. A growing attention to architectural preservation, adaptive reuse of buildings, the discovery of "new" heritage sites, the building of monuments, the renovation of historic precincts, and even a renewed interest in the development of a History of Toronto Museum: all of these attest to a remarkable renaissance in a commitment to telling Toronto's story.

Since time immemorial, Toronto's unique natural setting has been crucial to the development of its economy, social life, and spiritual and creative imaginations. In the eighteenth and nineteenth centuries and for much of the twentieth, Torontonians felt they had to dominate and control their natural environment—to burn, break, bury, or beat it back—in order to progress. In the new century, however, we are finally developing a dynamic relationship with nature, learning that it is paramount to support and sustain it if we are to continue to benefit from it.

What gives this current wave of interest and activity some special quality and staying power is its direct connection to the great forces of change swirling about us. The challenges and opportunities now presented can be effectively dealt with only by paying attention to the "processes that have created" Toronto and by digging into the arsenal of our civic culture. The globalization of the economy engenders a need for creative institutional

and entrepreneurial responses at the local level, while the worldwide environmental imperative of sustainability demands that we pay attention to the immediate interconnectedness of things and be responsible for the consequences of our actions. Torontonians must do what they have always done when faced with change—re-create, reinvent, and reinvest. It is through exploring our history that we can mobilize lessons from our own experience and put them in the service of Torontonians in the twenty-first century.

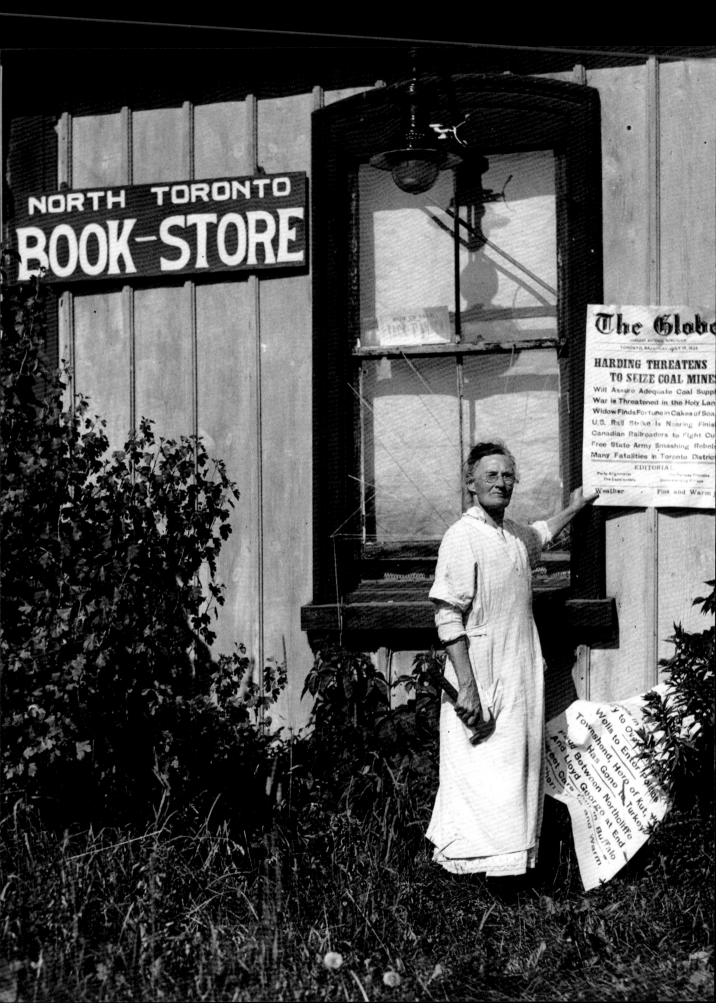

VOX POPULI
SIOBHAN ROBERTS

THE SUBJECT OF TORONTO USED TO BE EXCLUSIVE TO A HANDFUL OF WRITERS, JOURNALISTS, AND HISTORIANS. NOW, IN THIS ULTRA-DEMOCRATIZED MULTIMEDIA AGE, THE CITY IS OPEN FOR ANALYSIS, DISCUSSION, DEBATE. SIOBHAN ROBERTS CONTEMPLATES THE PUBLISHING PHENOMENON OF *uTOpia*.

ON A SUNDAY NOT LONG AGO I was heading east along Bloor Street toward Yonge and bumped into a friend. "Off to Holt's for some shopping?" he asked. Alas, no. My destination was beyond those subliminally tempting fuchsia flags of fashion, one block north on Yonge Street to the Toronto Reference Library (the largest reference collection on the continent, a librarian informed me). There, browsing the shelves, I found all the old reliables expounding on the subject of this city.

Robert Fulford's *Toronto Discovered* and *Accidental City: The Transformation of Toronto* hold pride of place, though the latter is on a separate shelf classified as "special collections." Mike Filey is well represented with *The TTC Story*, *I Remember Sunnyside*, and *Toronto Sketches* (editions one through five), to itemize but a fraction of his oeuvre. The 1974 second edition of Eric Arthur's *Toronto: No Mean City* (first published a decade earlier) is an obvious favourite; it's at the bindery. And, for a curiosity cabinet of the arcane, how about, *Shhhhh! Don't Tell Anyone: Folk Tales of Old Toronto* by William C. H. Dowson. This edition is a "photoreprint" of the original, pounded out on a typewriter with the help of whiteout (crusty white smudges on the title page blot out an extra *h* in *Shhhhhh!*).

Absent from the shelves, however—both in the fourth-floor main reference department and the first-floor circulating browsery—are the library's two listed copies of *uTOpia: Towards a New Toronto*, a collection of essays published by Coach House Press in 2005.

According to the online catalogue, in the Toronto-wide public library system there are eight copies of *uTOpia* out with readers. Eight are on hold. One is lost, perhaps left on a bus or stolen. But the reference department's

copy of *uTOpia*, the catalogue reveals, is "In Process." That is to say, the book was perhaps deemed popular enough in circulation that the library's ordering committee finally decided to purchase a copy and add it to their august collection of 1.6 million catalogue items, thereby bestowing upon the book the coveted there-for-all-eternity-and-always-in-the-library capital R "Reference" status. "Certainly looks like we were a little late to the party on this one," confesses a librarian in the main reference department, on the condition that she not be named.

Indeed, *uTOpia*'s stable of authors gather in the literary equivalent of a spontaneous street party for the masses, hybridized with the heady edge of a French salon, and the blogosphere's indulgent democratization of both experts and content. Who knew so many Torontonians whose names don't ring a bell (and even those who do) felt sufficiently connected to their urban habitat—beyond the gooey gum always sticking on your shoe—to ponder thoughts into words on the page (some better arranged than others), and for the usual small-press pittance ($100, a copy of the book, and the publisher's undying gratitude)?

The impetus behind *uTOpia* is primarily good old-fashioned urban reform, but put forth by what you might call a next-generation contingent—youthful in their fresh, engaged, and energetic perspective, if not always in biological years—and charged with a passion and idealism about the city that dates to Mayor David Miller's 2003 sweep into City Hall. "It's kind of nice when you've been a cynic for so long to encounter idealism," says thirty-something co-editor Alana Wilcox, from her cluttered command-central nest at Coach House. "It's refreshing. And it's contagious."

The organizing conceit of *uTOpia* has about it a "psychogeographic" sensibility, a concept invented by the Parisian situationist Guy Debord. "The

term is deliberately vague," notes Dylan Reid, a *uTOpia* contributor and member of the Toronto Pyschogeography Society. The definition of "psycho-geography" on the society's website is "the specific effects of the geographical environment on the emotions and behaviour of individuals. The streets of Toronto become a playground, and each route presents a new urban adventure as participants step out of their daily routine and explore the city's overlooked corners to imagine the dynamics of a better future urban environment."

The *uTOpia* books (the second volume, released in 2006, is *The State of the Arts: Living with Culture in Toronto*, and the third, published in the fall of 2007, is *GreenTOpia: Towards a Sustainable Toronto*) are governed by similar pulse-taking modus operandi, with the invitation for submissions cast far and wide (and with specs stipulating, "We want the book to be positive and hopeful").

The first scattershot volume of *uTOpia* contained curatorial and flaneurial takes on sidewalk pavement by Philip Evans; the secret lives of public toilets by Deborah Cowen, Ute Lehrer, and Andrea Winkler; a wishful reverie on what our waterfront would've-could've-should've been by Sheila Heti; and a plea of sorts by Shawn Micallef (founder of the Toronto Psychogeography Society) titled "Psssst. Modern Toronto just wants some respect."

In volume 2, Natalie de Vito's essay titled "Mom, Dad, will you co-sign my mortgage?" opened by saying, "If, as some have suggested, Toronto is a teenaged city, then the city's non-profit arts organizations could be seen as overgrown kids in their mid-thirties—still living at home, unable to save enough cash to pay for their own places." Anna Bowness's piece explores the hidden cameras that are "photoblogging the city's every move." And the underground scene of Toronto rappers who are lacking aboveground infrastructure is addressed by Jill Murray and More Or Les.

Then there's the Gore-green volume 3. It was culled from over a hundred submissions, each imagining how the city might demonstrate more environmental wisdom: gardening the Gardiner; composters for dog poo in parks; drinking less coffee.

And Wilcox says there could very well be *uTOpia 4*, and more. As she exclaimed in the e-mail call for submissions for volume 2, "*uTOpia* . . . has been, much to our surprise, a huge hit. As it turns out, Torontonians are ravenous for dialogue about our city."

"Toronto used to be the sort of place you could define easily enough," noted William Kilbourn in his editor's introduction to another classic on this burg that is shelved in perpetuity (and in special collections) at the Toronto Reference Library: *The Toronto Book: An Anthology of Writings Past and Present*, published in 1976. "It was an Indian village once; then, a trading post; a fort on the edge of Empire; a sleepy colonial town; a bustling Victorian city; and, only yesterday, a modern metropolis that saw itself as another London or New York and managed, just, to achieve Belfast and Buffalo."

"Then," Kilbourn observed, "quite suddenly, things changed. In the 1970s Toronto was something unique and glorious under the sun. It became a place to praise, extravagantly, but much harder to define."

Things in the Big Smoke, it seems, are in transition again, compelling a new set of Torontonians to step out of their daily routine, explore the city, and yet again define, or redefine, the Big Smog. Though do note that with Mayor Miller's latest slashing to the city budget, the Toronto Reference Library is no longer open for exploration or consultation on Sundays. And the library board agreed to cancel the purchase of 14,000 items—*uTOpia* made it onto the reference shelves just in the nick of time.

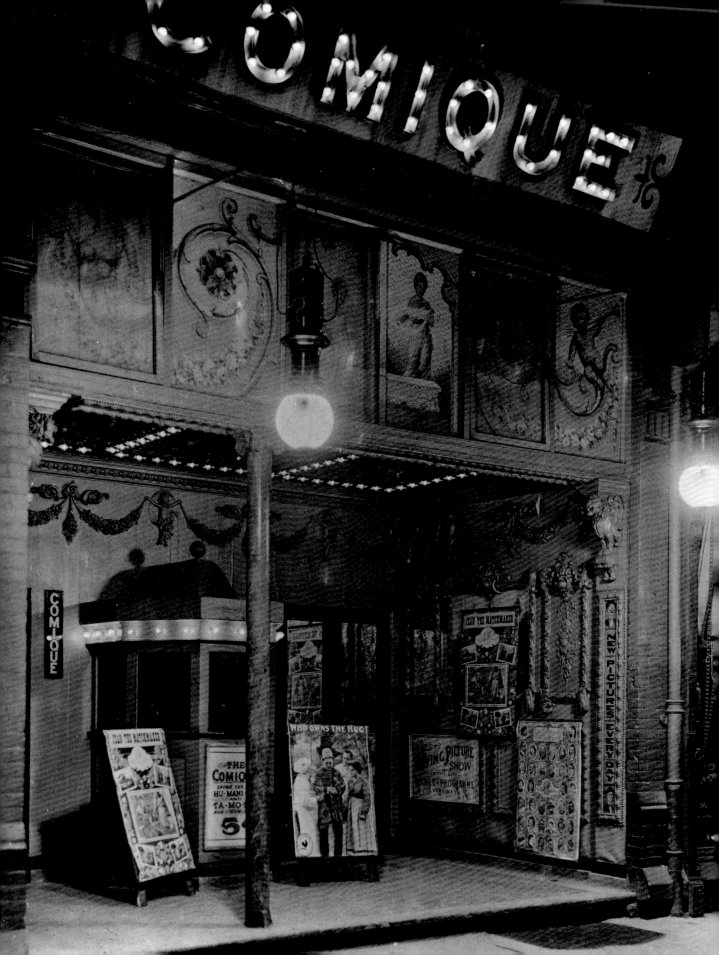

AT THE CROSSROADS
MERIC GERTLER

TORONTO IS POISED TO ENTER A NEW AND EXCITING AGE, WRITES URBAN GEOGRAPHER MERIC GERTLER. BUT DESPITE ITS ENVIABLE STRENGTHS, TORONTO'S CREATIVE ECONOMY IS NOW AT A CRITICAL JUNCTURE IN ITS EVOLUTION. THE FUTURE BECKONS. BUT WHY DO PLANNING POLICIES STAND IN THE CITY'S WAY?

NO DOUBT ABOUT IT, Toronto has been bitten by the creativity bug. Our self-declared "Year of Creativity" seemed to last at least eighteen months—longer if one judges by the presence of those uplifting "TO Live With Culture" street banners. The campaign celebrated the contribution of the arts to the life of the city, capitalizing on the revival of many of the city's top venues for cultural performance and display to make the point.

In September 2006, Toronto's first Nuit Blanche brought out hundreds of thousands of normally staid citizens to celebrate the arts at a handful of sites around the inner core of the city. Some of those partying in the crowded ten-block strip beyond Trinity-Bellwoods Park along the western reaches of Queen Street West might have paused from their all-night revelry long enough to notice the incongruous presence of sales offices for the Bohemian Embassy and the Westside lofts. In doing so, they would have come face to face with the most tangible symbols of a critical choice now facing the city.

A year before "The Year," the City of Toronto produced an important *Culture Plan* to serve as a blueprint for the cultural fulfillment of its citizenry. Tellingly, this plan made a quiet but important point: while there is no denying the functional and symbolic importance of building world-class ballet-opera houses, conservatories, concert halls, and museums, many of the city's arts organizations still struggle to pay the rent, meet their payroll, and keep the lights on, not to mention finding the wherewithal to sponsor the production of new creative works.

The same theme was picked up in a subsequent document, jointly commissioned by the City of Toronto and the Province of Ontario, arising from a study for which I served as research director. Our final report, *Imagine*

a Toronto... Strategies for a Creative City, argued that culture, creativity, and cities are intimately intertwined, and that there are many good reasons for focusing public action on developing a city's creative capacity.

Creative activity and creative people give life to a city in many different ways. Particular areas have now become closely identified with (and by) the distinctive cultural movements and products they produce: their music, their architecture, their films, literature, art, fashion, and so on. Through their contributions to its various cultural "scenes," the arts define a city's identity and generate the buzz that draws in more creative people from other places. Artists have also long been recognized as the vanguard in regenerating and recycling our city's older neighbourhoods, kick-starting a process that often ends up working all too well.

We also know that the so-called cultural industries—publishing, film and television production, broadcasting, new media, music recording, visual and performing arts, entertainment, advertising, and architecture and design—now make up a large and, in many cases, rapidly growing share of the economy of our city-region. One yardstick of this trend is the tremendous growth of employment in creative occupations—painters, sculptors, and other visual artists; photographers; actors, producers, directors, and choreographers; writers and editors; musicians, composers, and conductors; architects and other designers—in the Toronto region since the start of the 1990s. Employment in this group of occupations has grown at nearly four times the rate of growth of the overall labour force over this period. Our research also showed that Toronto's rate of growth in this group of occupations over the 1990s outstripped that of other cultural centres in North America, including New York, Los Angeles, San Francisco, Chicago, Boston, Miami, and Montreal.

But the impact of creativity on the health of a city runs even deeper than this. Scholars of many disciplinary stripes agree that we are now in a creative age—a time when the generation of economic value in many different sectors of the economy depends directly on the ability of firms to embed creativity and cultural content within the goods and services they produce. Familiar goods such as clothing, furniture, and food products depend on creative and cultural content for their competitive success. We consumers are willing to pay higher prices for products that are well-designed and culturally distinctive. Knowledge-intensive products such as computers, mobile communication devices, and biomedical technologies are born of the innovative spark of well-educated, creative workers. They also exploit appealing and ingenious design to enhance their success in the marketplace. Apple proudly proclaims that while iPods may have been manufactured in China, they were *designed* in California.

Artists play a key part in this process, both directly and indirectly. Most of them hold down multiple jobs to make ends meet. In doing so, they apply their creative flair in a variety of settings that would not normally be recognized as falling within the "cultural industries." But they are also active agents in promoting and protecting tolerance, freedom of expression, and respect for difference and dissent. And it is these intangible qualities—difficult to measure, except perhaps by their absence—that constitute the social infrastructure for innovation, risk-taking, and creativity across the economy.

Our review of some of the most celebrated examples around the world concluded that a strategy for developing a city's creative capacity needs to focus on four key ingredients. First and most obviously, one cannot have a creative city without people appropriately educated to engage in creative

activity of all kinds. Hence, it is critical to invest in capacity-building at all levels of our education system—not just by ensuring the health of local colleges and universities teaching art, music, and design, but also by enshrining the importance of arts-based education in the public schools.

There is also a well-recognized need to develop the enterprise-building skills of creative people. There are at least two aspects of this finding. Artists, designers, and artisans are, by definition, highly creative. And yet they are often challenged when it comes to running the business side of the house. They need help arranging the finances to sustain and grow their enterprises, to develop and implement business plans, and even to learn how to price their services properly. At the same time, entrepreneurs in many other sectors of the economy can benefit by learning how to enhance the creative content of the goods and services they deliver—for instance, by making more effective use of design.

We have also learned that creativity seems to flourish in those places that champion the cause in a concerted, connected, and consistent way. This quality of connectivity is evident at two different scales—at the neighbourhood level and that of the city-region. Creative cities find ways to nurture talent in those precincts where it first emerges. Often it is the neighbourhood schools or community centres that provide the focal point for developing the talents of local residents—especially in those parts of the city we think of as being "at risk." On the other hand, a series of local, small-scale initiatives can be much more effective when they are linked together by some kind of overarching organization that crusades for resources and social respectability. This sort of city- or region-wide structure also serves the purpose of enabling specialized cultural organizations and neighbourhood entities to find common cause, share resources, and learn from one another.

49

Finally, a creative city strategy needs a coherent approach to space. While it is important to have world-class performance and exhibition spaces for elite creative activity, it is perhaps even more important to ensure an ample supply of affordable, stable space for the artists and other creative workers and businesses that feed and support the wider creative economy.

Given its critical importance, this latter point deserves further elaboration. We know that artists and other creative enterprises seek urban space that is affordable, accommodates their functional requirements for space and light, permits the mixing of residential and working uses, and is favourably located with respect to other fixtures and features of the urban environment. These are often anything from old, formerly industrial buildings that are accessible by foot, bicycle, or public transit to shopping centres, cafés, pubs, clubs, bookstores, art schools, potential artistic or commercial partners, clients, and competitors. And while artists play a leading role in this process, it is important to recognize that other creative businesses may inhabit such spaces alongside them. For example, the emergence of new media and design industries in Toronto, Montreal, and Vancouver during the 1990s was strongly concentrated in older, previously industrial/warehouse, inner-city neighbourhoods. As the venerable Jane Jacobs once famously put it, new ideas get hatched in old buildings.

Such neighbourhoods, once occupied by creative activity, soon attract others who are drawn by its vibrant cultural and street life and its "bohemian chic" appeal. Gallery owners are followed by more upmarket retailers, who are soon followed by property developers intent on capitalizing on the local buzz. Land values and rents rise, reflecting the increased productivity and desirability of the neighbourhood. The contradictory nature of this change

soon becomes apparent, as the very process of upgrading and renewal that was set in train by artists and creative enterprise ultimately leads to the geographical displacement of this same creative activity, which can no longer afford the rents.

Our research documents this same dynamic in leading cities across North America and Europe. Artists and other creative enterprises are displaced from their original locations as these neighbourhoods become inhabited by competing uses that can afford to pay higher rents. Perhaps most importantly, in the absence of deliberate intervention by the public or non-profit sectors to create and protect affordable, stable space, the future viability of this creative activity in the region is threatened.

This last point has been borne out even in celebrated centres of free enterprise such as London and New York City—arguably the capitals of global capitalism. In both cases, deliberate efforts to retain creative enterprises within mixed-use neighbourhoods by providing them with affordable space on a long-term basis have been essential in ensuring their future viability amidst strong pressures for land-use changes.

Recent events in Toronto underscore that creative activity here faces these same challenges. A thriving residential property market has created strong pressure on artists and other creative enterprises, making it difficult for them to stay in their existing locations. However, a number of innovative organizations are providing them with affordable and stable spaces—most notably the non-profit organization Artscape, which currently operates half a dozen projects accommodating a mix of artists, creative enterprises, and related activity in neighbourhoods like Queen Street West, Liberty Village, and the Distillery District. Artscape is also involved in a number of pending

projects, including the redevelopment of the Wychwood car barns and the Sony Centre for the Performing Arts (formerly the Hummingbird Centre). Toronto is also blessed with the good works of philanthropically minded families such as the Zeidlers, whose firm urbanspace has been responsible for such wonders as 401 Richmond, 215 Spadina, and the artistically refurbished Gladstone Hotel. However, the lengthy waiting lists associated with these properties attest to the very large unfulfilled demand for this kind of affordable space, situated within a rich and diverse mix of complementary and supportive activities.

The recent case of Toronto's West Queen West Triangle serves to underscore the precarious existence of artists and the creative spaces they (try to) inhabit in this city. The area has become the site of a much-publicized dispute between three developers wanting to build large, high-rise condominium projects on the site, and Active 18, a group of local residents (many of them artists) who prefer to see a redevelopment plan that is more in keeping with the area's distinctive character and more overtly supportive of its creative practitioners. The Triangle—an area of land running along and to the south of Queen Street West, from Dovercourt to Gladstone, and north of the railroad tracks—has been recognized as a key hub in Toronto's creative landscape. It is home to many creative industries as well as related activities that anchor and support these businesses in the area—artists' studios; live-work studios; rehearsal, performance, exhibition, and office space; galleries; light industry; bars, cafés, and restaurants; the Museum of Contemporary Canadian Art; the Toronto Fashion Incubator; and the Drake and Gladstone hotels.

The neighbourhoods immediately adjacent to the Triangle contain Canada's largest concentration of artists and creative enterprises. In addition

to the mix of land uses noted above, this area offers affordable and flexible space for both creative industries and creative workers (including artists) who prefer to live and work in the same location. Much of this space is located in older buildings, such as 48 Abell Street, that formerly accommodated industrial and commercial uses. Such buildings spawn creative enterprises because they offer unparalleled flexibility of use and multiple tenancy, which ensures a supportive and stimulating portfolio of potential artistic and commercial partners, customers, and suppliers nearby. In short, this neighbourhood offers the ideal mix of the fundamental elements for a successful creative city: affordable space, creative people, a concentration of creative enterprises, and strong connectivity at the neighbourhood level.

And success begets further success. West Queen West also attracts artists and other creative workers and enterprises because it has already accumulated a critical mass of similar people and activities and their co-location permits the many forms of collaboration (planned and spontaneous) that underpin successful creative enterprise. Much of this activity is often oriented to short-term projects that require the rapid self-organization of teams of creative freelancers and suppliers, and neighbourhoods such as West Queen West support these production forms most efficiently. Related to this, such concentrations of related activity also support the generation of all-important local buzz: the circulation of knowledge within a collection of producers in the same and related activities, which further spurs innovation and creativity. They also support the equally important ability to observe and monitor one's "competition," keeping abreast of new trends, styles, practices, and products.

Such concentrations of creativity-based economic activity cannot be created overnight, but take years to develop. Moreover, the kinds of

relationships described above constitute a delicate ecology of connectivity, in which each of the component elements depends on interaction with other elements around it for its continued viability.

From the perspective of the creative economy of the entire Toronto region, the artists, creative businesses, and workers based in the West Queen West area also comprise a vital part of a wider ecology of interrelationships. Local fashion designers, musicians, actors, photographers, and other workers in the visual and performing arts in this neighbourhood constitute an important source of talent and creative output for businesses located elsewhere in the Greater Toronto Area. They also represent a reservoir of future creative talent that is currently being incubated and developed in the stimulating environment of the West Queen West Triangle. In this sense, the spaces for performance, exhibition, and sale of creative products within the district complement and support the larger, higher-profile performance and exhibition spaces located elsewhere in the city, such as the Art Gallery of Ontario, the Royal Ontario Museum, the Four Seasons Centre for the Performing Arts, the Sony Centre for the Performing Arts, the Princess of Wales Theatre, and other well-known venues. In the words of writer John Lorinc, these local features constitute a critical part of Toronto's wider "cultureshed."

Given the above, it is clear that the concentration and mix of current activities in and around the West Queen West Triangle—people, enterprise, space, and the connectivity that binds them together—are critical to its current and future success as a creative hub. It is also clear that the introduction of large, new single-use residential redevelopment projects into this district would upset the sensitive ecology of creative activity that has evolved in this area over the past ten to fifteen years. By displacing a substantial number

of artists and other creative enterprises, and by disrupting the related mix of supportive land uses that have anchored the flourishing creative economy in this district, such redevelopment threatens the continued viability of one of Toronto's—and Canada's—most noteworthy concentrations of creativity-based activity.

This conflict has recently played itself out at the Ontario Municipal Board, with the City of Toronto arguing for somewhat lower densities and a richer mix of land uses in the projects, including a more significant component of affordable live-work space for artists. After two months of hearings in the fall of 2006, the board issued a decision that capitulated entirely to the three developers, virtually ignoring the evidence-based testimony of Active 18 and dozens of expert witnesses—the present author included.

The intensity and unanimity of the public response in the wake of the decision undoubtedly played a role in convincing the provincial government (to which the OMB reports) to intervene. With the October 2007 election on the near horizon, the Province second-guessed the board and asked it to conduct a review of its earlier decision on procedural grounds. But the broader significance of this case is evident, since it has served to articulate for Torontonians the choice we now face between two rather different development paths. That we now see at least two choices instead of one "inevitable" future is itself a major achievement. The development industry and professors of urban economics repeat the mantra that urban land should be dedicated to its "highest and best use." In this well-rehearsed discourse, "highest and best" is defined simply by the private land market and ability to pay. Social benefits arising from the presence of other land uses (though they may not be able to pay the same market rents) are routinely ignored.

And yet the examples from New York and London attest most eloquently to the truth that non-market approaches are essential if creative activity is to be accommodated in the city. On a recent trip to the UK, I visited an old industrial building in Lewisham, a poor London borough south of the Thames that is home to a large black community. This building now houses the non-profit Cockpit Arts Deptford Studios, an incubator for creative enterprise of every imaginable sort. Artists rent affordable space without the worry of future rent increases, and supportive training onsite helps them develop business skills. A few minutes away, the sparkling new Laban Centre for dance education, built on a reclaimed brownfield site, dedicates one of its studios to a thriving community dance program—both to give something back to its host neighbourhood and as a shrewd way of identifying and developing budding local talent. These are but two examples among many in a city that has recognized that its future economic and social sustainability will depend on its ability to generate and develop creative talent across a diverse swath of London neighbourhoods. In one of the world's most expensive property markets, ownership of land and premises by public and non-profit entities is simply accepted as an investment worth making, given the social returns it generates.

In light of mounting evidence confirming the wider social benefits of this creative activity throughout the urban economy, there are compelling reasons for rejecting the ideology of highest and best use in favour of something else. Instead of a future dominated by the depressing, cookie-cutter sameness of "luxury" condos, Toronto could be a city that systematically provides affordable housing and workspace for artists. We have already produced world-leading projects within our borders that do just that—we know how to

do it. Instead of a future dominated by the logic of the market, we can embrace a model in which highest and best use is redefined to reflect the many real social benefits that flow from creative activity. Instead of a Toronto in which the poor become increasingly isolated (both socially and geographically) from the rest of the city, we could deliver arts-based community development along with high-quality public education and affordable housing to neighbour-hoods and communities at risk.

Despite its many enviable strengths, Toronto's creative economy is now at a critical juncture. Cultural activity still struggles to attract the continuing financial and program support it needs to thrive. Artists and other creative enterprises face constant competition from other land uses that threaten to displace them from their current locations, challenging their ability to survive. The City of Toronto has produced laudable—indeed innovative—plans to promote culture and the creative economy within its boundaries. And yet, as the recent OMB hearings on the West Queen West Triangle suggest, such plans will run aground so long as they are undermined by a land-use planning system that is inherently incapable of supporting the goals they espouse.

Nevertheless, there are still grounds for optimism, especially in the legacy of innovative approaches that have emerged from the city's public and non-profit sectors. The backlash against the OMB decision on the Triangle has already triggered calls for a fundamental reappraisal of the status quo in land-use planning. A new consensus is emerging that the interests of our city would be better served by a planning system that is more dialogical, consultative, and community-based, in place of the narrow, adversarial approach we have now. There is also a growing recognition of the wider contribution that culture and creative activity make to the vitality of the city-region and its economy.

And the recent pairing up of initiatives such as the Strong Neighbourhoods Task Force with the talents of organizations such as Artscape gives hope that we can develop the creative potential of people living in many different parts of Toronto—not just the sought-after bohemian precincts of the inner city, but also our most physically and socially challenged neighbourhoods.

Three decades ago, Margaret Thatcher justified her slash-and-burn approach to governing Britain by claiming that "there is no alternative." We have made significant progress in this city toward the realization that our future path is *not* preordained. While the choices we face are now more clearly defined than before, however, the path we follow will depend on local political action and governance processes that lead to effective consensus-building. In these times of global economic shocks and flows, it is at least reassuring to know that the choice remains largely in our own hands.

SCOTT JOHNSTON

TORONTO'S REGENT PARK, Canada's oldest and largest public housing project, represents one of the city's poorest neighbourhoods, with a reputation for drugs and violence. My photographic excursion into the community revealed something completely different: the quiet vibe of an old resort replete with amenities such as swimming pools and ice rinks, all within a quiet sanctuary removed from the urban fray surrounding it. The aim of the community's original planners was to create a self-contained "garden city," the vestiges of which still existed as I roamed the grounds before bulldozers and wrecking balls razed the neighbourhood in the name of urban renewal. The exhibition that grew out of the photographs presented viewers with a chance to look inside a neighbourhood that only a few outside the community have actually seen, and to reveal the complexity and the unique environment of a well-known, but not-so-well-understood, area of Toronto.

I did not set out to expose poverty and deprivation, and discovered that the surroundings were quite nice, quieter than most of downtown, but there was a strange underlying tension. At first, I saw things on a large scale: the buildings, the vast green space, the landscape, and the design. Then I started to focus on certain areas that I found particularly interesting, in visual terms. I attempted to capture its uneasy peace. It is a very open downtown location, but somehow claustrophobic at the same time—a place that seems to be almost uncertain of itself, and in the process of disappearing.

You can see more of Scott Johnston's work at scottjohnstonphoto.com.

FACING PAGE: 17 UNCONVINCED CHAIRS (2006)

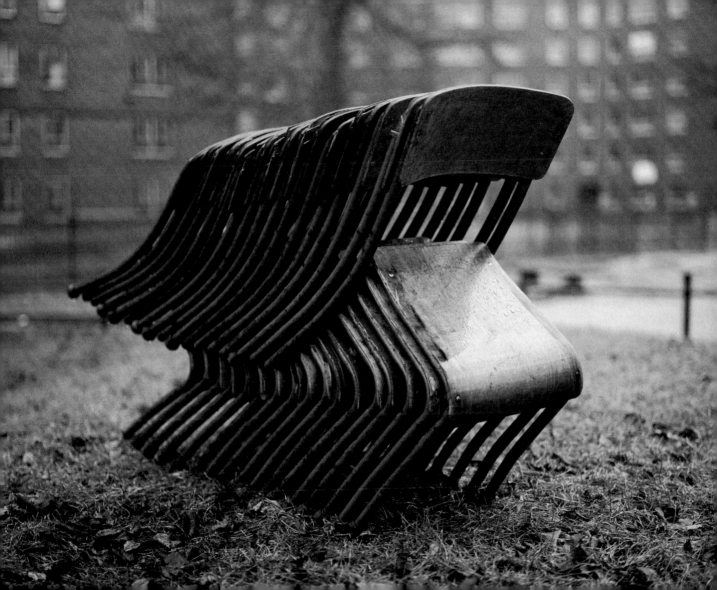

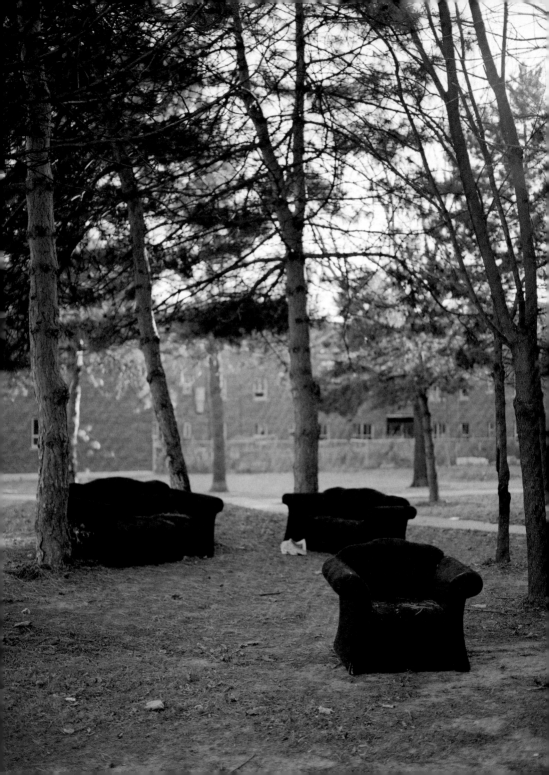

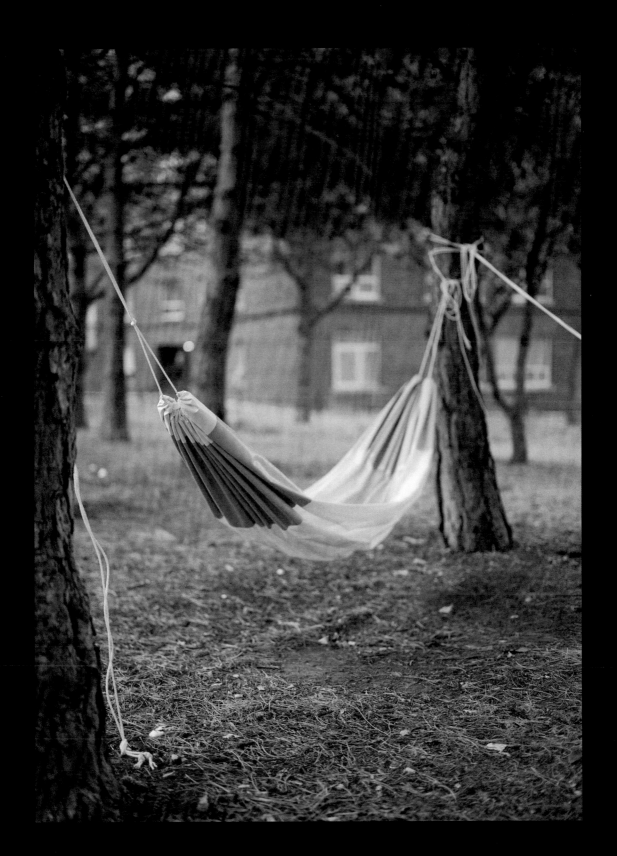

HAMMOCK (2006)

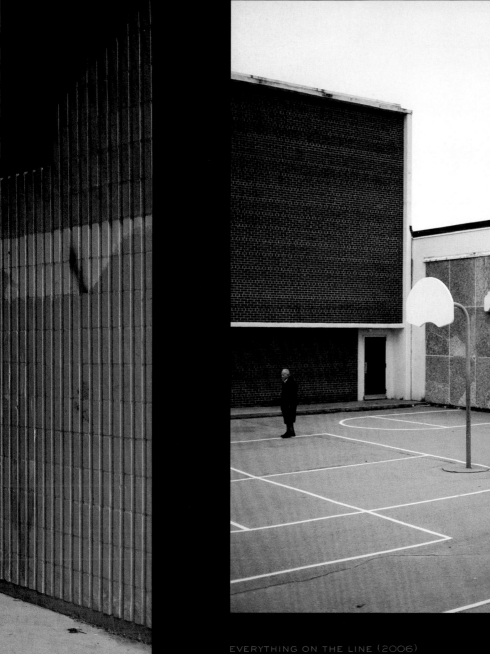

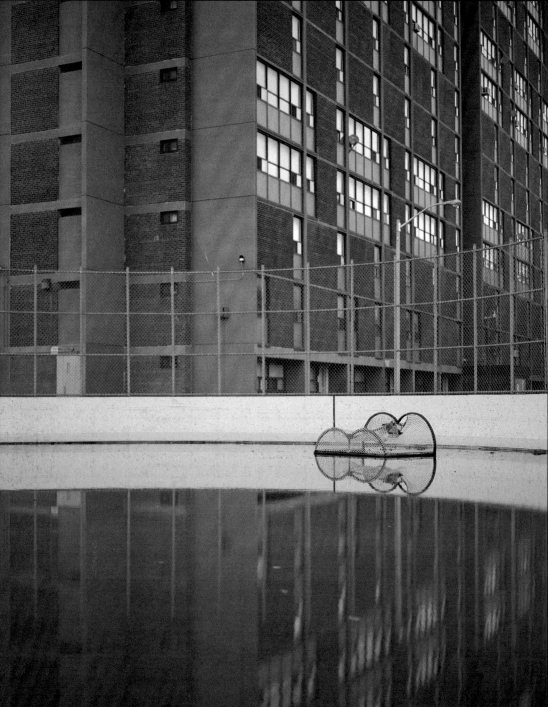

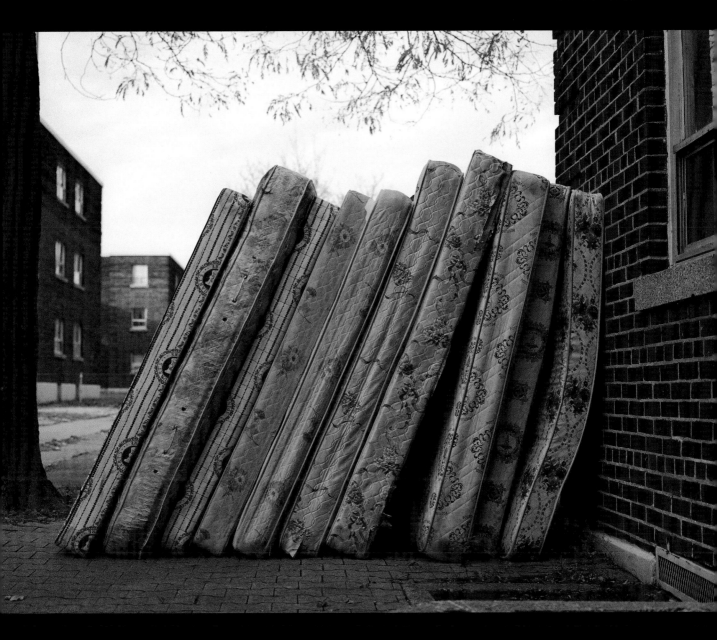

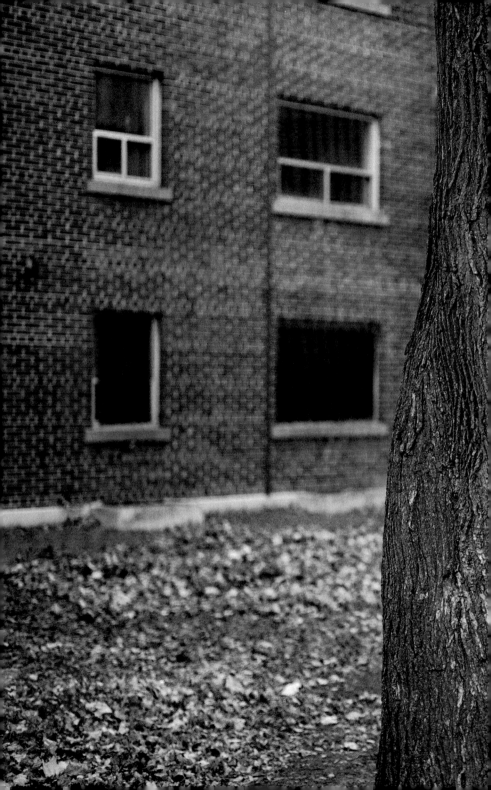

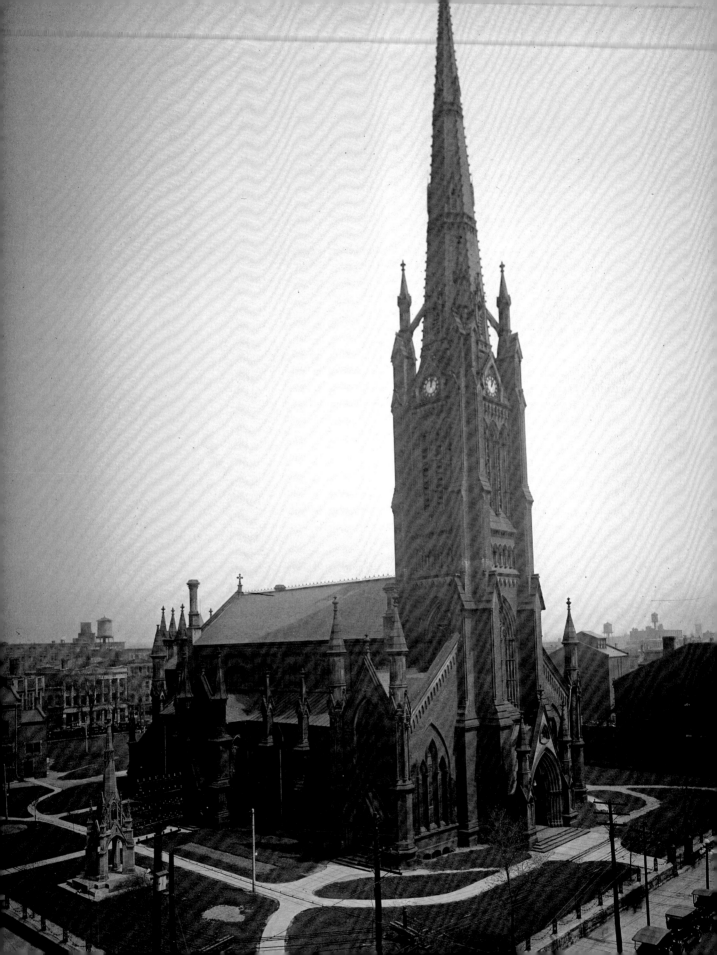

ROCK OF AGES
JOHN ALLEMANG

THERE WAS A TIME WHEN THE SPIRES OF TORONTO WERE MORE THAN ARCHITECTURAL STATEMENTS. THEY BESPOKE SOCIAL CONVENTION AS MUCH AS THEY DESCRIBED THE SPIRITUAL ASPIRATIONS OF A DEVOUT CITIZENRY. TIMES HAVE CHANGED, AS JOHN ALLEMANG OBSERVES. IN THE SUBURBS, NEW TEMPLES, SYNAGOGUES, AND MOSQUES ARE THRIVING. IN THE CITY'S OLDER CORE, THE LONG-ESTABLISHED PEWS CAN'T AFFORD TO BE COMFORTABLE ANYMORE.

THE CITY OF CHURCHES, they used to call Toronto. Although I'm sure the pious citizens heard it as praise, having laboured to cover so much of the downtown with their vast testaments to Christian virtue, I've often wondered if it was meant more as a dig—the way Toronto the Good, that other long-lost epithet, always makes you think of a dull, smug place where the city fathers took pride in chaining up the parks on Sunday.

While the buildings remain as a reminder of the days when civic architecture was more God-fearing, the city has largely moved on. Church-building (and mosque-building and temple-building) has migrated to the booming suburbs, and somewhere a clever sociologist is writing a thesis that explains why the old traditions now endure best in the newest places. It's certainly one of the key ways in which the surrounding regions of Toronto are so different from the urban core, and must involve some combination of immigrant success, community-building, the kind of family values conservative politicians are so desperate to profit from, cheaper real estate that can support all those sprawling statements of faith—and, at heart, a feeling that old-time religion still has relevance, perhaps even more relevance, alongside garish shopping malls, treeless tract housing, and long wide roads going nowhere fast.

Spoken like a true downtowner. I'm a confirmed skeptic who was raised quite happily in the kind of bright Scandinavian-modern Lutheran church that defined sunny suburbia in the 1950s, and now I don't pursue worship in any form. I live in the Toronto that used to be the City of Churches, which is to say that in the course of an average day I can walk by a dozen of those splendid old monuments to the greater glory of God, and I hope it doesn't

sound too typically crass and godless if I confess that most of the time I find myself thinking like a real-estate connoisseur—as in, that tumbledown/abandoned/seen-better-days church would make a great loft development. Which is better than knocking it down, the other favourite Toronto solution for rationalizing its out-of-step past.

But looks can deceive, as I'm sure it says somewhere in my long-neglected Bible. One of the holy places I walk by most often is Trinity-St. Paul's United Church, which in that typically intensifying urban way now co-exists cheek-by-jowl with Bloor Street's budget sushi restaurants, pricy Annex Victorians, a Kinko's copy shop filled with anxious students seeking some sort of quickie salvation, a desolate playing-field-cum-dog-park (dog-walking in some ways having taken over as the downtowner's new religion), and a 24-hour Dominion store that makes no claim to nourish the spirit despite its eternal openness. TSP, as it calls itself with a no-nonsense effacement that's another way of saying "not your grandfather's church," may well come across as the one thing that doesn't belong in the picture. But that's only if you're going by the powerful sense of another time that a city block's worth of consecrated Credit Valley sandstone can exude.

Trinity-St. Paul's—sorry, I still like the stories and the histories proclaimed by those words—isn't about to go condo any time soon. This is a rare downtown church that has figured out how to move not just with the times but in many ways well ahead of them—in the lead, the vanguard, when the church is doing the job its members and supporters have mapped out for it.

A modern suburban church, especially one of the prayer-palace variety, can thrive by doing one big thing: praise the Lord. Trinity-St. Paul's survives its way through modernity by doing innumerable things of every spiritual

shape and size—if Satan finds time for idle hands, then this place of social-justice dialogues and Baroque sinfonias, homeless outreach and ethical-investment discussions, Urdu classes and a pretty complete collection of twelve-step programs, salsa lessons, and Maundy Thursday foot-washing must be pretty well impervious to the trendy temptation of letting life go to waste.

I don't go to church—solid Satan material, you'd guess—but so extensive is Trinity-St. Paul's reach that I realize I've been there half a dozen times in the last few years. One sweltering spring evening, I sweated to the oldies as the world-renowned Tafelmusik orchestra (which not so improbably makes its home in the unairconditioned amphitheatre-like church) played Bach's B-minor Mass on their vivid Baroque instruments. At intermission, we spilled out onto already crowded Bloor Street and talked about timeless pleasures while the metropolis seethed around us. On a very different night, I took part in a benefit for the church-based Out of the Cold program, reading political poetry side by side with vamping jazz singers and sweetly melancholy urban folkies. And early one Good Friday, in the company of someone much more worshipful than I've chosen to be, I found myself feeling the power of silence during a vigil marking the death of Christ, which culminated in a solemn group of us following a cross as it was carried down game-for-anything Bloor Street. If I felt a little too much like I stood out, I think this was the point. There's always a risk in taking belief out into the world, but that's also where it finds its strength.

Somewhere in all this zealotry-for-our-times, there's a meeting of God and faith and good works, of justice and Gospel truths and the art of being human. (To be fair, there's also a badly antiquated heating system, which could drive anyone less dedicated to the suburban Promised Land.) Trinity-St.

Paul's prides itself on being inclusive, so there will always be room for faithless, godless people like me, as much as I'm surprised to count myself part of someone else's mission.

But it works both ways. Trinity-St. Paul's is part of my mission—to live that fully human life in a real city where a cumbersome old building from Toronto the Good can still aspire to greatness.

DARKNESS AT THE EDGE OF TOWN

PETER KUITENBROUWER

A QUEST FOR A BICYCLE BASKET IN VAUGHAN REVEALS TO PETER KUITENBROUWER THAT TORONTO'S ENTHUSIASM FOR SUSTAINABILITY IS ONLY SO MUCH HOT AIR—IF THAT ENTHUSIASM IS LIMITED TO THE CITY'S CORE. TORONTO'S SUBURBS ACCOUNT FOR 84 PER CENT OF ONTARIO'S GROWTH, AND MANY OF THEM APPEAR TO HAVE ENVIRONMENTAL IRRESPONSIBILITY BUILT INTO THEIR FABRIC.

It is a sweltering day in July and I am at Weston Road and Highway 7, in the City of Vaughan. I am standing in a vast parking lot in front of a shopping area called—a bit grandly—Piazza del Sole. As Toronto columnist for the *National Post*, I am here to research a series called "The 905 Diary." But I have a second task on my mind today: I am also searching for a wicker basket for my wife's bicycle. She asked me if I wouldn't mind picking one up for her while I'm out. It was an innocuous enough request—or so it seemed.

We live in downtown Toronto, and we like to walk, ride the streetcar, or ride our bicycles. We cherish stuff that's becoming increasingly scarce in our city, such as sidewalks, seeing other pedestrians, strolling or riding a bike to the corner to buy a litre of milk from a shopkeeper. Like many who live downtown, I try to stay away from the vast suburban ring that chokes Toronto. It's like one of those medieval maps: "Dragons be here."

The basket I need to find has to attach to the existing rack on my wife's bike. It must be a big and flattish rectangular basket, not the kind sold in a bicycle shop. But the search for such a fundamentally downtown accoutrement—a basket to attach to her Kronan, a Swedish army bike, in which she can transport groceries to our home just off Queen Street West—underscores my deep sense of feeling *dépaysé*. I am a stranger in a strange land. I am far from the familiar territory of the downtown in this land of big roads and tiny trees.

Still, there are times when even the most determined downtowner is seduced by the siren song of suburban shopping: infinite choice. The intersection of Weston Road and Highway 7 has shopping on all four corners: Piazza del Sole on the northwest; the Seven & 400 Power Centre on the southwest; Woodbridge Square east of Weston Road; and, to the south,

Colossus Centre, named for the twenty-screen movie theatre that looks like a flying saucer about to disgorge a conquering army of aliens. There is bound to be a basket here someplace.

VAUGHAN IS NOT A PLACE most people visit on purpose. People travel to the McMichael Art Gallery and the Kortright Conservation Area without knowing that they are in Vaughan. It was largely farmland until a few years ago. Vaughan, which starts at Steeles Avenue where Toronto ends, and runs to the King/Vaughan Road, between Highway 50 and Bathurst Street, calls itself the City Above Toronto. It is one of the nation's fastest-growing cities; according to Statistics Canada, Vaughan grew by 31 per cent between 2001 and 2006, to about 250,000 souls. Anyone who takes Highway 400 to Muskoka will have noticed that the fake mountain of Canada's Wonderland, which once seemed remote, is now surrounded by houses. Welcome to Vaughan.

The City of Vaughan is at the forefront of an alarming trend across Canada, most pronounced in Toronto: the reasonably sustainable organisms called cities—in which many people use public transit to get around—are not growing much. In the first decade of the new millennium, Canada is the fastest-growing nation in the developed world, and most growth has been car-centric sprawl. From 2001 to 2006, Statistics Canada reports, Brampton, next to Vaughan, grew by 33 per cent, Whitby by 27 per cent, and Markham, by 25 per cent. In fact, Toronto's suburbs accounted for 84 per cent of Ontario's population growth in that period, and the growth of Toronto's suburbs is more than twice the national average. The "Welcome to Vaughan" signs (or

Brampton, or Markham, or Whitby) should have mechanically adjustable population figures—like the prices on gas station signs. The similarity of design would be entirely apt.

Politicians claim to promote public transit, but the very design of these places makes transit useless for most excursions. We may mouth environmentalism, but our urban design ensures that every generation is more car-dependent than the last. We will pay a high price for this unregulated growth in developer-driven "communities": not just in deteriorating air quality and increased global warming, but also in ensuring that Canadians, most of whom do nothing but drive, will get fatter. Apparently, they aren't riding a lot of bicycles.

I begin my basket quest at Piazza del Sole, a kind of strip mall on steroids, that looks weirdly like a movie set. It has giant stucco battlements jutting from the roof lines, advertising stores such as Linens 'n Things, Toys "R" Us, Penningtons, and Borgo for Men. The name Piazza del Sole is a nod to the Italian Canadians who predominate around here, and an attempt to lend a little class. But instead of a piazza, the stores front a prodigious parking lot. Above the covered sidewalks that connect the stores are arches bearing paintings of Italian scenes: St. Peter's Basilica, the Colosseum in Rome, and the Leaning Tower of Pisa. Rather than lend distinction to the place, the Italian scenes remind me that I am thousands of kilometres away from architecture that the builders of this place consider beautiful.

Linens 'n Things has plenty of stuff I didn't know I wanted: a wall with twenty varieties of coat hangers; large serrated plastic knives in several bright colours, apparently to cut lettuce (I usually tear mine); hundreds of seat cushions, in paprika, ruby, chamois, and delft blue. But no baskets.

I wade across Weston Road to Michaels—"The Arts and Crafts Superstore." Its head office is in Texas, which seems appropriate given the store's immensity. This is my first time in a Michaels store. I suspect it will be my last.

I wander around in a daze, staring at boxes of five hundred Popsicle sticks and kits to "antique" your photos before putting them in a scrapbook. I'm getting confused. Last Christmas I built wooden trains for my son and the sons of some friends, using grape crates that my neighbours piled up on their front walks. This simple, modest, inexpensive basement activity is what I would define as arts and crafts. To give the genre its own superstore feels like a contradiction in terms. Now I'm getting depressed. But a Michaels clerk befriends me: "It's really a store for women," he explains. "Guys come here at Christmas. The store has really neat Christmas lights and we guys can get out our power tools." Michaels does have a basket aisle, but all the baskets come in packs of four and cost $50. Another clerk suggests I try HomeSense, just across Highway 7.

Bravely, I set out on foot. I have decided that walking will be quicker than trying to turn left at the intersection of two ten-lane roads. This proves to be a mistake.

There is no way to walk through this place. Politicians say they want to save the planet, reduce carbon emissions, fight global warming. And then they happily approve developments like this.

The progress of humanity, if you can call it that, bewilders me: we've gone from a street, which is a genuine community where people stop to buy flowers while walking home from church, to a mall, a kind of proto-community where people at least can gather, or cross paths, as they walk from store to store, to Vaughan, where people drive from store to store. And Vaughan is by

no means unique: Mississauga has a similar new Big Box Hell zone on Mavis Road, where, even though the liquor store and Loblaws are side by side, the design dictates that people drive between them.

All newspapers are pro-development. The *Los Angeles Times*, famously, built LA through its pro-development boosterism and the new homeowners all subscribed to the *Times*; similarly, after the *Toronto Star* moved its printing plant out of Toronto and into Vaughan, the *Star* ceased asking, "What does it mean for Metro?" and instead invented a new, inclusive term for the sprawl it helped create: Greater Toronto. At the *National Post*, which like the other papers depends on real estate advertising, there are limits to how much I can criticize development.

Still, even by the low standards of scrutiny that the press gives to the relentless march of sprawl, Vaughan has become a symbol of development gone wild. Tendering contract scandals are so common that the City Above Toronto now has the nickname, the City Above the Law. The mayor's speeding tickets disappeared before making it to court. Planning appears to be minimal: in late 2006 the council voted to spend $100 million on a new city hall replete with granite and marble—this in a city of a quarter-million people that has no hospital and no plans to build one.

THERE IS ONE PLACE in Vaughan that cheers me up—or at least it used to: downtown Woodbridge, the stretch of Woodbridge Avenue between Islington and Kipling avenues. Woodbridge used to be a quaint little Ontario town. Its main street was speckled with shops, a library, a post

office, a drug store, and a doctor who lived in the biggest house. Alas, during a recent visit it appeared that the developers had won again. A stately two-storey Georgian brick home with leaded glass windows, surrounded by fourteen towering, mature black locust trees, was empty. A sign on the lawn proclaimed: "Proposed Official Plan and Zoning Change to permit a 5-storey, 60-unit apartment building." I'm all for density, but why wreck history to build it?

During that same visit I met a woman walking briskly up the avenue. She had just come from the bank. "We were here for twenty years, and we moved to Kleinburg," she said. "It's the next stop up. Woodbridge got too big. They destroyed the quaintness of it. If you're here for lunch, go up to Kleinburg." At the west end of the strip, several century homes were doomed to make way for the Woodbridge Gates condos, which a billboard advertised as "Luxury Living in the Village." The irony, of course, is that once all these condos are up, the "village" will be gone.

I went into an old wooden house: the offices of *Lo Speccio*, "The Only Italian Weekly." Sergio Tagliavini, the editor, was sitting grandly behind an ornate wooden desk. Behind him hung a huge framed drawing of the Piazza de Milano, his hometown. Here is a guy, I fantasized, who is going to speak out in favour of saving the past. I pointed to the drawing. "You care about history, don't you?"

"Well, that church [in Milan] is six hundred years old," he replied, lighting a Viscount. The buildings in Woodbridge hardly belonged in the same category, he said. "In Woodbridge, some homes are beautiful. Some are old. That's not enough. If you preserve everything, then you don't move. Then you stay as it was a hundred years ago."

Later I lunched at Berto Osteria, where the owner, Berto Marcoccia, gave a different view: "I think you lose a lot when you tear down," he said. "The old Anglo-Saxons of this part of Woodbridge put up as much of a fight as they could." His business is slow now, he says, because "old Woodbridge has kind of been forgotten." Later I met Jean Murray, one of those "old Anglo-Saxons," who attended a number of meetings at Vaughan City Hall, trying to save some history. "It's a sad thing," she said. "The character is gone." She plans to move away.

WHEN ITALIANS MOVED to Toronto after World War II, they settled in the neighbourhoods around College Street, west of Bathurst, near where I now live; areas that I consider sensibly designed with retail stores and streetcar routes on the main strips, and housing on the side streets. They opened businesses that became legendary, including California Sandwich, on Claremont Street, and La Paloma, an ice cream shop on St. Clair Avenue West. These two have now opened branches in Piazza del Sole—gargantuan emporia compared to their forebears in downtown Toronto.

Continuing my quest for the basket, I pause at Vaughan's California Sandwich and sink my teeth into a sweet veal cutlet with onions, $6.70. "It would be good to buy shares in this," says Brian, just back from golfing at the National, and wolfing down a medium chicken. "They're always busy."

I go next door to La Paloma, an "authentic gelateria and café" painted Tuscan yellow, which boasts seventy flavours of outrageously delicious gelati, including bacio (whole hazelnuts in chocolate), arancia (tangy orange), and

pesca (sweet peaches). Franco Canzone, who owned the St. Clair La Paloma from 1978 to 1990, now owns this place with his son, Philip. Every day they truck fresh La Paloma gelati up from the St. Clair location. Those inner-city neighbourhoods bred the creativity that created California Sandwich and La Paloma; it is hard to imagine any kind of innovative new businesses springing up in the wastelands of Vaughan today.

Still, these morsels of authentic culture—in a sea of ersatz retailers peddling imported junk while flying foreign flags—cheer me up enough that I am ready to continue my quest for the basket. As I ford the gargantuan parking lots on foot, I am the only pedestrian in sight. I am wondering why people build places like Vaughan.

THE RESIDENTIAL AREAS in Vaughan are as aggressive in their rejection of the importance of common spaces as the commercial areas. In the 1950s, people moved to the suburbs to escape the concrete jungle for wide-open spaces and greenery, and in older suburbs such as Don Mills, bungalows and split-levels sit on generous lots, with perhaps a couple of houses' worth of space between them, and lots of common space. People heading to the burbs today don't seem to care for outdoor space. They build three-car garages that also have room to park their kids' electric cars; the kids no longer play street hockey but rather basement hockey, on rinks painted on the vast cement floors. Standing cheek by jowl with small backyards, these huge houses make the landscape resemble a Monopoly board near the end of the game, when everyone has bought hotels.

It's all about the bigness. Once, on a rainy morning in March, I went to Vellore Village, where developers had torn a hole in the forest to put up "estate" houses so big they have names. On Grandvista Crescent, Aspen Ridge Homes had its sales office in a sample of "The McKinley," 2,955 square feet; next door was Rose Haven Homes' "Villa Visconti," 3,127 square feet. Further down the crescent I came to a muddy construction site, where Peter Lefneski, who said he was "semi-retired from the military," and another guy named John, were carrying a pallet's worth of heavy sacks of versatile polymer-modified thin-set mortar into a huge home, framed from wood and wrapped in DuPont Tyvek HomeWrap. Peter was hopscotching across sheets of pressboard laid over the muddy yard. Forty bags of mortar, he said, would be enough to lay the tile on the ground floor; they'd need another pallet of mortar for upstairs. "Go ahead and have a look around," he invited me. "That upstairs room, across from the master, is the walk-in closet." It is the size of a bedroom.

One street south, on Dolomite Court, Joe Monteiro and his family had moved into their new house a few months before. The house is twice the size of the place he left, a 1950s-era home in an older part of Vaughan. By the land purchasers' consent the homes on this street, built by different people, are all in a French chateau style: stone on the front, two- and three-car garages with false hinges that give them the appearance of carriage doors, bell-shaped roofs, and ornate iron railings. It looks like Disneyland.

Mr. Monteiro is a freelance conveyancer, which means that he checks titles for land purchases; like many people around here, he makes his real money buying and selling real estate in Toronto's white hot housing market. "I got the lot for a great price, for $300,000," he said. "I'm in for $850,000, with the house, and I'll probably put it on the market this summer for $1.3

million." In short, he built it for money, not love. He waved at his ornate dining room, empty of furnishings, and a living room, which looks as though one ought not to use it (for fear of making a mess). "I have ordered a dining room set," he said. "It's coming from Indonesia or someplace. If I had it to do over again, I would do it different. I wouldn't build a living room and dining room because people don't use them. We don't sit down and have suit-and-tie dinners any more."

For efficiency, Mr. Monteiro built this house with spray foam insulation, double-pane windows with argon gas between the panes, and a high-efficiency furnace with a two-stroke motor. He said it costs less to heat this place than his last home, which was half the size. On a more fundamental level, though, Vaughan is the most anti-environmental place I have ever been—the design forces people to use their cars for every detail of existence.

True efficiency would take a much different form. I think of new areas I visited recently in Amsterdam, where they lay down streetcar tracks and bicycle paths before they even build the new homes. Vaughan planners would never require developers to spend money on such things as long as the suburbs around them, Brampton and Milton and Markham, grow unimpeded. Yes, the Region of York, which includes Vaughan, has a new transit system called Viva, with swank blue Belgian-built buses; the buses are grand but you can't take them to go shopping, for example, because when you alight, you can't walk from store to store.

I support development—when it is done right. I favour immigration and a growing Canada. But the way Toronto is developing worries me profoundly. When Tony Ruprecht, our member of provincial parliament—who sits with the currently governing Liberals—rang the doorbell of our downtown home

not long ago, he handed us a pamphlet about his commitment to our green future. In 2006, his government, led by Premier Dalton McGuinty, decreed a greenbelt around Toronto, proclaiming "the end of sprawl as we know it." The law nonetheless leaves 60 per cent of prime agricultural land unprotected from development in the Greater Golden Horseshoe. The law also states that in ten years, governments will review the greenbelt to decide whether the land should remain protected or opened for development. Developers are always major contributors to provincial politicians—which means, obviously, the much-vaunted greenbelt is far from safe.

These days I feel increasingly trapped in an urban area so vast that I can't leave it. And I am not alone; not long ago I met with Will Alsop, the famed British architect who has opened his North American office in Toronto. "If I drive north towards Georgian Bay," he said, "I am shocked by the size of the city. This city has only 3.5 million people but occupies a big footprint. Socially, that's irresponsible. People have no choice, they have to use their cars."

The Liberals have recently vowed to ban incandescent light bulbs and restrict use of plastic bags, to help our environment. Worthy moves, but hardly dramatic. A government with real balls would enact European-style laws that protect agricultural zoning, period. Vaughan, which is about fifteen kilometres square, is only half paved: the province can protect what's left, or at least mandate transit-friendly development: in short, it can order cities to lay down commuter-train tracks and bike paths as they develop, and zone land for corner stores to which residents can walk. And cities must deal with waste water and trash within their boundaries. Ottawa, too, must enact a national transit strategy. Otherwise, Canada's richest farmland will all disappear in a vast and bleak metropolis.

SWEATING NOW, I finally get to the Colossus Centre. I walk by Sport Mart and Smart Set and Liz Claiborne and La Vie en Rose and Office Depot and Mr. Big & Tall. I have to jump curbs and dash through parking lots since there are no sidewalks linking one row of big boxes to the next. The asphalt reflects the scorching heat of the July sun; no trees or buildings shade me as I walk. I finally give up at Jacob Connection, dehydrated, despairing, and alone.

I go back and get my car. Driving, I have no trouble finding HomeSense and, next door, Solutions ("Your Organized Living Store") having a Hot! Fun! Sale! Here, I find the basket I need. I head back downtown, back to my comfort zone. Visiting Vaughan makes me appreciate the simple pleasures of cities built before World War II: places where clotheslines are permitted, where kids walk to school, I can walk my dog to the corner to get a slice of pizza, and window shop in the stores on the way, and I can load my empties into my bike basket to go to the beer store. I believe I am not alone in sensing that this is a better way to live: the houses in my downtown neighbourhood have tripled in price in the past ten years. Sensibly designed neighbourhoods are cherished for their scarcity. Developers and politicians who cotton to the public's craving for true community may find they can make a lot more money, generate more tax revenue—and do something good for our collective future as well.

And the basket? It fits perfectly. Somebody stole its little white cloth liner the other day outside a local juice bar, but the basket works just fine.

UNSUNG HERO
JOHN BARBER

IF TORONTO'S ETHNIC DIVERSITY WERE JUST AN
ACCIDENT, THE EXPERIMENT MIGHT END IN THE SAME
DISASTERS THAT HAVE BEFALLEN OTHER CITIES. BUT
JOHN BARBER BELIEVES THAT TORONTO MIGHT SUCCEED
WHERE OTHERS HAVE FAILED. TO IMAGINE THAT THIS
POSSIBILITY EXISTS BY CHANCE IS TO IGNORE THE
CITY'S HISTORY AND ONE MAN'S ROLE IN
CREATING THE IDEA OF TORONTO.

FACING PAGE: CITY OF TORONTO ARCHIVES, SERIES 1057, ITEM 4725

I FIRST VISITED THOMAS L. WELLS Public School in far northeastern Scarborough as part of a jury for Toronto's 2007 Urban Design Awards. I had to persuade my fellow jurors to make the trek, but we were all astonished by the perfect Potemkin village we found, albeit hidden away rather than shown off. The school is gorgeous and generous to the point of being luxe. Its trampled, still-treeless playground is a vision of multicultural paradise. There are more than nine hundred children coursing through the sun-washed corridors of this opulent palace of early learning, and not a single one of them appears to be white.

The place filled me with pride. This is not Toronto the bumptious WASP outpost, certainly not the legendary Tory Toronto that so appalled Charles Dickens. It is Toronto as seminal experiment in twenty-first-century democracy, triumphantly beaming its success to the furthest corners of the world.

But not long after we visited, in the middle of the night, a girl ran bleeding from a nearby house, crying that her mother was being murdered. Her mother was dead from stab wounds by the time police arrived, along with another woman in the house and their murderer, the girl's stepfather, who stabbed himself after killing the other two. The entire family had just attended the girl's Grade 8 graduation ceremony at the new school.

At the time of the crime, news reports described the little-known neighbourhood where it happened as "posh," indicating a certain surprise at the discovery while at the same time distinguishing it from ordinary Scarborough, where such tragedies are assumed to be commonplace. Called Morningside Heights, it is executed in the New Urbanist style to resemble the nineteenth-century neighbourhoods of the old city, which makes for an

incongruous contrast with the Alvar Aalto-esque modernism of the school. But the posh is as deceiving as the utopian schoolyard. Behind every other green gable are multiple immigrant families. Some even rent garages, their presence indicated by the appearance of human-scaled entrances in what used to be large garage doors but are now walls. The school is the first the city has built since the Mike Harris Tories almost succeeded in destroying secular public education a decade ago. It was built to accommodate 600 students and opened to accept 900, the schoolyard instantly crammed with portables.

Thus one more Potemkin village is exposed. Even where they flourish, liberal dreams quail. In glimpsing the underside of these Heights, I am reminded of a conversation with a Montrealer, an urbanist, who commended Toronto's astonishing ethnic diversity but warned that it was an unprecedented social experiment of no certain outcome.

Alienation, upheaval, poverty, and despair are the very identity of the immigrant city. What's new in Toronto is our dawning understanding that the condition is everlasting. The city is never settled, only occupied. It is always dangerous, its violence rippling seismically and ceaselessly to expose new frontiers of weakness, opening new sinkholes, swallowing neighbourhoods whole. As I write this, police are looking for the person who just shot rap artist Michael George in Morningside Heights at three in the morning, killing him instantly with several shots to the head and chest. A black child killed in gang-war crossfire in another corner of the city is still warm in his grave.

Twenty-first-century multicultural paradise is no gentle place. Every week brings more deaths from the savage gang warfare that harrows Toronto's black immigrants and their Canadian children—the latest class of untouchables in a stubbornly repetitious history that encompasses earlier waves of Italians,

Jews, Catholics, Irish, Eastern Europeans, South Asians, and others, all of them once routinely identified by epithets now so forgotten they needn't even be suppressed. But new ones always arise. There are always more languages, more extremists promoting ancient hatreds, more and bigger ghettoes, now even truck bombs. Unsettled generations of rootless occupiers have produced a civic terrain so impossibly fractured as to be unknowable, built on a vast but generally shallow cultural history, its positive identity steadily approaching nil.

What happens when people from what used to be called the Third World simply get up and move in next door to the people of what used to be called the First World? Globalization is economic in origin but the experience of it, especially its violence, is local and cultural. Toronto, it now seems, is one explosion away from a new role as object lesson in how multiculturalism went wrong.

THE CRITICS ARE PRIMED, a dire chorus rising with every new bombing and murder in another European capital. Why, they ask, should Toronto be exempt? Many insist that we should emulate the European reaction even before the bombs explode: declare new limits to liberal tolerance and promote national or "traditional" values—while strictly suppressing dissent from them. If Babel is as enervating as our conservatives remember, no new tower built along the same lines is more vulnerable than ours, the ultra-diverse metropolis of a notoriously diffident nationality.

The striking vision of multiculturalism at work does nothing to answer its critics. Instead it becomes ominous, like an inappropriate bumper crop on an overheated planet. The radically mixed demography of Toronto and other leading Western cities today is an experiment unprecedented in human history, and it is going badly wrong in Western Europe, the birthplace of the Enlightenment that first made such a thing conceivable. There is no example anywhere else to guide us to a better fate, and no obvious reason to expect it in our own defenselessly tolerant outpost.

But nothing has exploded yet—nor ever, in fact. The one bout of political violence that earns Toronto a mention in world history—specialist volumes only—was the 1837 Rebellion, a notorious farce. What makes this ever-boiling immigrant city truly remarkable is its long history of social peace. The absence of violence makes for dull history, but it requires an explanation. It's not enough, as Canadian conservatives, apostate liberals, and European observers so often do, to assume there is nothing different about this terrain, to imagine that Toronto's enduring success at integrating and elevating migrants from every corner of the world is the by-product of impersonal forces acting in the absence of meaningful history. It just happened, given the geopolitical circumstances and, given a new set of circumstances originating elsewhere, it could be upset as effortlessly as it emerged.

The view of English-speaking Canadian society, history, and institutions as foreign in form and origin is near universal, even among natives, especially among Torontonians. Each new wave of immigrants becomes free to declare its arrival as the key event in a stuffy outpost's great cultural awakening. Its monuments are putty. Its founding myths are judged treacherous—racist,

paternalistic, colonial—and buried in shallow graves. The origins of the city's own political culture remain bizarrely inaccessible to its citizens today.

But it is Toronto's enduring if unheralded civic culture that may allow it to become the peaceable exception to the laws of Babel. One could say there is no terrain on earth in which "secular humanism" has sunk deeper roots, nor any polity that has more successfully beaten down the special claims of religion, language, identity, or any of the other endlessly various, excluding nativisms—Toronto's particular *bête noire* being its own notorious Tory past.

How did a city known historically for rigid conservatism and intolerance, a deeply colonial hotbed of radical nineteenth-century Waspism, end up like this? Toronto is notorious as a place where political violence, when it occurred, was Tory in origin, usually spearheaded by Orangemen and supported by respectable opinion. Did its essential character, unsupported by the once-valued "British connection," simply collapse under the weight of twentieth-century immigration? Did everything change suddenly in 1982? Or, contrary to most prevailing theories, is it possible to believe that Toronto changed because Torontonians changed it?

The proposition is too romantic for us, but let it be said: Toronto's true identity was forged in a long, bitter struggle by free citizens against empires without and, most critically, the colony within. It is a triumph of muscular liberalism. Our evolving constitution, especially the fundamental principles contributed by the earliest Toronto Reformers, is the record of victory over powerful demons that still haunt less-established democracies. Canadian democracy didn't arrive on a plate; it was hard won. Toronto Toryism didn't wander off; it was beaten down.

In this romantic view, the modern city's lack of identity is no accident but rather a Herculean achievement, revealed as such whenever some new neo-fascist party wins another election in Europe. In Toronto we have made such events unimaginable. Nowhere on Earth are the politics of blood and tribe less respectable than they are here, in this dangerously diverse city. That is the tradition history demands we conserve as the city copes with increasingly uncontrollable global migration in the new century.

To understand that legacy I return from suburbs so new they still lack cemeteries to the hill called Spadina, where a now-abandoned burial ground once held the mutilated remains of Robert Baldwin, the depressed and forgotten founding hero of Toronto. It would require a history of greater pseudo-mythological vigour than ours, and a hero less manifoldly tragic, to honour this place for what it is, the Mount Vernon of Canadian democracy. But there it is anyway—a broad lawn on a hill with a scrim of scrubby trees blocking its command of the grand avenue that begins below it, overshadowed by the outrageous Edwardian pile next door and misconstrued by the mansion that crowns the hill and shares its name. Born in 1804 and known to history as the first prime minister of the united Canada, a post he shared with Louis-Hippolyte La Fontaine, Baldwin's official career is lost in the confused and obscure prelude to Confederation. Looking back with fresh eyes, he emerges as the original genius of Toronto's indigenous liberalism, the impeccably tolerant moderate whose dogged pursuit of political reform transformed his own city, province, and nation, ultimately helping to free millions of disenfranchised people in Canada and throughout the world.

Baldwin was educated by John Strachan, vital organizer of the colonial oligarchy, and learned early to understand and respect the neighbours and

near-kin who became his lifelong opponents. Although thriving amid the rulers, the Baldwin family never joined them. The emergence of Spadina on "the mountain" in the distance above the town was a rising local family's first bold dissent from colonial orthodoxy.

The only surviving sketch of the first house, completed decades after 1835 when it burned down, shows a simple but finely proportioned gabled structure with a narrow, modestly classicized entrance offset in the south-facing end with plain caps and sills adorning ample windows of Palladian inspiration. It was a backwoods temple of Enlightenment values that approached the Greek Revival then becoming the official style of republican idealism in the United States—but drew back, as befitting the views of its builder, William Warren Baldwin, Robert's father, a Whiggish immigrant schooled in the debates of Irish nationalism but unquestionably English in his loyalties.

A doctor who turned to the law following his emigration to Upper Canada (a transition that matched the needs of an underpopulated but over-ruled colony), W. W. Baldwin became an early reform leader who was valuable mainly as a respectable front for marginal figures dismissed as traitors by colonial governors. His greatest contribution was his withdrawn, duty-bound second son, Robert, who honoured his father by going on to win the prize held out to him since birth—a democratic constitution for the new country.

Imagination can scrape away the Edwardian intrusions but it struggles to rescue the democratic ideals embodied in this vanished mansion on the hill. The Baldwins don't help. Deliberately exploiting the tactical advantages of respectability, they clung militantly but unheroically to the middle ground, resisting the revolutionaries as stoutly as they battled "Tory violence." Even the term they adopted for their great cause, "responsible government," was a

euphemism designed to disguise its true nature—to help smuggle untethered freedom inside an imperial consciousness incapable of distinguishing democracy from its handmaid, revolution. As fulfilled by his recessive son, the guise of bland respectability proved perversely successful, forever cloaking the constitutional genius that conceived a native democracy on a hill above Toronto.

Unlike his charismatic father, Robert Baldwin hated politics. He was an indifferent orator and never mastered the rudiments of organizing and campaigning. Forced by an irrepressible sense of public duty to carry the country on his shoulders during its formative years, he dramatized his necessity—and secured his place in history—with successive resignations from office. If the colonial government was not properly constituted according to his exacting principles, he would resign—and the government would fall. Thus the arch-Tories of the Family Compact retreated, step by step, as democracy in Canada advanced.

Despite the obscurity he sought and ultimately won, no other figure of his day—or any other day—stands up better to contemporary judgment than Baldwin. As a leader of the Upper Canadian Reformers and minister of every, often short-lived government they joined, he defended religious tolerance and unfettered democracy from the beginning of his career. Following union of the two Canadas, he insisted on linguistic equality despite Tory rage. He fought for women's rights, defended public education, and created self-governing municipalities to counter the residual imperialism of the emerging Canadian constitution—legislation more progressive than anything that has come since, most of which slides back. Doggedly attacking the last monopoly local Tories commanded—indeed defying the city's entire

Protestant establishment—he founded the University of Toronto as a secular, independent institution.

Baldwin's influence is nowhere more telling than in the story of the famous Durham Report, the empire's first historic concession to North American democracy. It begins with an interview in Toronto, where the Baldwins, father and son, briefed Lord Durham on the workings of what they called responsible government, following later with detailed correspondence on the subject. The innovative Baldwin formula for preserving an imperial governor, while making him exclusively accountable to a locally elected government, became one of the final report's two key recommendations. But Robert Baldwin proved his place in history by his forceful rejection of the imperial blueprint's second recommendation: the total assimilation of French Canada. Defying the openly expressed bigotry of Upper Canadian Tories and George Brown Reformers, who had united in the enterprise to erase Quebec, Baldwin responded by inventing—again, almost single-handedly—the concept of Canada as a bicultural nation.

Uniquely among English-speaking politicians in Canadian history, Baldwin was revered in Quebec. Even today, he is better known to Montrealers than Torontonians, the Quebec National Assembly having named a local electoral district after him in 1965, at the height of the Quiet Revolution.

Like Macdonald and Lincoln, the great unifiers he heralded, Robert Baldwin was a chronic depressive, psychologically predisposed to see the world as it actually is, freed from the delusions of hope yet emotionally incapable of shirking its burdens, the heaviest in his clear view being political leadership. Unlike either Macdonald or Lincoln, Baldwin disappeared beneath the weight. Following the death of his beloved wife, Eliza, on the eve of the

aborted 1837 Rebellion, he described his future as "the waste that lies before me." It was a view he never found cause to alter during the subsequent years of his greatest political success. He withdrew to Spadina in middle age, where for once he successfully resisted fresh calls to serve the new nation he had founded, and died a recluse, probably deranged. His will stipulated that his coffin be chained to his wife's, his body mutilated to replicate the scar left by the Caesarean section that had hastened her death more than twenty years earlier—a "last solemn injunction" ignored until his son, William Willcocks Baldwin, exhumed his recently interred body and supervised the operation a month after his father's death. "It was a suitably strange end for one whose public persona and private agony were the sum of a man few understood, few loved, but all honoured," his biographers write. Not long after his death, his estate foundered. The Baldwin family lost Spadina.

School histories embalm the Baldwins in the arcana of their euphemisms, while popular accounts struggle to elevate the erratic, ultimately pathetic rebel Mackenzie to the status of democratic hero. Few acknowledge the world-historical impact of Robert Baldwin's ultimate achievement, which solved a constitutional puzzle that had confounded Edmund Burke and the empire's most enlightened statesmen a generation earlier. The Canadian innovation of "responsible government" spread quickly, as if by infection, throughout the empire where the sun never set. It made every colony an aspiring nation, eating empire from within.

Fittingly, the theory needed to explain such a process is the work of a Torontonian, Harold Innis, another provincial genius much honoured and little understood. To Innis, all creative and ultimately disruptive change in established empires originated on their geographic and cultural margins, far

from the ruling metropolises, where mastery breeds an orthodoxy that is increasingly rigid and ill-adapted to conditions on the margins. The conquered territories, geographic and intellectual, foster the essential reforms that legitimize empire—or not, in the case of the most resistant, therefore ill-fated imperial monoliths.

Innis traced the glory of ancient Greece to the country's origins on the barren, straitened margin of warring empires. Our small claim consists in what the Upper Canadian Reformers, led by a backwoods constitutional genius, accomplished with their hard-fought victory over local Tories and, ultimately, the imperial rigidity that propped them up. In a modern world of increasingly intolerable imperial politics, there is still no better model of productive dissent— and no ground more conducive to its expression than ours.

THE SOUTH ASIAN DIASPORA in Toronto will soon comprise a million people, most of whom, at any one time, will be immigrants. It is notably successful, defying a worrisome trend that is retarding the social mobility of other recent immigrants. Its children throng such schools as Thomas L. Wells. How many would there be, what success could they hope for today, had Robert Baldwin not dared to speak truth—and stubbornly demonstrate its virtues—to imperial power 170 years ago? And what would induce them to migrate in such numbers to a city that had failed to work free of its colonial confinement?

Without Baldwin, British imperialism remains immune to reform; revolution becomes the only plausible route to democracy. Without Baldwin,

Gandhi is impossible—not simply because Baldwin invented the techniques of non-violent resistance to imperial power, skillfully turning the British constitution against its own guardians, but because he created the democratic space, in Gandhi's South Asia no less than in his native Canada, where such techniques first became conceivable, let alone plausible. Gandhi learned the theory of civil disobedience from Thoreau, but the unknown prophet of his belief in satyagraha, "truth and firmness," was Robert Baldwin.

Baldwin learned resistance to political violence in his cradle. He was an able practitioner, a lawyer, by the time a Tory mob broke Mackenzie's press and threw his type in the lake. He was the only one in Toronto willing to defend Peter Matthews and Samuel Lount, the two rebels hanged for their part in the botched uprising a decade later, which he did with a passionate but doomed appeal for clemency. The climax of his struggle came a decade after that, with the passage of the notorious Rebellion Losses Bill, which forgave former rebels in both Canadas, lifted their exile, and restored their property. It was an epochal gesture of conciliation that secured Canadian democracy by forcing the colonial governor to sign a bill both he and his imperial masters strongly opposed. At the same time it established the religious, cultural, and linguistic comity essential to the existence of a united Canada. Baldwin was burned in effigy and almost killed the night the bill passed, when Tory riots swept the Canadas and one mob attacked his Montreal lodgings.

Considering the advances Baldwin and La Fontaine achieved once the two Canadas united, memorialized by the achievements of their short-lived "Great Ministry," is enough to make an Upper Canadian nationalist regret Confederation. The two old Canadas fit together in a way the new big one,

with its own colonizing agenda, never did. When Quebec separation appeared imminent following the failure of the conciliating Meech Lake accord, Baldwin spoke through the medium of Ontario Attorney-General Ian Scott: "If Quebec separates," Scott joked, "we can always join them." The famous Last Spike was another nail in the coffin of an outmoded leader who never liked railways nor dreamed of continental conquest. Had he been alive to prevent it, Baldwin never would have let Riel hang.

No city can claim a founder so consistently generous, so persistent in his defence of the disenfranchised and excluded, one more adept in his constitutional philosophy or far-reaching in his works—nor one more depressed or forgotten. In his time he was universally admired for his principles and his virtues, the greatest of which—his legacy and our essential inspiration—was what Virginia Woolf called "the melancholy virtue of tolerance."

As clouded as the legacy may be, as marginal as Baldwin's Toronto remains in a new English-speaking empire even more dominant and violent than its predecessor, its successes still shine. Most importantly, this legacy is ours—not some script handed down from a distant metropolis, be it London, Paris, or Washington. It is a distinctive constitution that was forged in a long, local struggle against imperial diktat, one that brilliantly reconciled internal contradictions that the new imperial mentality—in terrorized London, burning Paris, or paranoiac Washington—still struggles to perceive. Toronto's astonishing pluralism, tolerance, and openness are no accidents, but rather the eloquent expression of its true native culture. To abandon that now would be tragic.

The sadness of reform is that, unlike revolution, it never succeeds and, therefore, can never be neglected. Where revolution provides answers, often

sufficiently thorough to forestall necessary change for generations, reform follows avenues, never quite arriving and never out of the woods, its failures exposing long flanks to further attack. Nobody can call Tory violence in Toronto today a quaint memory, a decade after a manufactured crisis that aimed to dismantle secular public education in the city, overturning a fundamental victory of our nineteenth-century constitution makers. The same policy returned in different guise this year when the Progressive Conservative Party promised public funding for all religious schools, reaching out to the already isolated tribes of the multicultural city with the promise of total separation. The old struggles never cease. The hydra has a million heads.

But never have the city's secular roots, exemplified by its truly public schools, been more important to its future than they are today. Schools are the essential institutions of multiculturalism, which is properly understood not as doctrine of division but as the soft path to integration. Public schools are where divisions heal and Canadians are made in loyalty to strict democratic principles—principles held far above the loyalties that rule private lives and minority communities. They must be inculcated with Jesuitical fervour. To save Toronto we must save the schools—constantly.

There is little glory but much hope on the creative outskirts of empire, where we began and where we remain, satellite to a new regime. But this is where, Innis biographer Alexander John Watson suggests, any future innovations capable of sustaining Western legitimacy will arise—"from the geographic margin (the first generations of newly arrived immigrants and refugees), the social margin (women and gay intellectuals), the cultural margin (our First Nations) and the linguistic margin." Our destiny is to be painfully open, to explore new frontiers of miscegenation. Our civic duty is

IN PERSPECTIVE
WILLIAM SAUNDERSON-MEYER

ONCE A YEAR, SOUTH AFRICAN JOURNALIST WILLIAM SAUNDERSON-MEYER VISITS TORONTO. WHAT HE FINDS IS A CITY THAT IS ACCOMMODATING AND FRIENDLY. HE ALSO FINDS A PLACE THAT IS AS MADDENING IN ITS SELF-DEPRECATION AS IT IS ENDEARING.

FOR EIGHT YEARS it has been my annual good fortune to travel from Durban, on the East Coast of South Africa, to work for some weeks in Toronto. Although it is always at the end of summer, when the city is bathed in that mellow, honeyed Canadian light that makes magical the grimiest cityscape, working in a place—albeit briefly—is different from being a tourist. One benefits from the sightseer's fresh eye, while being around long enough to have fond illusions exposed.

Toronto was something of an accidental destination. I am a journalist with a passion for Zimbabwean stone sculpture and the exhibitions' curator of the not-for-profit African Millennium Foundation, which was established to promote this exciting work internationally. Through a series of coincidences, a few exhibitions were held near Peterborough, but it seemed to me that the obvious place for sophisticated fine art would be Toronto.

Artistically, ours has always been an ambiguous relationship with Toronto. While the work is well-established in Europe, especially in the United Kingdom where we also exhibit every year, it was new to Canada. It therefore had to overcome an innate scepticism about anything coming from Africa, as well as a certain dismissiveness toward work created by indigenous peoples.

I remember well the long argument I had with a Toronto newspaper's art critic who refused to consider the exhibition for review because Zimbabwean stone sculpture was not "serious" art. The fact that critics for some of the best publications in London, Stockholm, and Copenhagen engage very seriously indeed with our shows cut no ice. This kind of attitude is an aspect of Toronto's small-town persona, a trait that is infuriating in this instance but endearing in its more benign manifestations, such as the city's lack of pretension. Nor was the

art critic's attitude universal: ordinary Torontonians have embraced the work with an enthusiasm that has brought me back year after year.

The relationship we have with the city that we call home is intensely personal. It's analogous to marriage. No matter how strained matters might appear, smart-aleck outsiders would be wise to remember that the liaison almost invariably started as a love affair. Not that a love affair with Toronto would be a wild ride. Not even the city's greatest admirers would claim it as the *femme fatale* of the world's urban centres. It's Paris that is sexy, sophisticated, and passionate or perhaps, closer to home, Montreal. Toronto incarnate is a mature beauty: attractive but not flashy, carrying that dignity of a certain age but lively and imbued with a sensual warmth.

My initial impression was that Toronto is very similar to London, where I lived for five years. Whereas many cities have been riven by ethnic conflict, both London and Toronto are generally harmonious, multi-ethnic patch-works; both are also metropoles of sufficient critical mass to have a liberal (with a small *l*) influence on the political and social agendas of the innately more conservative wholes of which they are part. But while London is secure in its pre-eminent position in British life and now challenges for the title of the de facto capital of Europe, Toronto is far more uncertain of its standing. This may reflect the fact that Toronto is not the capital of Canada and that because of the vastness of the country, there are always going to be the counter-vailing claims—Vancouver? Calgary? Montreal?—of competitors.

South Africa has interesting similarities. To curb the rambunctious and brash influence of that ungodly mining town, Johannesburg, at the formation of Union in 1910, it was decided that the country would have three capitals: Cape Town, where Parliament is sited; Pretoria, the administrative seat of

government; and Bloemfontein, the judicial capital. Johannesburg is the nation's economic powerhouse but is draped in none of the official bunting. Consequently it has a perpetual attitude of being hard done by. Toronto, too, has this faintly aggrieved air.

This is not to suggest that Toronto is some thin-lipped, embittered dowager. The city's charm is underestimated both by visitors and locals. The texture of downtown Toronto is lovely, its citizens are remarkably friendly and accommodating to outsiders, and it is the perfect size in that it has all the cultural amenities one could hope for, while still small enough for services to work—it appears—efficiently. One can wander around downtown Toronto at any time without feeling unsafe—something that distinguishes it from most big cities, including London. More astonishing, especially to someone coming from crime-ridden South Africa, is the insouciance of Toronto friends who think nothing of leaving their homes unlocked while they pop out, as if they were living in an English village in the 1930s.

There is more than a touch of Calvinist propriety to Toronto, a deliberate underplaying of the frivolous or ornamental. What desperate lack of commercial and architectural imagination has embraced as the city's new vernacular the sterile, cookie-cutter condominiums that are shooting up all over central Toronto and destroying the rich, older fabric of the city? There is also the city's squandered setting on the lake. One wonders what dour Scots function-alism still prevails that the heart of Toronto is cut off from the magic of the water by a swath of expressway and rail lines?

This is the downside of that same village mentality, something that Toronto has to break from if it is to achieve its potential as an exceptional place. The public transport system is slow, antiquated, and inadequate. And

the newspapers, including the *Globe and Mail*—once arguably one of the world's quality titles—are becoming desperately parochial, filled with small-town self-importance and smugness.

On balance, to this foreigner, Toronto displays in microcosm some of the modesty and awkwardness that characterize Canada the nation, trapped as it is between the cultures of the New and Old worlds. It is a puzzling characteristic because in the same way that Canada underestimates its standing and clout, so too does Toronto. Both are surely now grown up enough to take with confidence to a larger stage.

SECOND NATURE

JOHN VAN NOSTRAND

TORONTO'S SENSE OF ITSELF WAS, TO A REMARKABLE DEGREE, ESTABLISHED BY THE COLONIAL SURVEYOR'S GRID. THIS IMPOSED ORDER HAS DEFINED THE CITY THROUGHOUT ITS HISTORY. TODAY, ARGUES THE WRITER, ARCHITECT, AND PLANNER JOHN VAN NOSTRAND, WE ARE REDISCOVERING THE LANDSCAPE WE TURNED OUR BACKS ON LONG AGO.

I AM DRIVING ON THE road allowance between Concessions 1 and 2 east of Yonge Street in what used to be York Township in York County— now known as Bayview Avenue. I am moving south along the back of Lot 19 (Mount Pleasant Cemetery), and in front of the 1930s modernist village of Leaside, which occupies Lots 12 to 15. I am heading toward Lake Ontario.

This grid pattern of concessions and lots, numbered east or west of Yonge Street and north of Bloor Street, formed a small part of one of the largest land settlement and surveying projects undertaken in the British Empire. The grid resulting from it is the construct through which Torontonians constantly move as they find their way around their city, and it has been with us for over 200 years. While it has obviously defined Toronto physically, it has also defined it psychologically. It not only gave, and continues to give shape to the city, but has also shaped the way we think about it.

In large part many of the changes that are taking place in Toronto today—our struggle to reclaim our waterfront; the prospect of a revitalized and "naturalized" Lower Don; the creation of major new parks at Downsview and Ashbridges Bay; the efforts to "daylight" the buried Taddle and Garrison creeks—are attempts to break free of the often arbitrary dictates of the grid. Consciously or not, the grid effectively neutralized our relationship with landscape—the lakes, rivers, valleys, and plateaus that define the nature of the place in which we live. Without that relationship, Toronto became merely a place to work—a city whose culture was one that was almost wholly controlled and dictated by those who governed it.

Today, consciously or unconsciously, we are rebelling against this dictated order. It's a rebellion that, at its extreme, is represented by the jagged

outcroppings of the new Royal Ontario Museum or the pencil legs and polka dots of the new Ontario College of Art & Design. On the street, it is found in our attempts to create new kinds of public space like Dundas Square and a new City Hall Square, and in the brave new magazines that write about opportunities to improve public life in Thorncliffe Park or at Jane and Finch. At home, it's in the gardens that are being planted with native species and the light wells being ripped through dark Victorian housing. It's a rebellion that is sparked by a new idea of ourselves and our city—one that yearns for meaningful and actual change. Words, music, and pictures are simply no longer enough. We want to give shape to our city in the same way that the grid gave shape to the colonial governor's idea of us.

Speaking not just as a citizen but also as a practising architect and planner, I view this as a fundamental transformation—one that is having and will continue to have a profound effect on the future of the city—and as it unfolds, Toronto will change from the largely colonial capital that I feel it still is. If Toronto can embrace the natural landscape on which it sits and that it has so long ignored, it will take an enormous step toward becoming a culturally independent city, one that is rooted in its riverine landscape, on the shores of one of the most dramatic and most beautiful lakes in the world. In so doing it will emerge as a city defined by its place, rather than by a structure imposed long ago by officials sitting in London or Portsmouth who neither knew nor cared about its landscape.

This transformation from the prescribed idea of a place that is largely unknown to those controlling it, to an idea of the place itself by those who occupy it cannot be explained without a thorough understanding of our past—something from which we have been almost as estranged as we have

from the landscape we inhabit. Without that history, London will simply be replaced by Chicago, or Barcelona, or even Montreal, and we will remain a people—no matter how diverse, how tolerant, and how modern—without an idea of ourselves and our place. How can we possibly make a great city without that idea?

THE OVERALL PLAN for Upper Canada (later called Ontario) was conceived in Quebec City in the late 1780s under the direction of Guy Carleton, Lord Dorchester. Dorchester served as a colonel in the British capture of Quebec in 1759 and was appointed governor in 1768. He subsequently repelled the attempted American invasion of 1775–1776, near the end of the American Revolution, but was criticized for his slow pursuit of the retreating rebels. He was appointed commander-in-chief of New York in 1782–1783. Being a loyalist, he was ultimately forced to evacuate, although he refused to do so until thousands of other loyalist refugees had been sent to safety—most of them to Canada.

Dorchester returned to Quebec as governor in 1786. Like James Murray before him, he was convinced that the loss of the Thirteen Colonies was primarily due to the fact that the British colonial government had lost control of its primary asset: land. "Crown" land, to be more exact. Led by George Washington, one of the youngest registered surveyors in American history, many settlers had pushed inland from the British-dominated coast. Crown lands were surveyed and sold off without the permission of the colonial offices in New York or London. The backcountry farmers who occupied these

inland lots were eager to gain permanent control of their land holdings and, ultimately, it was these men who formed the backbone of the revolutionary army.

Murray and Dorchester were determined not to let this happen in British Canada. As a result, they embarked on an extraordinarily comprehensive plan to ensure that Britain would not again lose control of its land—and of the economy the land engendered. Consequently, on his return to Quebec in 1768, Dorchester established the Land Office Department. Using compasses, axes, and an iron chain,[1] his surveyors laid out the most extensive land surveys ever undertaken within the British Empire. In the relatively short period of six years, nine counties, each comprising several townships, were laid out on the north shore of Lake Ontario from Stormont (Cornwall) in the east to York (Toronto) in the west. This pattern was subsequently extended westward along the north shore of Lake Erie as well.

In 1789, at the outset of these efforts, Dorchester published a revised set of rules and regulations for the surveying of townships and town plots in both waterfront and inland situations. These referred in detail to two types of townships—a waterfront township, to be situated on a navigable river or lake, and an inland township. The waterfront townships measured 9 miles wide by 12 miles deep, with a central radial town surrounded by commons that were, in turn, surrounded by 25-acre "park lots" intended for the use of townsfolk

1 Gunters Chain, comprising 100 links, measured 66 feet long and served as the primary measuring device for land surveyors. All roads were, and still are, one chain (66 feet) wide, and the farm lots typically measured 20 chains (1,320 feet) wide by 100 chains (6,600 feet) deep. Town lots typically measured one chain (66 feet) wide by two chains (132 feet) deep.

for subsistence food production and raising animals. The remainder of the land was divided into nine "concessions"—each comprising thirty-five 200-acre farm lots. Our entire picture of southern Ontario today is governed by this model plan.

Most Upper Canadians occupied a certain lot in a certain concession on a certain concession road (or side road), in a certain township (now town) in a certain county (now region). The "Instructions to Surveyors" also noted that two out of every seven lots were to be reserved alternatively for the Crown and clergy, first to provide a source of revenue, through either sale or share-cropping, for the funding of public or ecclesiastical works, and second, to ensure that no single landowner or group of landowners could seize control of a contiguous large acreage.

In fact, very few of the towns that were to be associated with each of the townships were ever actually laid out (Cornwall being an exception), largely because their potential sites ended up straddling major lakes or marshes that had not been properly reconnoitred. As a result, towns in Ontario were located in a relatively haphazard fashion, irrespective of the overriding ideals of county and township planning. They typically grew up at the intersections of significant concession roads with navigable bodies of water or sources of water power. In effect, unlike most of the great cities of Europe that first occupied key military locations and then took dominion over their surroundings, the towns and cities of Ontario, including Toronto, were founded within the context of a larger pre-surveyed, regional plan.

In 1788, in accordance with an early version of Dorchester's rules, Gunther Mann, an army officer and military engineer, prepared his first idealized plan for a town called Toronto Harbour, which was to serve York County. It

follows the design of the waterfront town in many respects and shows the central mile-square town site, set back from the lake and surrounded by a common. The common was in turn to be surrounded by park lots stretching from Garrison Creek eastward over to the Don Valley. The York Town Plan was highly ordered, with lots allocated for jails, churches, parade grounds, and markets in a diagonal pattern of public squares.

In 1791, John Graves Simcoe was appointed to serve as Dorchester's lieutenant-governor of Upper Canada. Simcoe had a broader idea of Upper Canada—a "grand design," according to which a new inland capital, safe from American invasion and lying close to the centre of the province, would be located at present-day London. For him, York (Toronto) was a temporary location, a naval arsenal from which to move inland to the real heartlands. As a result, his "Plan for York," which was surveyed in 1792, was much less ambitious, but perhaps more practical, than Mann's. It comprised ten of Mann's eighty-one identical blocks, set back slightly from the water's edge surrounded by a much larger common that extended northward to Lot (Queen) Street. Long, thin park lots ran northward from Queen Street to Bloor Street, stretching from the Don River to Garrison Creek. North of Bloor, farm lots were laid out on either side of Yonge Street.

THE ORTHOGONAL RUINS of these lots are still apparent as I make my way down the road allowance toward the lake. Mount Pleasant Cemetery is, for example, one of the few surviving intact farm lots left within the city. But before I am able to take in my first "bay view," I must curve sharply around

the back of the Moore Park Loblaw's store in order to slip down into the Don Valley.

I am now off-grid and wandering on the curvilinear extension of Bayview into unsettled lands. Here no remnant of the surveyors' lines is visible—they were never actually laid out and survive only as lines on paper. The valleys, like the irregular north shore of Lake Ontario, could simply not be brought into conformity with the grid. As a result, they not only lie outside the settled area of the city, but completely outside its psyche. They are Other Places— wild, uncivilized, and hidden. Even today, as extraordinary as it may sound, there is not a single restaurant that looks into any one of Toronto's valleys.

The Bayview Extension winds east and then west before it finally descends to the valley floor marked by the stoplight at Pottery Road. The drive continues—past the Brick Works, under the Prince Edward Viaduct, and on to the two stoplights at the intersections of Rosedale Valley Road and River Street, both commandeered by homeless men taking advantage of red lights. The road straightens and re-enters the grid city, parallel to the now visible but realigned Don River.

The place where I am heading—the point where the Bayview Extension meets Front Street—is just beyond. It's not only the corner of two important streets but the southeast corner of the original city. It was—and it remains—a place where the grid of the city runs smack into nature.

As I reach the end of Bayview, my car turns 90 degrees to the west to join Front Street. Like the "baseline" of all the townships, this is the baseline of the city—the straight line drawn across the waterfront at a distance sufficient to ensure that it would not be "broken" by the natural, irregular, and uncivilized lakeshore, thus setting a solid base for the subsequent survey of regular lots

extending northward from the lake. In fact, the British called the lands located south of the baseline the "broken fronts" and considered them to be of little value to the Crown. In most communities they were occupied by the poorest settlers, including the French and Indians who pre-dated British rule. They were eventually acquired by the railways for next to nothing.

I see an abandoned railway bridge crossing the river and the tracks leading to and from it—up and down the valley—that bear further testament to the industrial takeover of these natural places. In contrast to a copse of soft maple and trees of paradise on the banks of the Don, the majestic sweep of the Don Valley Parkway turns here to join the Gardiner Expressway. I catch a glimpse of the lake, and the Toronto Islands beyond. There is an historic whiff of a nearby tannery. The railway embankment slopes up to its terrace and beside it is the former Gooderham and Worts Distillery that is in the process of being restored as a memory of the industrialization of these early water-front lands. As I swing due west, the powerful skyline of downtown—the central business district—opens up, confirming the historic value of being north of Front Street rather than south of it.

IN SIMCOE'S PRAGMATIC PLAN for York, the reason for the inclusion of extensive open space around the town, as well as its setback from the lake, was to protect the new town from the threat of an American invasion. Following the war of 1812–1814 (during which the Americans did, in fact, attack Toronto), the colonial focus moved away from defence and back to settlement. George Philpott's plan for the city in 1818, by which time the population had

reached about a thousand residents, shows how the open space along the lake had begun to fill in and how the park lots had begun to be farmed. In 1834 the park lots were annexed to the city as it expanded north to Bloor Street. Thus began a period of the gradual, piecemeal subdivision of individual farms into residential blocks and the subsequent annexation of groups of these blocks into the city—within an expanding infrastructure of roads and services placed on the alignment of the colonial grid—that extended right up to 1950.

The inability of the colonial grid to cope with the irregularities of landscape meant that the emerging residential city was unable to engage— and, indeed, eventually turned its back on—the natural contours and physical "irregularities" of the town's site. Residential neighbourhoods were typically located on the flatter tablelands between the valleys and were created by re-subdividing (hence the word "subdivision" that continues to be used in Ontario to define any new extension to a city) the pre-existing park or farm lots. In the process, many primary and secondary natural features that bordered or crossed these tablelands—streams, woodlots, and hills—were initially avoided but subsequently filled in or otherwise obliterated to accommodate the expanding street grid. This began with many of the creeks and streams that flowed south from the Iroquois Shoreline (the ridge that crosses the city north of Bloor Street and roughly parallel to Davenport Road and Summerhill Avenue). These are the "lost rivers"—Garrison and Taddle creeks and others— that contemporary communities argue need to be rediscovered, uncovered, and restored to their original condition. This constructed erosion of the original landscape was soon extended to larger features such as the Ashbridges Marsh, which up to 1919 was one of the largest freshwater marshes on the

Great Lakes. The marsh was seen as useless and was filled in to create the Portlands.

My own neighbourhood—Summerhill Gardens, which was developed in the 1920s—backs onto the Vale of Avoca, one of the most dramatic ravines south of the Oak Ridges Moraine. When it still lay outside the city it was developed as the Summer Hill Spring Park and Pleasure Grounds that celebrated its natural beauty. However, the subsequent plans of subdivision that were prepared following its annexation to the city, turned their back on the valley. Today, it remains largely unknown to neighbourhood residents other than the most avid naturalists and adventuresome dog-walkers, and certainly lies outside the everyday life of our community. My wife, who grew up in our home, and her friends played endlessly in the Vale. It has since been occupied by some of the city's marginalized populations, who understand perfectly that the valleys are not public places and, as such, serve as safe havens for their communities. Unfortunately, this means that no one lets their children play in the valleys any longer and they have become even more remote from adjacent neighbourhoods.

Up to 1950, residential development in Toronto proceeded in a fairly haphazard, uncontrolled fashion. The typical block pattern of the nineteenth century was derived entirely from the original agricultural pattern. Maps of this period show the city to be composed of a mixture of farms, country estates, and a combination of urban and rural subdivisions, much like contemporary sprawl.

As the places people lived became ever-further removed from the surrounding landscape, other kinds of uses began to be considered for these open spaces. For a very short period, parts of it were viewed as potential

greenspace. Indeed, in 1852, the city fathers sponsored a competition to develop a continuous waterfront park right across the entire city. But industrial and commercial interests had already taken hold. Less than a year later, the idea of a waterfront park had been abandoned in favour of a new waterfront rail corridor that would serve the new industries that were already being erected in front of the city's original lakeshore. It is from this point that the lake began to be isolated from the city. The idea that Toronto even had a waterfront was buried until the late twentieth century and we are only now beginning to rediscover it.

New railways entering the city in a north-south direction were placed wherever possible in river valleys. Water supply and sewerage systems were also located there so that they could take advantage of natural topography to improve flows. As a result, new industries sprang up either within or along the valley edges as well as along the new waterfront railway, further isolating these extraordinary landscapes from the city's residential communities. This transformation of the natural to an industrial or utilitarian landscape had a widespread physical—and psychological—impact on the city, forcing it to re-examine and ultimately reject the importance of beauty in our surroundings. For a short period, it was considered possible to introduce large-scale infra-structure set hard against the waterfront or the valleys that could still be beautiful. Extraordinary examples of this sentiment are structures such as the Rosehill Reservoir, the Prince Edward Viaduct, the R. C. Harris Water Filtration Plant, and Union Station. But these infrastructures soon overpowered nature and any sense of a positive municipal relationship between the two was lost—as was the public's relationship with the extraordinary landscapes all around us.

There were counter-trends to the prevailing anti-nature tendencies of the city's development. It's worth remembering that during the late eighteenth and early nineteenth centuries, the idea of landscape in Britain was undergoing enormous change as well. Landscape architects like Humphrey Repton and Capability Brown and painters such as Constable and Turner sought to restore the idea of the pastoral English landscape obliterated under the Acts of Enclosure. Indeed, this flight from urban life had its origins in Toronto at the town's very beginning, with the lieutenant-governor's wife. Elizabeth Simcoe fled her husband's capital in search of the ideal landscape and built Castle Frank, overlooking the Don Valley. This was followed by the creation of a series of new estates by various members of the city's aristocracy that initially occupied some of the park lots but soon spread up onto the Iroquois Shoreline, overlooking the city. The ultimate expression of this search for nature was in the plan for Rosedale, which was the first developed area in the region to divorce itself almost entirely from the grid and follow the natural topography.

By the end of the nineteenth century, wealthy Torontonians had begun to leave the city altogether in search of the relationship with landscape that they had lost inside it. They purchased their own lakes or pieces of waterfront property on Lake Simcoe or in the Muskokas and were pleased to commute to it. Today, Toronto has one of the highest percentages of second-home owners in North America—a phenomenon that spreads across all income groups and one that has further aggravated our alienation from our own urban landscape. Increasingly, the city became simply a place to work. In other words, it became exactly what its founders and original planners had hoped: a successful colony.

Little attention was paid to public space and public institutions within the colonial city. Primary public space was linked with institutions, and buildings

like the Grange and "old" City Hall typically faced the lake down long avenues such as John Street and Bay Street. This pattern became more difficult to repeat as the city grew further back from the lake, with the result that the creation of meaningful public space became more haphazard. An interesting attempt was made in 1909 to address this deficiency with the Toronto Guild of Civic Art's publication of its *Report on a Comprehensive Plan for Systematic Improvements in Toronto*.

THE NATURE OF TORONTO changed dramatically in 1943 with the publication of a new master plan for the Toronto Metropolitan Area. This plan proposed the introduction of major "residential redevelopment areas" within the existing city. It also suggested that the pre-existing city should be surrounded by seven new "satellite towns," each accommodating 30,000–40,000 residents and each served by its own industrial area. The towns were shown as being located on the tablelands and new industrial parks were located along the river valleys. These in turn were proposed to be separated from the colonial city by an "inner Green Belt" that would be formed by combining the city's existing valleys with "parkways" located within them. The greenbelts were to include the Humber and Don rivers and their tributaries, connecting at their respective headwaters near present-day Downsview Park. Finally, the plan illustrated a new network of "superhighways" that would create a ring around the city, linked by a number of north-south and east-west crosstown "expressways."

Ironically, like the plans for the colonial city before it, the 1943 Metropolitan Toronto plan was largely derived from urban models outside

the country. For example, the idea of separate towns of no more than 40,000 persons where residents could both live and work, surrounded by open space, was derived from Ebenezer Howard's notion of the "garden city" that he had introduced in Britain at the turn of the century.[2] The plan also drew on the ideas of "green towns" that were planned and built under Rexford Guy Tugwell's Resettlement Administration to relocate poor, inner-city families outside American cities as part of President Franklin Roosevelt's New Deal.

The 1943 plan had a profound influence on Toronto and completely redefined its relationship with nature and the former colonial city. It also led to the formation of the Municipality of Metropolitan Toronto, comprising the pre-existing city plus four new boroughs that corresponded roughly with the proposed satellite towns—Etobicoke, East York, North York, and Scarborough. The plan resulted in the introduction of the first Regent Park Redevelopment Project—the first example of high-density, urban renewal in the city—and led to the planning, design, and construction of a major loop road around the city formed by Highway 401 in the north, Highway 27 in the west, the Gardiner Expressway in the south, and the Don Valley Parkway[3] in the east. The plan also tabled a series of new expressways that included the Black Creek Parkway (since built); the Spadina Expressway; the Eglinton Expressway; and the

2 Inspired by the Utopian novel *Looking Backward*, Howard published *To-morrow: a Peaceful Path to Real Reform* in 1898 (reissued in 1902 as *Garden Cities of To-morrow*), organized the Garden City Association in 1899, and founded two cities in England: Letchworth Garden City in 1903, and Welwyn Garden City in 1920.

3 A combination of superhighway and greenbelt was proposed for the Don Valley.

IF I LOOK INTO THE FUTURE from my historic vantage point at Bayview and Front, I can imagine that where I am standing will soon be at the centre of an extensive new park leading down to the banks of the Don River, on the edge of a major new residential community lying between the park and the central city. I see myself standing in the middle of a large meadow and as I turn 360 degrees, the new panorama unfolds. There is a marsh to the north-east, with red-wing blackbirds flocking around it. There are low hills, with paths and gardens between them, leading up to an outlook. There is an urban prairie stretching down to the edge of the Don River, a broad trail running beside it, and a line of lattice-work hydro towers stretching to the east. I can see the broadening mouth of the re-naturalized Don River, full of cattails and stretching out under the Don Valley Sweep. There is a playground across the meadow, beside a modernist pavilion and change rooms. Rising in the distance is a new mid-rise urban neighbourhood, with shops on the ground floor and taller housing beyond. There is a broad avenue with a central planted boulevard leading back into the downtown, and through the trees I can see the city beyond. There is something truly revolutionary in this view—revolutionary for Toronto: the distinction between city and its landscape is blurred.

Toronto is in the process of completely redefining its relationship with nature. The work currently underway at the mouth of the Don River and the re-establishment of the waterfront as a major public space are perhaps the most significant indications of this. At the same time, there is renewed interest in "daylighting," or re-exposing, valleys and water courses such as Garrison and Tattle creeks that were literally buried in the nineteenth century. At a more pervasive level, there is the increasing fascination with the "denaturalization" of landscapes such as at High Park that were destroyed or overrun by so-called

invasive species. There is not a major garden shop that does not now stack plants and trees and shrubs that originally grew wild here but were annihilated or displaced. The new Toronto Botanical Centre and the new Humber Arboretum are signs that there is a reimagination underway that will likely begin to manifest itself in large as well as small ways. This could involve the reinvention of imagined landscapes lost—as occurred in Europe in the nineteenth century.

Our residential neighbourhoods are changing radically. New neighbourhoods in the outer city are being planned and designed to emulate the compact, nineteenth-century housing estates found in the inner city, while the high-density apartment forms originally introduced in the outer city are now being introduced in the inner.

This new evolving pattern amounts to a complete redefinition of public space and public institutions. Major regional parks are either being planned or are already under construction, including Lake Ontario Park, Don River Park, and Parc Downsview Park. A series of significant new public spaces are also being created, such as Dundas Square, the new City Hall Plaza, and a number of new pocket parks and promenades along the waterfront. These in turn are being complemented by major new streets that reintroduce nature in the city and seek to rebalance pedestrian bicycle and automobile movement— St. George Street, through the University of Toronto campus; Bloor Street (from Church Street to Avenue Road); and the emerging Queen's Quay.

On the institutional side, many of the city's traditional cultural institutions are being completely and radically reinvented and rebuilt—including the Royal Ontario Museum, the Art Gallery of Ontario, the Royal Conservatory of Music, the National Ballet, and the Ontario College of Art & Design. At

DAVID
KAUFMAN

IN HIS 1932 PAMPHLET ENTITLED "The Disappearing City" and in subsequent writings, Frank Lloyd Wright proposed the creation of a utopian social environment that was neither urban nor rural, but a sprawling settlement of one-acre plots inhabited by families self-sufficient as farmers and artisans and bound together by, of all things, the growing ownership of private automobiles and trucks. It is easy to imagine that this vision arose out of a sense of revulsion for the increasing concentration of humanity in the world's major cities, often in conditions of intense poverty, coupled with a romanticism about the wide-open American landscape and its potential for purifying its citizenry. "The Disappearing City" attempted to proscribe urban overcrowding by advocating a return to a form of village life, not suburbia as we came to know it.

In 2006, when I decided to name an exhibition of my photographs "The Disappearing City," I was not aware of Wright's pamphlet or its subject matter, and yet I feel today that I was looking at the city through the opposite end of the same temporal telescope. Many of the great urban areas of the developing world and some of the developed world are, as Wright described Depression-era American cities, ugly, congested, polluted, and economically mismanaged. Even in North America and Europe, where immense strides have been made to eradicate the grinding poverty of a century ago, we have what Wright called "the inhuman vertical city," in which urban densification is driven by a complex interaction between residential and commercial development, the eternal desire of urban dwellers to find and afford safe, clean habitation close to city centres, and the fallout from over-reliance on the automobile and underdevelopment of public transit, especially in North America.

There are two large-scale processes at work that define the structure and visual appearance of a city like Toronto, which is absorbing annually tens of thousands of new residents, many of them immigrants. One is the continuing growth of the suburbs, albeit with slightly increasing density, which are now beginning to merge with Toronto's exurbias (which resemble Wright's vision of the urban future). Second is the suburbanization of urban life in many parts

FACING PAGE: FRUIT AND VEGETABLE STORE, GERRARD ST. EAST NEAR BROADVIEW, JUNE 2003

THE DISAPPEARING CITY

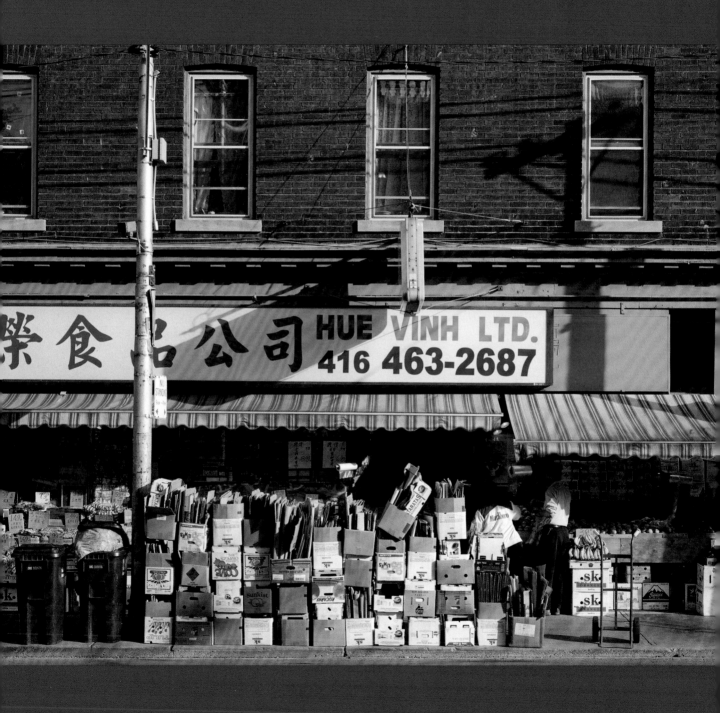

of the city proper. The hallmark of this suburbanization is the disappearance of mixed-use areas of the city, which were the economic foundation and social skeleton of urban neighbourhoods. The defining characteristic of the suburb is not a particular form of residential housing but homogeneity, and without the mixed-use environments that characterized our cities for much of the twentieth century, the urban neighbourhood as we knew it is an endangered species.

I grew up in Montreal in the 1950s and 60s, in Ville St. Laurent, an old French-Canadian, slightly suburban district, and attended school in Outremont, an established central French and immigrant part of the city. As a teenager, I loved roaming around downtown, and during my last year at McGill University I lived just off St. Catherine Street. When I began the serious pursuit of architectural photography in 1984, though living in Toronto, I returned repeatedly to Montreal to try to capture those parts of that wonderful city that were old when I was young (not unlike Atget roaming around Paris before World War I). I have tried to do the same in Toronto where, unfortunately, the stock of older buildings was much smaller to begin with and has diminished even more rapidly.

The parts of cities that I invariably find interesting are the parts that remind us that cities were once composed of neighbourhoods that offered the full possibility of human life—work, commerce, worship, recreation, entertainment, and even debauchery—all within walking distance of your home. Small industrial and manufacturing plants, local businesses, a variety of housing, movie theatres, restaurants, real service stations, bars, corner stores, churches, and schools—these were the infrastructure of a neighbourhood. In the invitation to my exhibition I described that neighbourhood's streetscape in this way:

Scenes reclaimed from a mid-century urban childhood: the weathered doors and sagging stoops of ancient storefronts, the maze of gleaming silver of street-corner industrial plants, the chiaroscuro of late afternoon sun

raking across the facades of factories, the infinite, heart-breaking beauty of time-worn brick, the shadows cast by looming octopus-armed electric standards.

Those streetscapes are almost all gone; those that survive are usually found in the poorest sections of the city. If it wasn't for condo-ization, there would be no factory structures left within the city core. With the disappearance of complex local mini-economies within the urban environment, often all that remains of the neighbourhood fabric is the local school. New districts that are springing up on Toronto's downtown "brownlands" are vast aggregates of condominium towers and stacked townhouses, urban in density but suburban in character because of their numbing homogeneity, evoking the lines of Malvina Reynolds's famous 1962 song, which was a critique of the conformity of suburban life: "Little boxes on the hillside, little boxes made of ticky-tacky . . . a green one and a pink one, and a blue one and a yellow one . . . and they all look just the same." And everywhere the pervasiveness of multinational corporations; unlike the English "local," there is nothing local about your local Starbucks or Burger King. A brand is not a place, and how will neighbourhoods grow in new urban areas where people have no economic or social ties?

These photographs, then, are a plea for preservation, not just of buildings that merit a heritage designation, but also of structures that have no particular economic or aesthetic value but contribute to the quality and variety of streetscapes. We need to think small, even in the downtown parts of the city. We need to resist the intense economic pressure for densification that results in thirty-storey condominium towers that pack more and more people into smaller and smaller spaces. All these things are connected. As a photographer concerned about architectural history, facing the explosion of the new in Toronto and growing visual sameness, I feel there is less and less to photograph. This is a loss not just for me, but for all the residents of this city as they speed toward an anonymous future in which little remains of our material past.

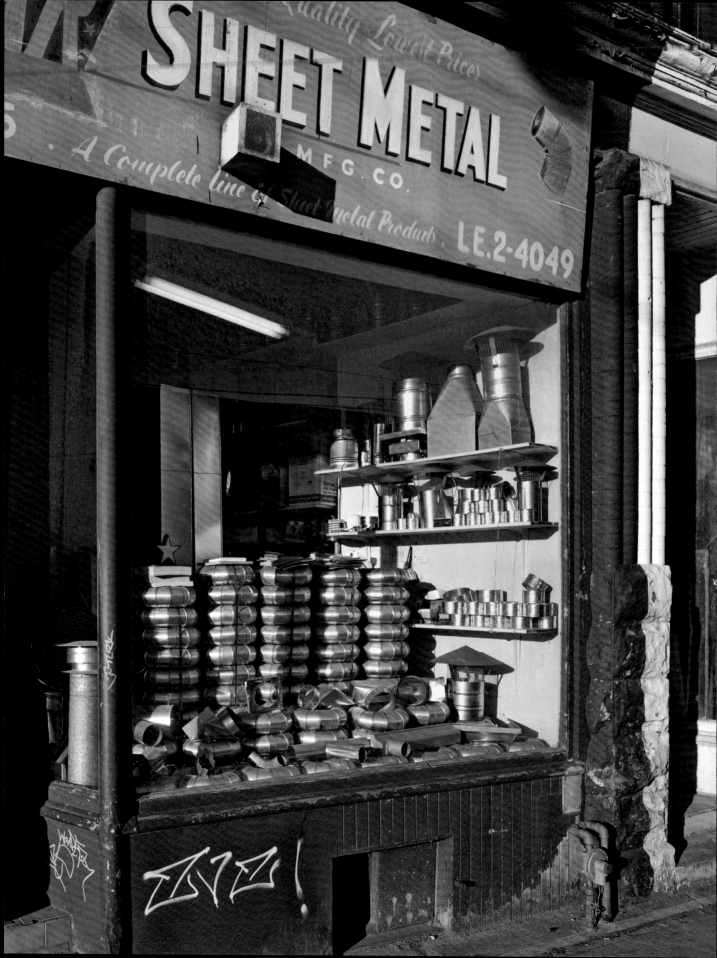

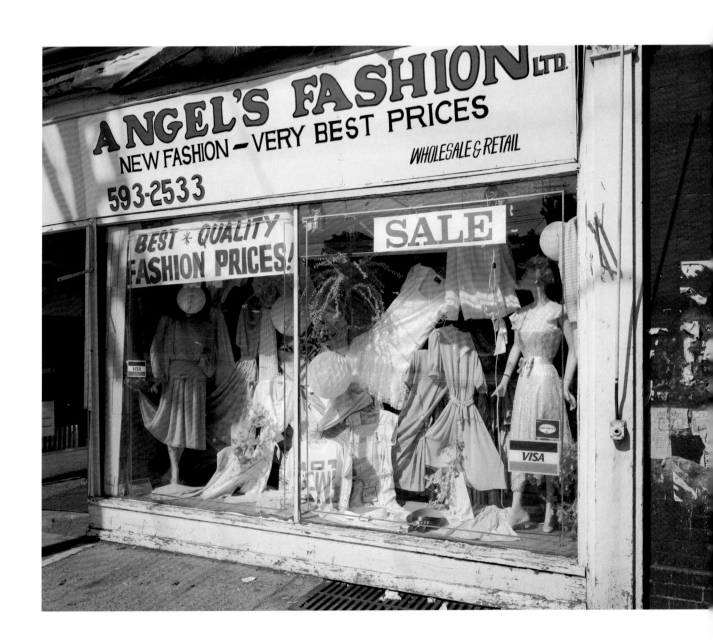

TOP: ANGEL'S FASHION, SPADINA AVE., JULY 1985

FACING PAGE: STAR SHEET METAL, DUNDAS ST. WEST, JUNE 2004

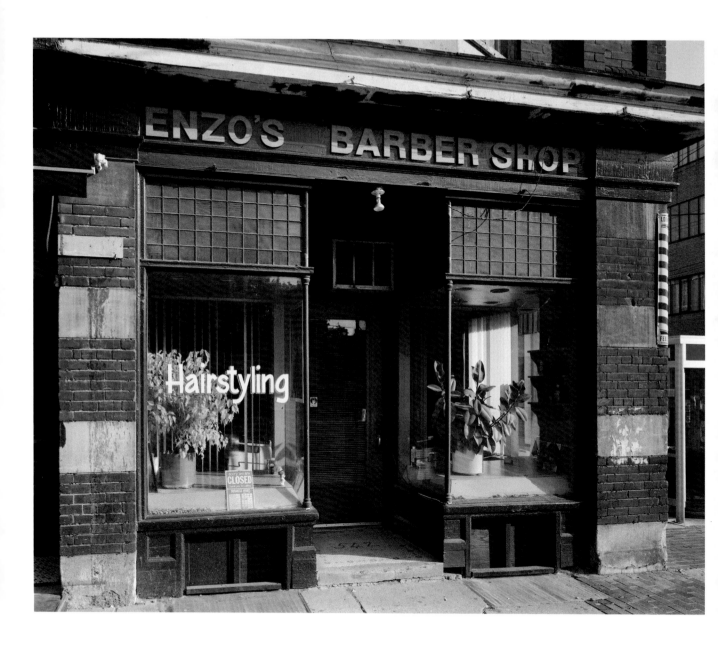

TOP: ENZO'S BARBER SHOP, COLLEGE ST. AT EUCLID, SEPTEMBER 1996

FACING PAGE: CANARY RESTAURANT, FRONT ST. EAST AT CHERRY, JUNE 1990

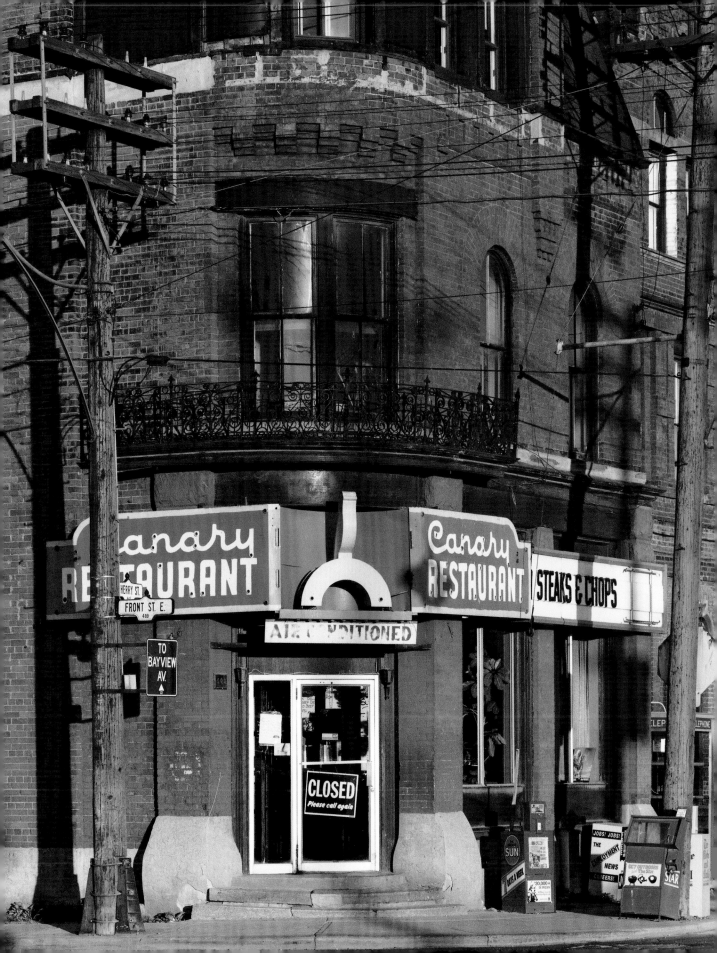

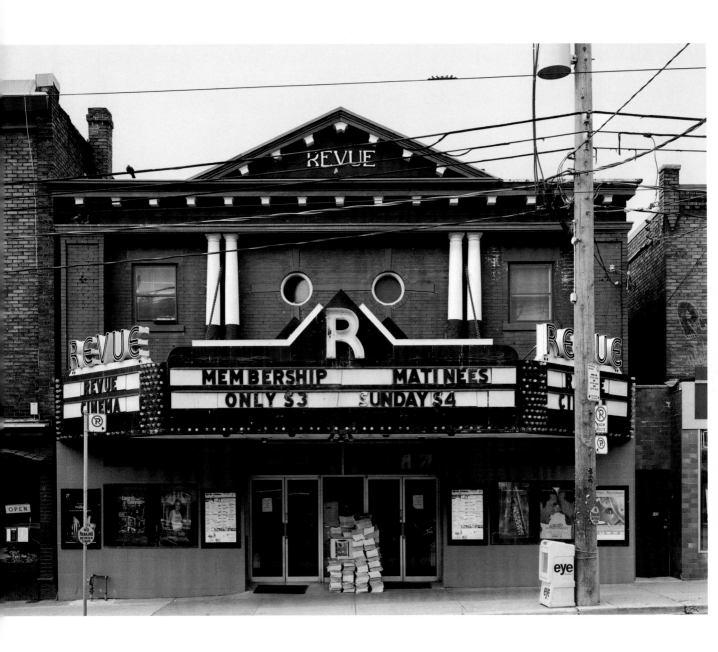

REVUE THEATRE, RONCESVALLES AVE., JUNE 2003

1581 DUNDAS ST. WEST, JUNE 2004

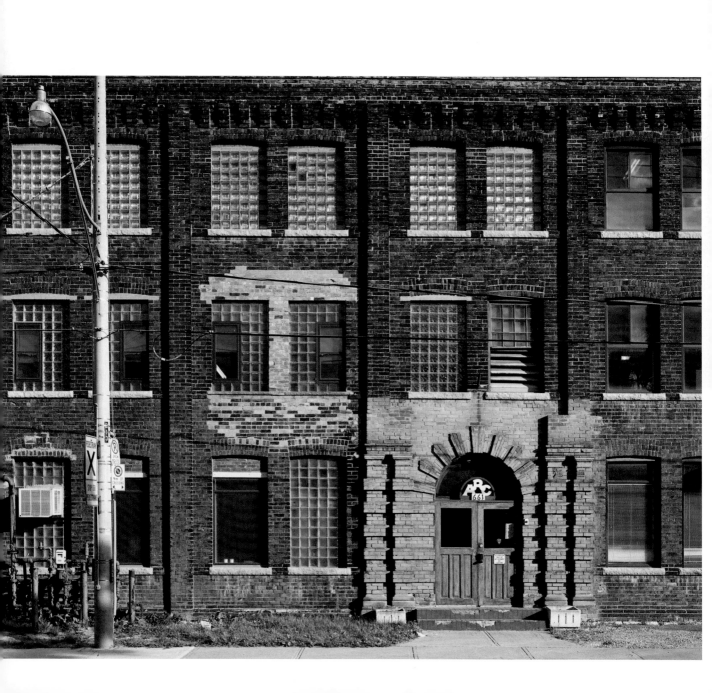

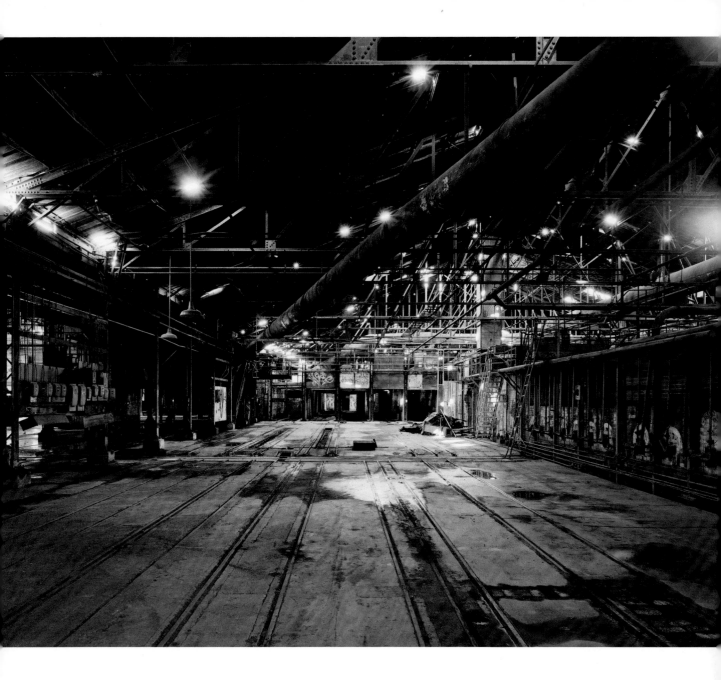

TOP: DON VALLEY BRICK WORKS, DECEMBER 2003

FACING PAGE: A.R.C. INDUSTRIES, 661 EASTERN AVENUE, JULY 2000

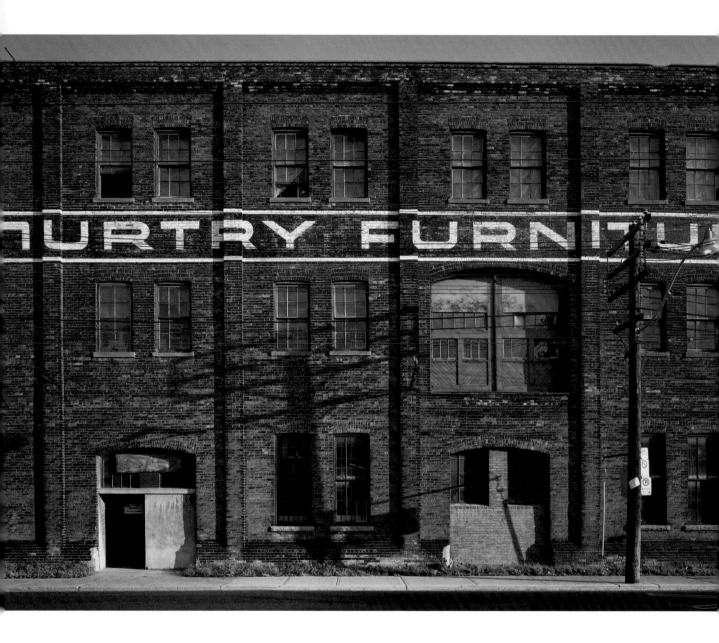

MCMURTRY FURNITURE FACTORY, AUGUST 1996

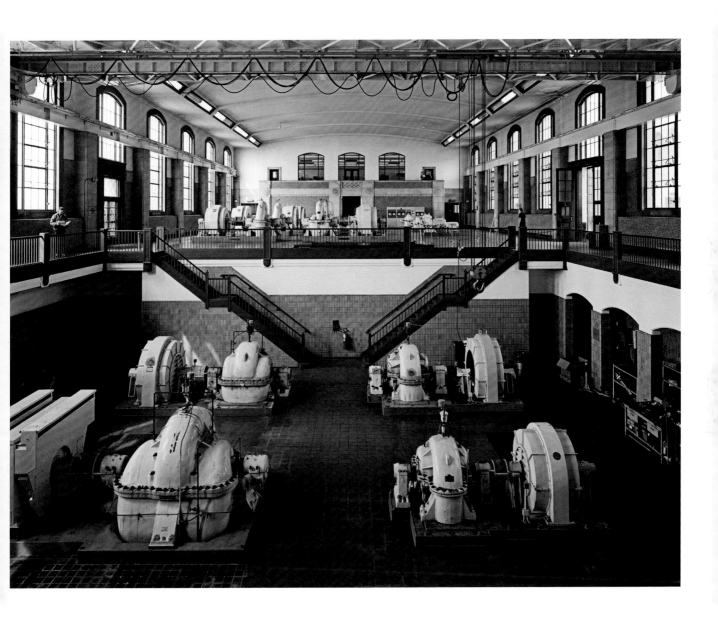

R.C. HARRIS FILTRATION PLANT, PUMPING STATION, MAY 2001

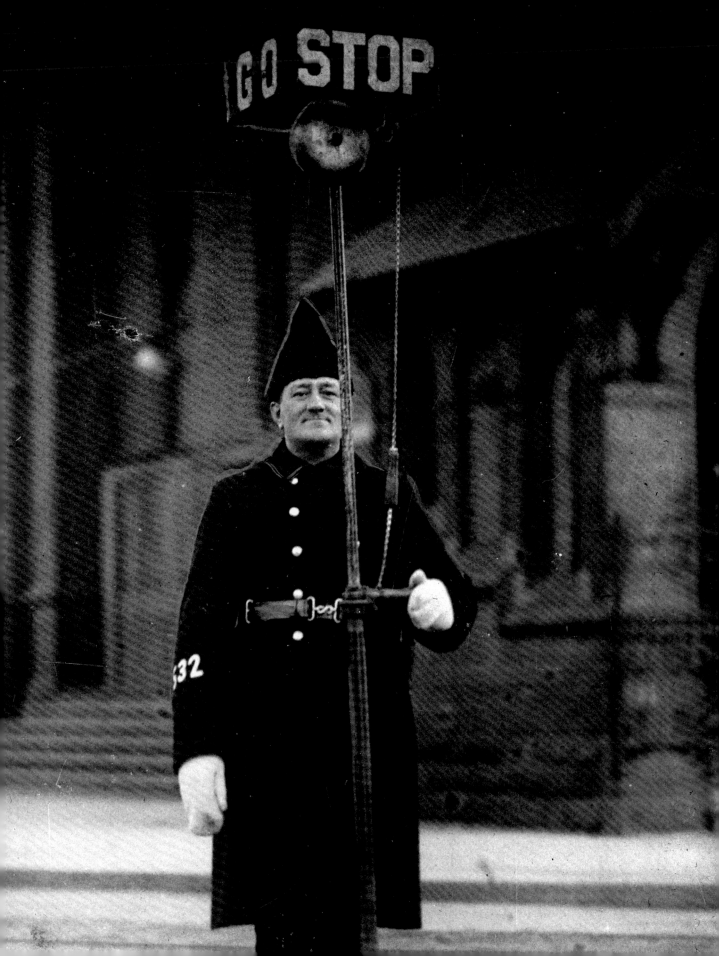

TORONTO,
THE OUTLAW
TABATHA SOUTHEY

TORONTO HAS ALWAYS HAD A WELL-ORDERED
CITIZENRY—FAMOUS FOR WAITING AT RED LIGHTS WHEN
THE NEAREST CAR IS TWO BLOCKS AWAY. HOWEVER,
HUMOUR WRITER TABATHA SOUTHEY HAS PROOF THAT
THE CITY'S ACQUIESCENCE TO AUTHORITY MAY BE
COMING TO AN END. WILL CHAOS REIGN?

BRIGHT LIGHTS, BIG FUTURE
RICHARD FLORIDA

"THERE ARE ONLY A HANDFUL OF CITY-REGIONS IN THE WORLD THAT SIT ON THE FRONT BURNER OF WHAT I'VE CALLED THE RISE OF THE CREATIVE CLASS," WRITES THE CELEBRATED URBAN GURU RICHARD FLORIDA. "TORONTO IS ONE OF THEM."

I'M A HUGE FAN OF TORONTO. To me it is the quintessential city. It's not as big as New York or London, but it has as much or more diversity as either of them. And to its credit, it has not become completely gentrified and yuppified. It may be cliché to say that Toronto is a city of neighbourhoods, but it is one of very few great world cities that really does still have neighbourhoods, where people of different classes and ethnicities can mix and mingle, and where neighbourhood shopping districts are not overwhelmed by chains.

Like many cities at the cutting edge of this global economy, Toronto is going through some massive and far-reaching changes. Today, economic value is driven by our knowledge, synthesis, and creativity rather than manufacturing—our cities reflect this as they stumble, or adjust, or take advantage of the shift from an industrial to a creative economy. What's more, this change is essentially urban in nature. But what makes Toronto so transformative and exciting is that it is uniquely situated—geographically and socially—to take advantage of the global transformation to a creative economy.

There are only a handful of city-regions in the world that sit on the front burner of what I've called the rise of the creative class. Toronto is one of them. Whether it acknowledges this extremely advantageous position and works toward fulfilling this potential, or whether it clings to outdated notions of itself and retreats to the status of an unremarkable mid-level North American city is the question of the moment. And it's a big question—perhaps the biggest Toronto has ever faced. This is a pivotal moment in Toronto's history: does it move forward or stand still?

The creative class makes up 36 per cent of its workforce—of North America's ten most populous cities, only Boston, San Francisco, and Washington,

DC, do better. Toronto ranks second in the *world*, behind only New York City, on Lisa Benton-Short's "mosaic index"—a measure of a region's foreign-born population, not just the raw numbers but how diverse that population is, how many different parts of the world are represented in its mosaic. It also happens to be a crucial indicator of a region's openness to new ideas, to new people, and, therefore, to economic growth.

Toronto is the centre of one of North America and the world's largest mega-regions. Again, not quite as big as the one that stretches from Boston to Washington, or that which connects Chicago and Pittsburgh, or greater London or Tokyo, but among one of the world's ten largest. Toronto's mega-region has a gravitational pull that reaches from Ottawa to Buffalo. It has an incredibly skilled workforce and immediate access to a market that is enormous. It's close to the United States—as close as a region can be without actually being in the United States—and this combination of proximity and distance is one of its greatest advantages.

Many Torontonians don't think of their city's relationship with its region this way. Historically, Torontonians have demonstrated a kind of civic modesty that, while not entirely unattractive, sometimes works against them. Many Torontonians think of what exists beyond their municipal borders as a kind of disparate catch-all of economic and social interests. I expect that many Torontonians will be surprised to hear that, in my view, they sit at the heart of one of the most promising mega-regions in the world.

Torontonians may also be just as surprised by what, to an outsider, seems a truly remarkable strength: the city's deeply engrained sense of economic and social fairness. Perhaps an American is particularly sensitive to this quality, as it is a characteristic that is often absent in the cities and

potential they present. To put it simply, Toronto is not set in its ways enough to imagine that there is any good reason to struggle against what is very clearly becoming the prevailing current. This is only an attitude, I realize—but it is an attitude that represents a very clear competitive edge. Whether Toronto has the wisdom to capitalize on these advantages is what those of us who watch it with interest from a distance are very eager to find out.

It's difficult to overstate how profound the economic, social, and technological changes are that we are living through. The dislocations caused by—and hopefully solved by—the emergence of the global creative economy are going to be horrendous. Those regions that successfully manage those dislocations will thrive—it's as simple as that. Thanks to its unique geographic location, its incredibly skilled and diverse workforce, its love of neighbour-hoods and true quality-of-place, its abiding sense of fairness and equity, and its globally minded outlook, Toronto is set to become a model of sustainable creativity that the world will one day emulate, where the further development of the economy turns on the further and fuller development of the creative abilities, self-expression, and talent of each and every single person.

ALL SHOW
MARK KINGWELL

IS TORONTO DAZZLED BY THE EXCITEMENT OF THE CREATIVE CITY AND AN IDEA-BASED ECONOMY? OR BLINDED BY IT? MARK KINGWELL WONDERS WHETHER THE TIME HAS COME TO ASK THE MOST IMPORTANT QUESTION A CITY CAN ASK ITSELF: WHAT IS TORONTO'S IDEA OF JUSTICE?

W<small>E ALWAYS ENTERED</small> the *Globe and Mail* building on Front Street by the back door, through the elevated parking lot, walking up the car ramp from Wellington Street. Using the back ramp was a sign of belonging; the front doors, with their heavy festooning of Art Deco ornament, were for official visitors and other outsiders. Richard Needham, the legendary columnist who looked like a proto-grunge street person with his baggy dungarees and woodsman's shirts, descended the ramp every noontime, smoking greedily, having filed his day's quota of diary entries and caustic replies to readers' letters. "There goes a living legend," the city editor said to me one day. Barely living, I thought.

Inside the chaotic newsroom, not yet colonized by cubicles but instead a press of second-hand desks, we shared the boxy computer terminals because there weren't enough of them. We took rewrite by cradling the rotary phone's heavy-spined handset on the shoulder. We would loiter outside in the parking lot, or on the ramp itself, to smoke or swap gossip. It was there that a colleague writer told me that he had just received a six-figure advance for a book about a retail chain—something in those days I found hard to credit, almost mythological.

The ramp was the portal to a parallel universe, or at least to the underbelly of the one I usually occupied. Each morning I walked into a city of injustice, crime, death, and optimism. I worked at the *Globe* for five years during the 1980s, alternating with terms at graduate school in Britain and the US, and had the raw experiences every general-assignment city-desk reporter does. It was always a shock to take up the job again after months of just sitting around and reading.

I saw my first dead body, a woman incinerated by a gas explosion. I walked up to male prostitutes on Church Street, fence-jumping Jamaican cricketers on the UCC grounds, gypsy fortune tellers on the streets of Yorkville, and illegal drag racers on the long deserted lanes of industrial-park Markham and asked them to tell me their stories. I called a grumpy staff sergeant at 52 Division every night for two weeks, trying to get him to tell me something I could print. I was threatened, in person and over the phone. I got kicked out of a corrupt landlord's office in Regent Park. I did title searches in City Hall to find out who owned what. I sat in the harbourmaster's office when it still had a view of the harbour and no steakhouse on the ground floor. I admired his Italian suit and bland charm.

I listened to a lot of politicians and lawyers lie. I talked to athletes, actors, cops, firefighters, burglars, junkies, and a guy who walked into the newsroom one day and claimed to have built the bridge on the River Kwai. I missed the key line at a coroner's inquest—a young girl, describing the accident that claimed her sister's life, said "I felt myself drowning"—because I was distracted by a pretty reporter from another paper. I sat in the small bedroom of a man in Mississauga with my shoes off and my notepad out. His wife, daughter, two sons, and mother-in-law had all just died in the Air India explosion. I had knocked on his door and been admitted like an honoured guest instead of the intruder I was. He handed me photos of the family. "My whole world goes dark," he said.

City-desk reporting, at least in its ideal romantic form, is a kind of *flânerie*. Unlike their investigative colleagues, city reporters aspire to the status of purposeless walker and connoisseur of the city's sights, smells, tastes and textures. In the newspaper business this is still called news gathering, it more often feels like loitering with intent.

The great forebears of the city man are Addison and Johnson, even Hemingway, not Woodward and Bernstein. This idealized city man floats through the streets with nothing but a notepad and his curiosity, taking down dialogue, overhearing gossip, noticing details. Like the *flâneur*, he makes his aimless desire a project—his very aimlessness providing the only necessary aim. A better scene, a bigger story lies ever around the next corner, and the next. I was twenty-two years old and I had a business card and a laminated police ID that both said I was a newspaperman. I walked around my city with a new freedom and keenness. I saw it as grittier, uglier, and tougher than before—"before" being my confinement to that misleadingly porous enclave of self-absorption we call the university.

In truth, I was on specific assignments most of the time, and we drove more often than we walked. As well, *flânerie*'s devotion to the "totalizing male gaze," was already unpopular in the politically correct 1980s. Still, the notion of *flânerie* retains an important truth: we are all *flâneurs*. Each one of us must negotiate the streets of our city, mean or otherwise, every day. And what is revealed by this is that the hardbitten corners are no more real than the clean and civil ones—but also no less. Toronto, like all cities, exists in more than one way at a time; it is many places at once. Its architecture and plan make this obvious over and over. Consider the mundane gift, rare in many North American cities, of heading for no fixed indoors by night to the middle of town, traffic and commerce flowing around and through it. Even at the time of my city-man adventures, switching off bouts of study with days of bylines and interviews, I could not decide which site felt more natural.

I was studying theories of justice for half the year, wading through the muddy shallows of a great but unjust city the other half, and one side always

called back to the other, making claims of greater reality. The passing years have found me returned to what people consider a cloister, but which is better seen as an incubator of ideas. The value of the urban university is undiminished because, among many other things, it keeps asking us to define and refine what we mean by a just city.

What is our idea of justice? The hucksters and tourism shills tell us that Toronto is an intellectual city, a city of ideas. Even as I write, its expansive creative class is busy racking up the social capital we're told is essential to postmodern civic success. In one sense this is hardly news. The year I arrived at the University of Toronto, 1980, Marshall McLuhan died. His influence was so pervasive that his physical existence had been rendered almost superfluous, a development he would have appreciated. Harold Innis, less well known but arguably more brilliant, had tracked the change, already well under way, of Canada as a resource basket into a linked series of communications nodes, held together by thought. Northrop Frye was still lecturing and would last another decade. Allan Bloom had lately tested out his Straussian esotericism at Sidney Smith Hall. All of them had long since put Toronto on any map of ideas worth consulting, long before newsmagazine polls and website ratings. None of us who studied here, living in big shared houses in Kensington or the then mostly ungentrified Annex, had any doubt about that.

That fact has not changed. But the economic and social conditions of ideas have changed, here as much as elsewhere, putting the city on the brink of a certain kind of identity, and a certain kind of success: a creative-class boom-town. My suggestion is that we are thinking about this possibility in exactly the wrong way. The question for Toronto now is not whether ideas can flourish in this place, because demonstrably they do, but what consequences *in justice*

that flourishing will entail. On the edge of new identities and possibilities, what is our idea of justice?

MOST RECENT DISCUSSION of "idea cities" has betrayed a strange lack of political awareness. The talk has largely revolved around first the fact and then the consequences of what Richard Florida breathlessly called "the Big Morph." In *The Rise of the Creative Class* (2002), his oddly hucksterish work of bestselling urban geography, Florida noted not just that a city's economic success could be accurately correlated with its "Bohemian Index": the number of "writers, designers, musicians, actors and directors, painters and sculptors, photographers and dancers" to be found in the urban population. He also argued that this group was increasingly indistinguishable from the business leaders and entrepreneurs that a pre-postmodern picture would have seen as the creatives' natural opponents. Instead of opposing, they were blending. "Highbrow and lowbrow, alternative and mainstream, work and play, CEO and hipster are all morphing together today," he wrote. "At the heart of the Big Morph is a new resolution of the centuries-old tension between two value systems: the Protestant work ethic and the bohemian ethic."

The point had already been illustrated at length by the journalist David Brooks in his sometimes wry work of amateur social theory (Brooks called it "comic sociology"), *Bobos in Paradise* (2000). The fusion of bourgeois and bohemian—hence the unfortunate *bobo*, deliberately reminiscent of clowns and monkeys—resulted as a natural consequence of the information age, creating a new upper class, to quote the book's subtitle. The postmodern

information economy, which McLuhan (and Innis before him) had so deftly analyzed, has created, for the first time in history, a situation where ideas were as "vital to economic success as natural resources or finance capital." Bobos are the natural aristocrats of an idea-based world. If twenty-first-century Toronto, perhaps Canada *tout court*, was trending away from material resources and toward non-material ones—a think nation, a concept incubator—this was all very good news indeed.

"These bobos define our age," Brooks claimed. "They are the new establishment. Their hybrid culture is the atmosphere we all breathe. Their status codes now govern social life." The images of bobo work and play are now the stock-in-trade, if not mere cliché, of cultural description: SUV-driving, NPR-listening, Adorno-quoting upper middles who live for expensive fair-trade coffee and organic baby arugula, and hang a "Free Tibet" flag over the three-car garage of the house in Berkeley with a three-bridge view. (In Toronto, a lake view, proximity to Starbucks, a radio tuned to the CBC, and access to Cumbrae Farms organic beef.) Such images naturally generate absurdity, especially since cultural habits are always also ethical ones. "The visitor to Fresh Fields is confronted with a big sign that says 'Organic Items today: 130'," Brooks wrote. "This is like a barometer of virtue. If you came in on a day when only 60 items were organic, you'd feel cheated. But when the number hits the three figures, you can walk through the aisles with moral confidence."

Nevertheless, Brooks was even more enthusiastic than Florida about the possibilities of the new reality. The bobos, he suggested, are an "elite based on brainpower" rather than family ties. In an especially hilarious riff, he dismantles the presuppositions of the *New York Times* wedding announcement page,

Fest of the Zenith Real Estate Board, quintessential zippy go-getter G. F. Babbitt notes one of the great prizes of America's dedication to progress. "In other countries," he says, "art and literature are left to a lot of shabby bums living in attics and feeding on booze and spaghetti, but in America the successful writer or picture-painter is indistinguishable from any other decent business man." At the time, this was funny because Babbitt's claim was so preposterous; nowadays, it is merely the sad, mundane truth.

The natural but unfortunate reaction to the collapse of a value distinction is a rearguard action. As fauxhemians move in to gentrify an area, generating Starbucks franchises and Pottery Barn outlets, driving property values up and grotty art galleries down, the "real" bohemians, about to lose their studios, lofts, and self-image, arise in protest. Claims of authenticity are made, ever more emphatically and frantically, in an attempt to ward off the threat by force of magic. Justin Davidson, writing on the blog of *New Yorker* music critic Alex Ross, noted with some dismay the new concert hall planned for Hamburg, Germany, designed by the Swiss firm Herzog & De Meuron, which adds complex billowing glass sails to an existing harbourfront warehouse. This latest example of repurposing of industrial buildings as cultural venues joins the Tate Modern reconstruction in London (also by Herzog & De Meuron) to the creepy extermination-camp vibe of Toronto's own Distillery project. Davidson summed up the central point this way: "I have to admit to some queasiness about the current enthusiasm for fitting out power plants, factories and warehouses as postindustrial pleasure domes. Isn't there something inherently decadent about taking the means of production and transforming [it] into the means of consumption for the bourgeoisie?" These repurposed downtown workhorses, while clearly a good idea in an age of unbridled

sprawl, rubbed the authenticity types the wrong way, stirring a vague unease.

This reaction is of course foredoomed to incoherence, a fact indicated not least by Davidson's use of that telltale nostalgic adjective "decadent." Decadent! In an age that celebrates decadence as its baseline assumption, in this always-already-sold-out culture of ours, this is a charge without purchase, a holdover from a distant age of political belief. Consumption is what is produced by a postindustrial age. In fact, we could go further. We no longer merely produce consumption; in an experiential economy—a post-postindustrial age—the main product is ourselves as *consumers*, under the sign of consumption. And we consume that spectral product even as we produce it, cannibalizing our identities and desires with every entertainment choice or shopping-district purchase. The dynamic may be given a name, a label that philosopher, Paul Virilio, applied to the process by which a sick nation feeds off its own citizens rather than distant peoples: endocolonization.

The simplest reason the bobo reaction cannot succeed, however, is that bohemian authenticity, like coolness more generally, is part of a spectral economy. In Thorstein Veblen's terms, it is a *positional good*; that is, it depends for its value on the ability to differentiate one person from another. Like all positional goods, absent the relevant other person—otherwise known as social context—the good loses value. It is no longer a good. In the case of bohemian authenticity, as with cool, the good itself is not even a thing, so when the context shifts you have nothing at all left except a disgruntled memory. Music that, once cool, is rendered uncool by mainstream success— the ever-familiar cycle—is still music. You can still listen to it, maybe even enjoy it "ironically," possibly phase it back into cool somewhere down the fashion line. But authenticity is nothing without the inauthentic comparator.

predate and outlast you or me. In the built-environment city, inhabited by citizens, space becomes time, and vice versa. The justice of a city can never be confined to the interests of what G. K. Chesterton called the "small and arrogant oligarchy of those who merely happen to be walking about." It is always guided by the oppressions of the past as well as the interests of the future.

Justice is thus the constant pursuit of the possible, the idea of what is to come. It is not a steady state, nor a fixed outcome; still less an institutionalized plan or centrally directed program. The last point merits special emphasis because the idea of a just city is often misunderstood as the vision of a Just City, a City on the Hill. Here, for example, is Kingsley Amis weighing in on the point with typical bullying pseudo-logic. Defending his opposition to communism and decline into conservative complacency, Amis noted that he had "seen how many of the evils of life—failure, loneliness, fear, boredom, inability to communicate—are ineradicable by political means, and that attempts so to eradicate them are disastrous." He continued, "The ideal of the brotherhood of man, the building of the Just City is one that cannot be discarded without lifelong feelings of disappointment and loss. But if we are to live in the real world, discard it we must." The telltale false dichotomy of "real world" and something else—the world of theory, perhaps, or Theory—gives away the fallacy in play. Failure, loneliness, boredom, and the rest may well be ineradicable simply because they are part of the human condition, but political means must be among the ways we address them. I don't say they are the only way, and we can agree that *some* attempts at authoritarian eradication have proven dangerous. But what is equally true, in the one and only world there is, is that all those conditions are, among other things, political. We don't seek a Just City where

they are absent, only a just city where we might, to take one relevant example, cope with boredom by talking about what ails us rather than by shopping.

Contrary to the standard Machiavellian objection, justice of this humane and provisional sort is not antithetical to civic glory. Though a city in pursuit of glory may neglect justice, the opposite does not hold: a truly just city is always a glorious one because it allows greatness even as it looks to the conditions of strangeness posed by the other. It does not oppose development, including grandiose development, for the sake of some cramped sense of its own modesty; but it does demand, over and over, that all development be, at some level, in the service of everyone. Such a city starts with you, on the street, lifting your gaze and looking, for once, into the face of that person passing. This urban gaze is not male, or female; it is not casual or demeaning; it is not totalizing, it is liberating. It is the gaze that recognizes, in the other, a fellow citizen, which is to say one who has vulnerabilities, desires, and ideas just as you do.

These thoughts have been themselves a deliberate exercise in conceptual *flânerie*. Sometimes you have to walk before you can run. Sometimes, too, walking, not getting there, is the real point. We have a choice before us. We can continue to congratulate ourselves on how interesting and vibrant and creative we—some of us—are. Or we can bend some of that intellectual energy to the hard task of asking what we—all of us—could be. Justice in the city, like consciousness in the self, is an emergent property of complexity. As with the elusive object of the *flâneur's* desire, it is always slipping around the next corner. Toronto, like any potentially great city, is always on the verge of it. That's why we keep walking, looking, glancing, noticing—and talking, to each other, about what matters to us.

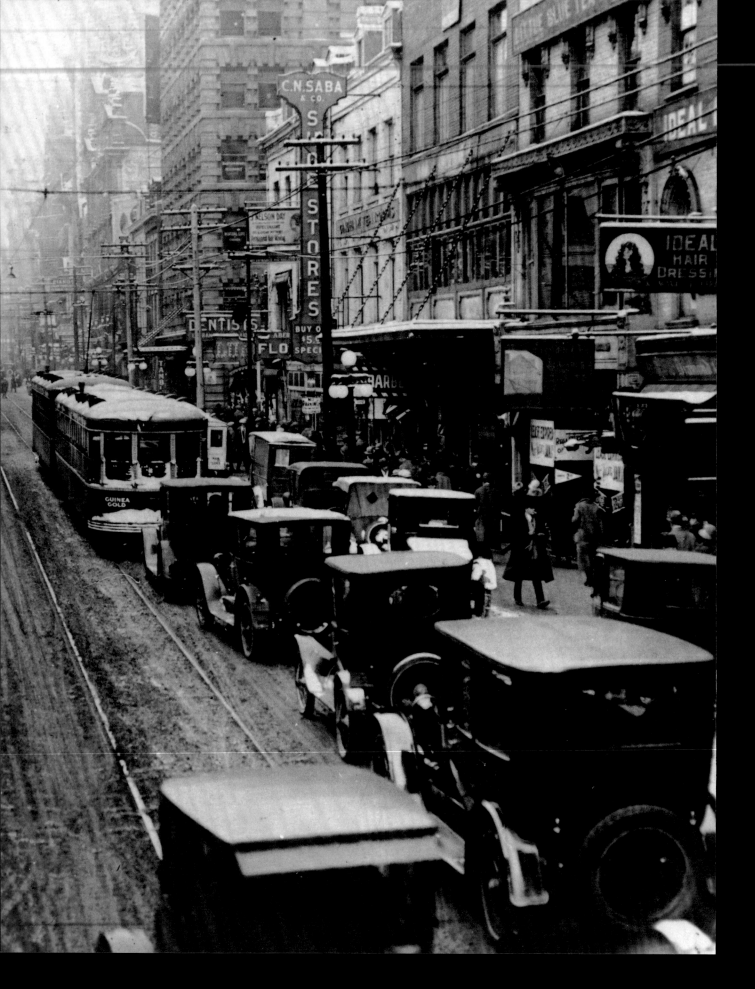

MY KIND OF TOWN
LINDA MCQUAIG

IN THE LATTER HALF OF THE TWENTIETH CENTURY,
TORONTO ASPIRED TO BE A CITY FOR EVERYONE, WITH
WELL-MAINTAINED PARKS, PUBLIC FACILITIES, AND REC-
REATION AREAS. BUT NOW LINDA MCQUAIG WORRIES
THAT TORONTO'S CELEBRATED EGALITARIANISM IS
GIVING WAY TO EVER-INCREASING DOMINATION
BY THE WEALTHY

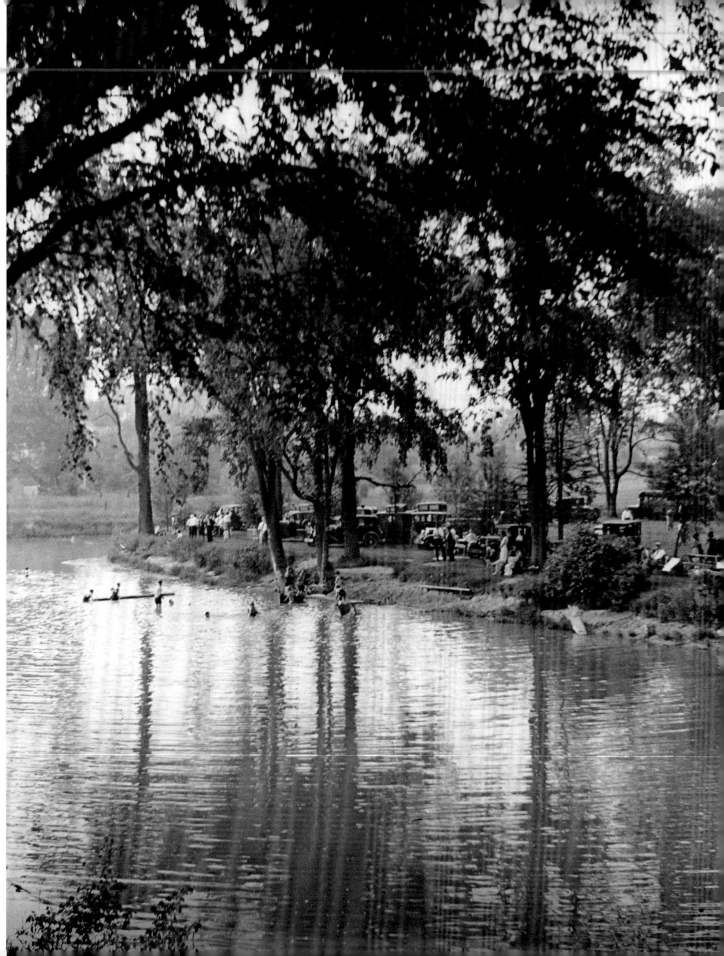

TURNING GREEN
PETER TABUNS

TORONTO, LIKE MANY CITIES IN THE WORLD,
STANDS AT AN ENVIRONMENTAL CROSSROADS. HOW-
EVER, AS A MEMBER OF THE PROVINCIAL PARLIAMENT
PETER TABUNS KNOWS ONLY TOO WELL, THE POTENTIAL
FOR WRONG TURNS AND THE TEMPTATION TO TAKE
THEM ARE VERY REAL.

STANDING ON THE LESLIE STREET SPIT looking northwest into downtown, all Toronto's promise and its potential downfall are visible in one sweeping survey of the horizon. Sunlight glints off the bank towers concentrated around Bay and King. In the process of generating an immense amount of economic power for Toronto, each tower consumes approximately the same amount of electricity as a small town. The towers are the destination of thousands of commuters who travel every day along a network of highways that stretches hundreds of kilometres in every direction. This web of roads counts the elevated Gardiner Expressway as one of its primary threads. From the Spit, where a curtain of trees keeps the Gardiner largely hidden from view, you can still hear the muted roar of the relentless current of cars streaming along it.

How Toronto uses energy, manages its water and wastes, and operates its transportation infrastructure can all bolster its future prosperity or undo its clout as an economic, cultural, and political epicentre. Environmental gains would attract, retain, and foster the human and investment capital for such a future. Environmental degradation will undermine the city's prospects.

Right now, Toronto finds itself at a moment at which it can remake itself from a manufactured landscape to an eco-capital. A number of converging crises are giving rise to opportunities to implement the sustainable solutions that have long been studied here and applied elsewhere. Aging infrastructure, continuing population growth, and climate change are challenges that need to be responded to before they reach a tipping point. How they are dealt with can create a new environmental reality for Toronto.

The potential for wrong turns, however, predominantly in the form of repeating past mistakes, looms large, and the impetus to take them is very real. Not just by Toronto, but by the other levels of government whose decisions determine what options are ultimately available to the city. So while Toronto is at an environmental crossroads, the path it finds itself on may not be one of its own choosing.

Toronto is contributing to climate change, but it is also at its receiving end. The city is already moving into a climate zone that is more typical of cities hundreds of kilometres to the south. This change will result in unpredictable elements, but there are some things we can confidently predict: more heat waves and more intense precipitation. Violent storms will pose huge challenges to Toronto's sewer and flood control systems—a downpour in August 2005, for example, literally washed away a section of Finch Avenue West and flooded the Highland Creek Sewage Treatment Plant, damaging 30 per cent of its equipment and operation. Raw sewage spilled into local waterways when its sanitary trunk sewer collapsed. The simple fact is that Toronto was not built for storms such as the ones we are already experiencing.

The need to prepare for the new climate comes at the same time as the city needs to replace its aging pipes and roads, along with other infrastructure. This could be the opportunity to introduce hardy green engineering solutions that would allow us to adapt to the weather we have made and to prevent it from getting worse. Dramatic investments in a much denser and more extensive tree canopy would provide storm-water buffers as trees hold large volumes of water and release that water slowly over a number of hours. In addition to helping with storm-water management, a large-scale investment

in tree planting would change the micro-climates throughout the city as tree canopies lower temperatures at both the street level, making walking more attractive for pedestrians, and in homes and businesses, reducing the demand for air conditioning. The development of green roofs would give us yet another option for buffering storm water as well as reducing building temperatures by providing shade and insulation on the thousands of hectares of flat roof surface that we have in Toronto.

Vehicle exhaust is one of Toronto's single-largest sources of gases that produce smog and cause global warming. Curbing the cars that currently sprawl, stream, or idle along our landscape would let the city breathe again on hot summer days and make deep reductions in the emission of greenhouse gases. The lingering debate about the Gardiner Expressway—does it stay or does it go—could be resolved if the congestion it was built to avoid was reduced, along with a revival of public transit that would make it redundant. Making these changes would mean turning away from building low-density sprawl that make roads and adjoining expressways the centre of the Greater Toronto Area's transportation system. If current development patterns persist, the time spent getting from point A to point B in the Toronto region will increase by 40 per cent over the next twenty-five years, costing local businesses in the range of $3 billion per year in lost time and lost production. But if the effort is made now to increase the settlement density of the GTA outside the core city, to develop a multi-core urban region, and to rebuild the inner suburbs to higher densities, we can contain and roll back traffic paralysis. Such land-use planning policies will build the population base necessary to make the case for transit investment, while at the same time ushering in a renaissance of pedestrian travel by building

community centres and libraries within walking or biking distance from people's homes.

But here again, Toronto's potential future—a future in which transit, not expressways, would run supreme—does not rest solely on its own actions. Right now, the Toronto Transit Commission's status of being the least-government-supported public transit system in North America hobbles investment in transit expansion. And the problem is not just limited to deferred expansion. Overcrowded trains and buses in rush hour that have no space for additional riders frustrate residents who want alternatives to driving. Transit managers and user statistics say the TTC is carrying more people than the system can handle, while still lacking in-demand routes such as a rail connection to the airport. Toronto finds itself in a chronic state of having to lobby for support on a project-by-project basis—in contrast, cities in the United States can rely upon a sustained funding partnership with state and federal bodies to keep their growing transit systems in good shape. The TTC's partner, GO Transit, faces a similar lack of support from other levels of government, principally from its founder, the Government of Ontario, whose investments in highway and road expansion continue to trump transit funding.

Toronto is like any biological entity in that it consumes material and generates waste. Our species continues to expend the Earth's resources at a rate far faster than they can be replenished. Reducing the use of materials and recycling what already has been extracted from the Earth is urgently needed. Already recycling and composting 40 per cent of its waste, Toronto has set its sights on reaching a diversion rate of 70 per cent by 2010. This follows the example set by Nova Scotia, which is seen as a waste management leader in North America. Accomplishing this will require the city to bring in measures

2.4 million people—over the next generation. This opportunity to build the new and replace the fading presents a once-in-a-generation chance to get things right on green power.

And if the city capitalizes on its potential to reduce electricity demand, it stands to become Canada's other energy-sector capital. Reducing electricity demand through increasing efficiency, bringing alternative forms of energy online, is a skilled-labour and knowledge-intensive enterprise. It will enlist Toronto's labour and intellectual capital in devising, refining, and implementing the solutions to reduce power use in its own backyard. Getting it right here makes for export to other jurisdictions.

However, Toronto's energy future is not entirely in its own hands. The province of Ontario ultimately decides which of the paths available to Toronto are open and which paths are blocked. The province has to decide how it will replace well over 80 per cent of Ontario's power capacity over the next twenty years. If it chooses to capitalize on programs that can dramatically reduce the amount of electricity wasted and significantly bring online power generated through recycling industrial heat, solar panels, hydro, and other renewables, then Toronto is well-positioned to become a leader in the energy revolution. If the province decides to stay on a fixed track of spending billions on nuclear mega-projects, this door will close. The past will repeat itself.

In the areas of energy use, urban density and transportation, waste management, and infrastructure development, a wrong turn will mean the further degradation of air quality, spiralling costs, and a less attractive city. We have the potential to make a huge difference in the next twenty years, for good or for ill. Yet the prospect of realizing that potential will be inordinately

determined by other levels of government. This persisting arrangement presents the most constant challenge to Toronto's need to become a capital of sustainability.

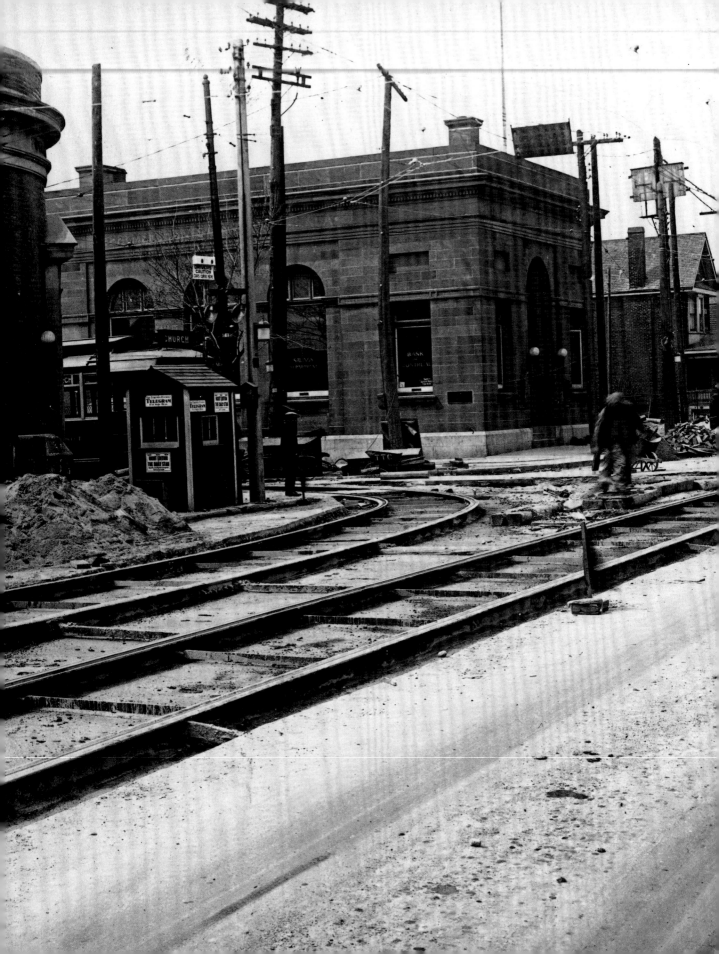

STOP AND GO
PHILIP PREVILLE

WHEN IT COMES TO CARS, THE CITY'S GRID HAS
BEEN OPERATING AT FULL CAPACITY FOR DECADES,
WRITES PHILIP PREVILLE. IT'S PEDESTRIAN TRAFFIC
THAT IS ON THE RISE, AND IT IS ISSUING A CHALLENGE
TO A GRID WHOSE SIGNALS AND PROTOCOLS ARE
DESIGNED TO TREAT ANYONE ON FOOT AS A
SECONDARY CONCERN.

THEY SAY THE AVERAGE PERSON spends six months of a lifetime waiting at red lights. I recently discovered an even more astonishing corollary to this axiom of urban living: the vast majority of those six months will be spent waiting at the same intersection, specifically, at the intersection closest to your home.

The lights closest to my last home, at the corner of Dupont and Christie streets in Toronto, stood between me and all my daily destinations. For the three years I lived and worked there, I crossed this intersection on foot at least twice a day: to get groceries, go to the bank, pick up a movie, have a cup of coffee, buy beer, wander north of the tracks to my favourite park. They stopped me twice every trip, once headed out and once on the way home. On big errand days, they dinged me eight, maybe ten times.

The seconds added up quickly. The lights at Dupont and Christie take thirty seconds to change in either direction, extended to thirty-five seconds for east-west traffic during peak hours. It's true that my wait was often less than thirty seconds, depending on where I was headed and at what point in the signal's timing cycle I arrived at the corner; it's also true that, late at night when the coast was clear, I tended to ignore the signal completely. Still, by my calculations, in only three years I logged at least thirty-five hours waiting at this one intersection.

Thirty-five hours, one full work week, at one corner or the other, merely waiting for the light to change. It gets worse. While I waited, I was indifferent to everything. My street corner was filled with the sounds of conversations, vehicles idling and revving, and trains on the tracks running parallel to Dupont: all flowed in one ear and out the other. I paid no mind to the telephone, cable,

and electrical wires overhead. I was equally unaware of the underground water, sewer, and gas networks. I could not remember any of the cars that passed through the intersection any more than I could remember any faces of the people who crossed my path. I became so familiar with my intersection that, through the miracle of pattern recognition, I was able to ignore all the static scenery and much of the dynamic movement too, reducing the bustle of the city to the faintest background drone, allowing me to entertain the rantings of my inner dialogue. And as I listened to myself think I stared into middle distance at the electronic interlocutor standing between me and the other side of the street. I was fixated on the orange Raised Right Hand, waiting for little white Walking Man to appear.

And so thirty-five hours' worth of absent-minded reflection eventually led me to collide with the revelation of my own oblivion: I have completely internalized the thousands upon thousands of tonnes of concrete, asphalt, plastic, wiring, steel, and stone that make up the grid, surrounding me, confining me, directing my movement, and influencing my behaviour every time I walk out my door.

Oblivion soon morphed into obsession. How did I manage to take such a massive edifice and swallow it whole? Late one night, emboldened by wine, I spent the better part of an hour with my ear pressed against the grey signal-controller box on the southwest corner, listening for any hint of an audible click whenever Right Hand switched over to Walking Man. I wanted to get to know him better. I crouched down to eavesdrop near the bottom; I perched on tippy-toes to snoop near the top; I went round to overhear on either side; nothing. People in their cars stopped, stared, and chuckled. One guy in a white sports car rolled down his window to toss an insult my way, but my

behaviour was so odd that words failed him. He turned his attention back to the road and, realizing there was no one else around, ran the red with a shit-eating grin on his face.

THERE IS NOTHING particularly unique or noteworthy about the Dupont and Christie intersection. Dupont Street is considered a "minor arterial" by city officials, meaning it handles enough east-west commuter traffic during peak hours to make said officials thankful, but not enough to make them worry. Dupont and Christie, however, is part of a greater whole, a four-corner sprocket in the city's vast, crowded grid.

On August 22, 2000, two employees from the City of Toronto's Traffic Data Centre and Safety Bureau came to Dupont and Christie to count vehicles, bicycles, and pedestrians. What they found was that, while the intersection appeared to be breaking even, it was in fact growing in ways that threatened its ability to function. A total of 18,298 cars flowed through it between 7:30 a.m. and 6:00 p.m., remarkably similar to the count of 18,252 from 1993. But of the cars headed south on Christie Street, 901 turned left onto Dupont, up from the previous count of 797. It was proof of a shopping invasion: in 1996 a big-box Loblaws opened on the northwest corner, creating a new wave of cars from upscale neighbourhoods to the north turning left on their way to the parking lot. It was also a harbinger: an extra 104 cars waiting, sitting in the middle of the intersection, and queuing. Since the left-turn lane runs the length of only two cars, the lineup was now regularly spilling over into the neighbouring lanes.

More remarkable still was the growth in pedestrian traffic, thanks to Loblaws and the café, Blockbuster franchise, design furniture showroom, custom drapery seamstress, and upscale bathroom boutique that turned up in its wake. A total of 2,420 people crossed on foot that day, compared to 1,579 in 1993.

These numbers appear worse on paper than on pavement; to the naked eye the intersection seems far from gridlocked. But this change is part of a broader transformation currently taking hold in Toronto. As condominium towers spring up throughout the city, especially in the downtown core and its surrounding areas, more and more people are going about their daily life without cars, conducting important portions of their day's travel on foot. When it comes to cars, the city's grid has been operating at full capacity for decades. It's pedestrian traffic that is on the rise, and it is issuing a challenge to a grid whose signals and protocols are designed to treat it as their secondary concern. There is nothing more annoying to a pedestrian than to stand on one side of a deserted street and wait an eternity for the signal to change—as they do at Willcocks Street, waiting to cross Spadina—ceding right-of-way to vehicles that never come. More often, though, problems occur when there is a surfeit of all kinds of traffic, and Dupont and Christie, as a case study of this emerging trend, demonstrates the many bad things that can happen when surplus pedestrians meet long left-turn queues. Both are forever playing beat the clock, trying to squeeze themselves through as the seconds tick down, and each gets in the other's way. A motorist trying to make a quick left on the yellow is stopped short by a pedestrian making a late crossing; the light turns red, and motorist is then trapped in the middle of the intersection; motorist, wanting to hurry pedestrian's progress, nudges forward into the crosswalk;

pedestrian, miffed, stands still and glares at motorist; a bleating chorus of horns fills the intersection.

Such stalemates usually don't last long, but a delay of even a few seconds can disrupt the driving rhythm of one commuter who is used to hassle-free passage. His happy morning cadences knocked askew, he becomes determined to reset them by making good time over the next two intersections; he becomes aggressive and cuts people off; they too turn irate, and a thousand tiny cruelties are perpetuated throughout the grid. Even without gridlock, there is griplock: motorists' silent throttling of the steering wheel as they elbow their way through city streets, and pedestrians' clenched fists and nerves as they forge through the battle zone of the crosswalk.

Pedestrians far outnumber their automotive overlords, but only on rare occasions do they take advantage of their numbers and revolt en masse. On the day of the Great Blackout of 2003, August 14, commuters were ejected from their office cubicles and from the subway tunnels, all converging at street level. I was at Bay and Bloor that day, and for those first afternoon hours of the blackout the street was teeming with more people on foot than it had ever seen in the course of a normal business day. Pedestrians were literally bottlenecking at the street corner, packed onto the sidewalk like sardines while they waited for a phantom signal to change. As the first renegade foot soldiers decided to screw the rules and ventured into the crosswalk as they bloody well pleased, motorists, rather than becoming aggressive, became timid: without traffic signals to enforce their right-of-way, and with pedestrians behaving unpredictably, they were suddenly frozen in place, afraid to move for fear of doing someone harm. And once the rest of the onlookers saw this dynamic at work—that is, once they smelled the motorists' fear—they all

flouted the rules, crossing in all directions at all times and generally acting as if they owned the intersection, which, for that one afternoon, they did. Motorists sat helpless until the traffic cop came to bail them out and restore the normal order of vehicle flow.

But even when the lamps are working fine, Torontonians' relationship to their infrastructure seems to be crumbling faster than the infrastructure itself. Obeying the signals—stopping, waiting your turn, minding the lines on the pavement and all that—is the most basic social contract we have. The more clogged our streets become, the more we need that contract, and the less inclined we are to honour it. Everyone is trying to steal an ounce of time, or space, or both, squeezing through on the red or jumping the gun on the green.

And standing in the middle of all this rapacious recklessness? Walking Man, the grid's human face. Tempers flare and preventable accidents unfold before him every day, and he is powerless to do anything. He cannot intervene, he cannot mediate disputes, he cannot warn people of imminent danger, he cannot utter anything beyond his idiosyncratic tweet-tweet and cuckoo for the blind. Imagine how he must feel. Walking Man deserves a big hug for shepherding people safely across the street. The reason he never gets his hug has less to do with his steel casing, and more to do with the simple truth that he remains a stranger in the grid.

THE CONCEPT OF THE urban grid goes back to the ancient Greeks, the sum of their fetishistic fascinations with philosophy, geometry, and political order: it was easy to map, navigate, and subdivide, accommodating to both

pedestrians and vehicles—whether powered by slaves, oxen, or horses—and expeditious in the transport of foodstuffs throughout the city centre. The grid stood the test of time and flourished from the eighteenth century onward. Much of Toronto's downtown grid was planned, and a large part of it built, in the 1790s by the city's founder, John Graves Simcoe.

Christie Street, named for the Christie family that makes good cookies, first appeared on the map in 1890. Dupont Street, named for nineteenth-century political scion George Dupont Wells, was built in sections through the 1890s, reaching Christie Street in 1894. Originally dirt roads, in 1900 the intersection was paved in cedar block, prized for its resilience and resistance to water. But cedar was better suited to horses and wooden-wheeled carriages than automobiles, which preferred asphalt. (As luck would have it for the nascent auto industry, asphalt, a residue of the gasoline production process, provided poor footing for horses.) From 1914 to 1916, as Ford was building its factory on the northwest corner, the intersection was rebuilt for motorcars. Sidewalks were poured in concrete, streets paved with asphalt. The early twentieth century was Toronto's golden pavement era, as the city resurfaced most of its grid.

The epic of that grid is, in fact, published at your feet. The sidewalks lining the Dupont and Christie intersection are all stamped with that familiar oval indent, showing the year in which the concrete was poured and, in much smaller type, the name of the contractor who poured it. There are half a dozen such stamps on the southwest corner alone, each with a different date. Most of the manhole covers have a date pressed into their steel, though some are so old they have lost their dates and their waffle ridges; one has been worn smooth as a skillet. The lamppost on the northwest corner is

made of wood, old rusting staples embedded in it like buckshot. But Walking Man and Right Hand, suspended on the lamppost, are in remarkably better shape, like new growth sprouting from the branch of an old tree.

THE STORY OF WALKING MAN'S origin is shrouded in mystery. In North America, the late Toronto pictogram pioneer Paul Arthur is widely credited with developing Walking Man and Raised Right Hand for Expo 67 in Montreal. But Walking Man has many histories, and one of them casts him as an innovation spawned by the rebuilding of the modern urban grid in pre-industrial cities. In fact, you can trace his genealogical roots to Toronto's population surge from 200,000 at the turn of the century to some 2.5 million today. In the 1920s, there were perhaps 10,000 cars at most on Toronto roads. Today, about one million vehicles are registered to Torontonians. Add to that the 300,000 vehicles that enter city limits from surrounding suburbs every day. For the last twenty-five years the grid has been crowded and congested, flirting with total gridlock, but never quite succumbing.

It's been able to do this—even while sidewalks, road widths, and street corners appear to have barely changed over the last forty years—because a vast majority of the infrastructure has been continuously tweaked with new and improved materials and additional regulations. New pictograms were designed for all traffic signage, explaining edicts like "no left turn" without the use of words—a boon for new immigrants and anyone else lacking in English literacy. Wide yellow backboards and LED technology have heightened the visibility of traffic signals, reducing the confusion and delays caused by

pedestrians are struck dead by vehicles in the Toronto area every year. They all must weigh heavily upon Walking Man's conscience, for it turns out that the history of his deployment throughout Toronto was technocracy's response to a tragic, and surprisingly recent, fatality.

Walking Man and Right Hand first appeared in Toronto in the early 1970s, but only at select intersections, without the Flashing Hand intermediary. On December 20, 1987, forty-three-year-old Sandra Dennison and her seven-year-old son, David, exited a church service around 8:00 p.m. at Islington and Fordwich, one of Walking Man's few Toronto sentry points at the time. They crossed the slippery road on the red and were struck by a car. David died at the scene.

David was not merely one of fifty-two pedestrians killed on Toronto roads in 1987; he was also one of three killed in a twenty-four-hour time span. Earlier that day, sixty-year-old Herbert Miller was killed crossing Keele Street; the next day, Leila Windgren, seventy-five, was struck by a car in heavy rush-hour traffic at Yonge and Balliol. But it was David's death—and the court proceedings surrounding it, in which the city was fingered for not providing enough information to pedestrians—that spurred technocracy into action: Toronto finally resolved to put Walking Man at every signalized intersection, and to use Flashing Right Hand, already in widespread use in other cities, as a sort of pedestrian yellow light.

And so, beginning in 1990, Walking Man and Right Hand were universally conscripted in Toronto as a buffer in the Faustian bargain with urban life, best described thus: if all parties co-operate, everyone will get to their destinations and the city will prosper, but a few people will die every year in the course of prosperity. Civil engineers are currently hard at work to

bring that bargain to a close: cars that drive themselves, always spacing them-
selves evenly, never gunning it on the yellow, always ceding the right-of-way
to pedestrians, and navigating the grid as efficiently as computerized bits.

What this proves is that the grid, although an engineering wonder, is a
perpetual work in progress. Yet its basic function remains nothing more than
the allocation of time, or more specifically, time for cars: thirty seconds for
cars going north-south, then thirty-five seconds for cars going east-west, and
so on. Pedestrians have always been an afterthought, expected to do nothing
other than piggyback upon the time allotted for vehicles. Flashing Hand is
now often accompanied by a countdown clock, as if to better instruct
pedestrians on the precise moment when it becomes their own fault if they
get run over. But as the city's population grows, as condo towers fill with
people, as the city expands its transit network to allow still more pedestrians
to commute, and as the population ages and its legs get creaky, it is the
sidewalks, not the roadways, that will become cramped and congested, and
the signals will have to be programmed and timed to finally accommodate
people, leaving cars as the afterthought, and installing Walking Man in his
rightful place as king of the grid.

AT NIGHT, FREED FROM the constant din of workday activity, my old
street corner shows its age. The road is a lattice of intricate cracks, a patchwork
of lighter and darker asphalt. Weeds poke through at the edges, manhole
covers pock the surface. The ruts in the pavement have become deep grooves,
black with burnt rubber nearest the worn stop line.

Still it gets no rest, its eyeballs watching over all directions at all hours. A new left-turn arrow, installed in 2004, now lights up the corner. The arrow will help, of course, because it will increase both capacity and flow. But it won't stop the onslaught. New condo developments will bring more miscreants like me, flouting and toying with the urban order. And the trains keep busy mostly with shipments of new cars and trucks, all of which will soon hit the pavement.

I have since moved from Dupont and Christie, a short distance north-east, two blocks above the tracks, where a new set of signals claim the lion's share of my waiting time. Right Hand and I, both tired of being at loggerheads, are taking the move as an opportunity for a fresh start. But my new street corner is no different. It also spends its days trying to corral a stampede of human chaos. It does so partly with the sheer physical mass and might of its materials, buffering and smoothing the onslaught of tonnes upon tonnes of vehicles screeching to a halt and peeling away. But it also does so with silent pleas to all who cross its path, and which now strike me as more desperate than I ever realized.

Of course, we are as anonymous as the grid we plow through every day. But that makes no difference to my sidewalk, worn down from all the abuse and due for repair. When the crew comes to fix it, I will spy them from my window. When their work is done and they are gone, I will run out and etch my initial in the soft concrete.

FOR ART'S SAKE
RICHARD BRADSHAW

THIRTY YEARS AGO, THE NEW OPERA HOUSE WAS A PIPE DREAM. TODAY, IT'S HARD TO IMAGINE THE CITY WITHOUT IT. TORONTO HAS COME A LONG WAY, WROTE THE CANADIAN OPERA COMPANY'S FORMER GENERAL DIRECTOR, RICHARD BRADSHAW, ONLY A FEW MONTHS BEFORE HIS UNTIMELY DEATH. BUT WHEN IT COMES TO SUPPORTING THE ARTS, TORONTO, HE BELIEVED, STILL HAS A LONG WAY TO GO.

SOMETIMES—THOUGH NOT VERY OFTEN—I have a chance to sit alone in the R. Fraser Elliott Hall. When it's empty—when there is no audience in the auditorium and no orchestra in the pit; when there are no ushers or maintenance people or set builders or lighting designers or cleaners or curious visitors on a tour—it is an almost deafeningly quiet place.

The entire hall is separated from the structure that surrounds it, supported by acoustic isolation pads that allow no noise or vibrations from the outside to intrude. Its architect, Jack Diamond, has described it aptly as an egg inside a nest. On the rare occasions when I have a chance to sit and reflect on what this place means to the city of Toronto, I can almost literally hear myself think.

The R. Fraser Elliott Hall is the main stage of the Four Seasons Centre for the Performing Arts. At the very heart of the city's downtown, it is a building that most Torontonians refer to simply as the Opera House. Its first audience gathered here for a gala concert on June 14, 2006—some three decades after the Canadian Opera Company first set out to create a new, badly needed opera house for Toronto.

It's hard to think of a thirty-year period as a turning point, but now, from here, in a hall that is already becoming known as one of the great opera houses of the world, I can see that it was. In those thirty years—the last eighteen being the years I joined in the fray—the city of Toronto slowly, steadily, sometimes painfully, shifted from being a city that rather half-heartedly wanted a dedicated venue for opera and ballet to a city in which the absence of such a structure is already almost unimaginable.

It was a long, sometimes exhausting process, but it was also exhilarating. If there were setbacks, we were quick to transform them into positive shifts

of direction. And—as I never doubted they would—those shifts finally led us to where we were going. The small band of dreamers who started out on that journey found that as we continued, as we gathered allies and supporters and advisors and volunteers and partners and donors, the city was changing around us.

In those thirty years Toronto changed into a place that not only came to agree with our cause, but eventually came to regard it as a necessity. It does seem more than slightly Pollyanna-ish to suggest that our timing was good. After all, it took thirty years. But as we begged, cajoled, argued, pleaded, and, yes, I admit, demanded that a new opera house be built, it became clear that Toronto was gradually but irreversibly becoming a place that was listening to what we had to say.

The city was becoming bigger, of course. It was becoming more diverse and more exciting. It was becoming more sophisticated. But most importantly from our point of view, it began to look as if Toronto was changing into a place where the arts no longer needed an excuse. Ten years ago, there were people who said, "Why should money go to the arts when there is a crisis in health care, a crisis in education, a crisis in social services?" But now the ground has shifted. Now that false dichotomy has been divested of much of the political power it once had. There's a sense that the arts are a critical part of the fabric of the city's life. Now people are saying we must find a way to fund health care and support the arts, deal with education and support the arts, address social and environmental issues and support the arts. The arts are not a separate wing of life in Toronto. They are an important part of an organic whole. And that's an enormous change. That is evidence of a city growing up.

MICHAEL AWAD

As an architect, artist, and urbanist the *city* is both the site and the source of all my inspiration.

Begun in 2001 *The Entire City Project* constitutes the practical and conceptual focus of my artistic practice. The urban environment is disassembled through continuous examination, observation, and analysis. The ultimate goal is to capture all the elements of the entire city; all the public spaces (interior and exterior), all the urban events, and all the people of the city. As a result, the visual richness and hidden complexities of daily life are exposed.

Many urban narratives are explored. Hours of walking, cycling, or driving through the city are collapsed into continuous ribbons of urban experience revealing unseen visual patterns. Static city fabric is separated from active city life. Complex interiors, such as art galleries and supermarkets, are collapsed into single images to reveal their true visual intensity, and hundreds of thousands of people are captured as they go about their daily routines.

The necessity to examine a wide range of urban experiences has required a wide assortment of techniques. *The Entire City Project* has developed different methods of visual capture to examine different aspects of urban life. Various technologies—conventional, industrial, scientific, and military—are employed

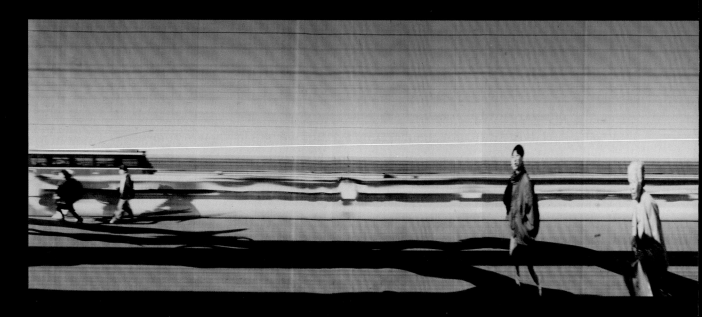

THE ENTIRE CITY PROJECT

interchangeably. The *Project* has required constant experimentation with custom-build cameras and custom-imaging software. Both film and digital media are employed, often simultaneously, to capture the widest possible range of visual experiences. Prints are created using a hybridized process of conventional chemically based printing and high-resolution digital technology. Final images range in size from 4 to 120 feet.

The presentation in this book, which I am calling *The Entire City Project: A City Becoming*, is made of many images of differing formats, but should be understood as a single continuous composition. Like a text, read left to right and top to bottom, this piece explores Toronto's ethnicity, daily life, special celebrations, individual places, and the urban fabric. Even though the *Project* has expanded to explore other cities, Toronto is, and will continue to be, both my technical laboratory and my principal subject.

The Entire City Project has been shown at the Power Plant Gallery, the 2002 Venice Architecture Biennale, and the Art Gallery of Ontario. Individual pieces have been commissioned by York University, the City of Toronto, the CONTACT Photography Festival, Pearson International Airport, and the AGO.

Michael Awad is represented in Canada by the Nicholas Metivier Gallery, Toronto.

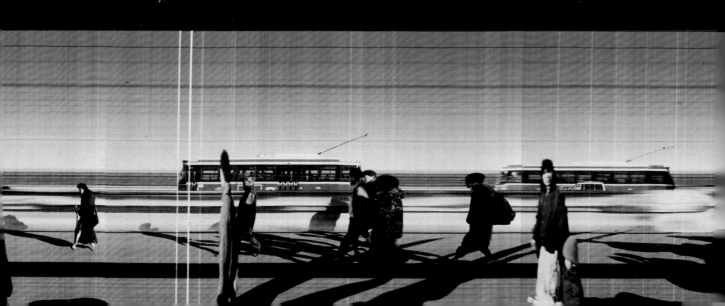

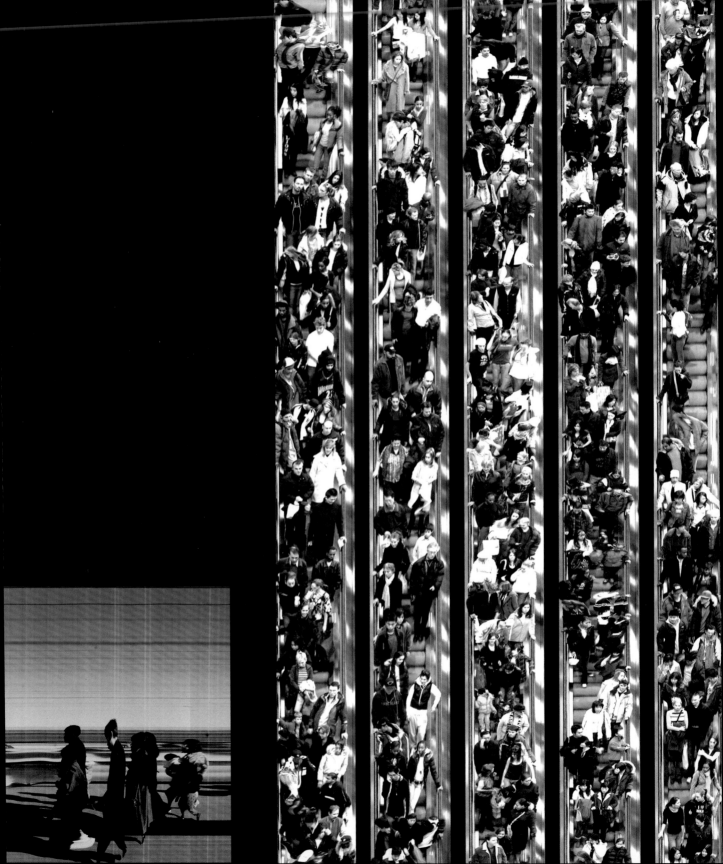

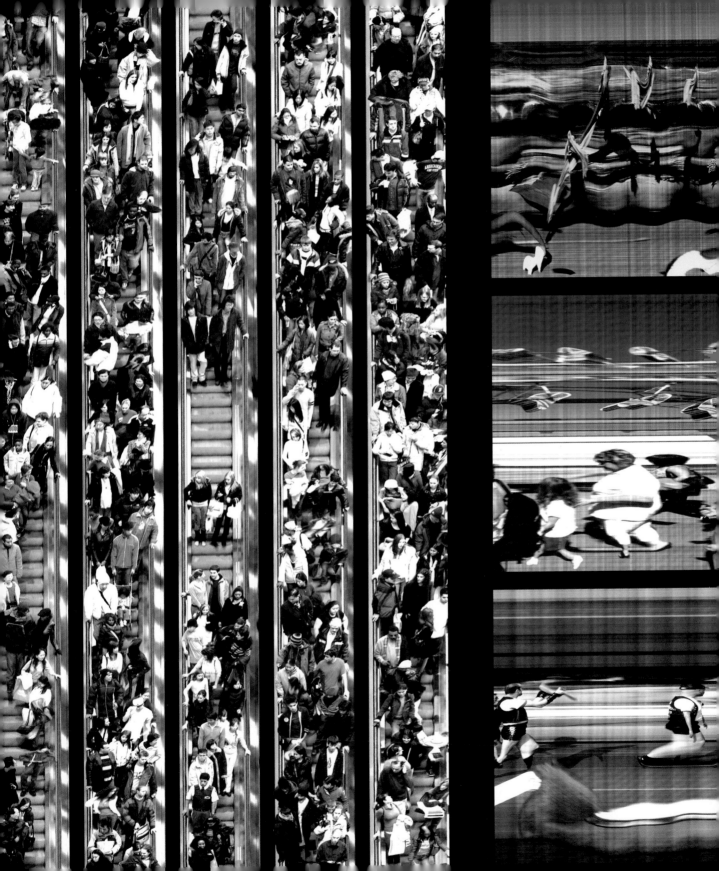

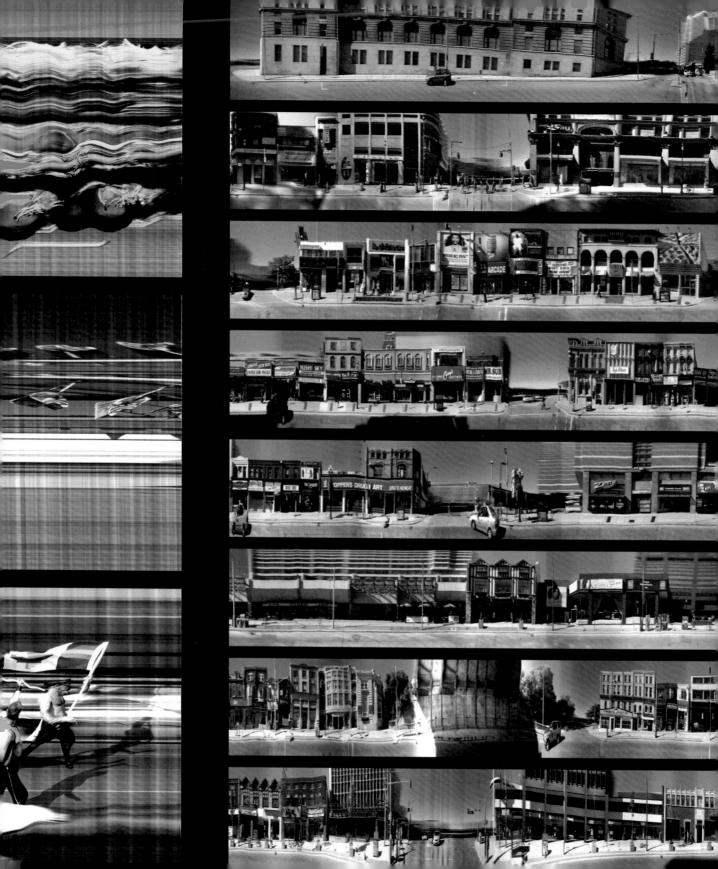

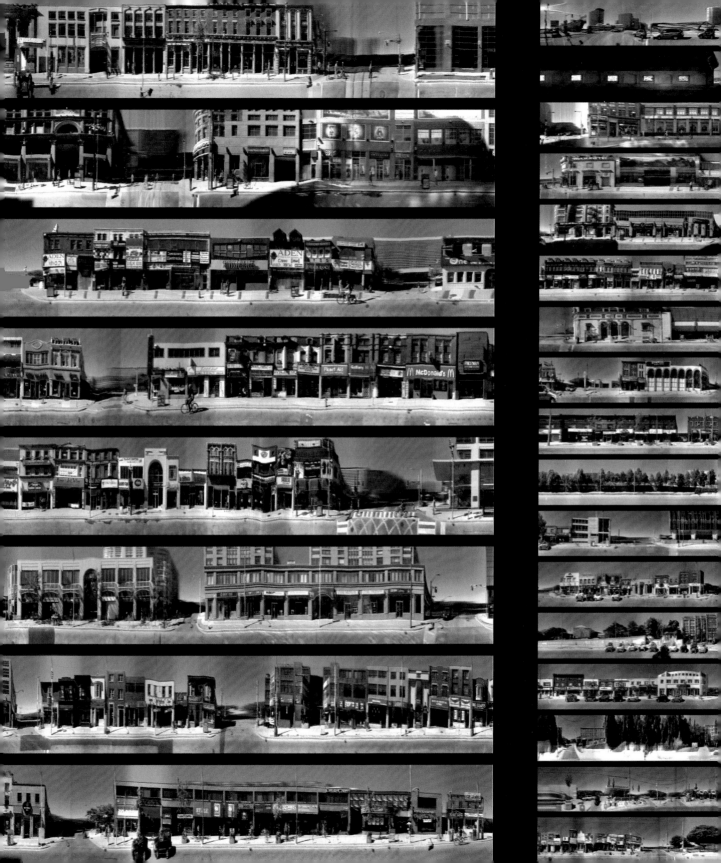

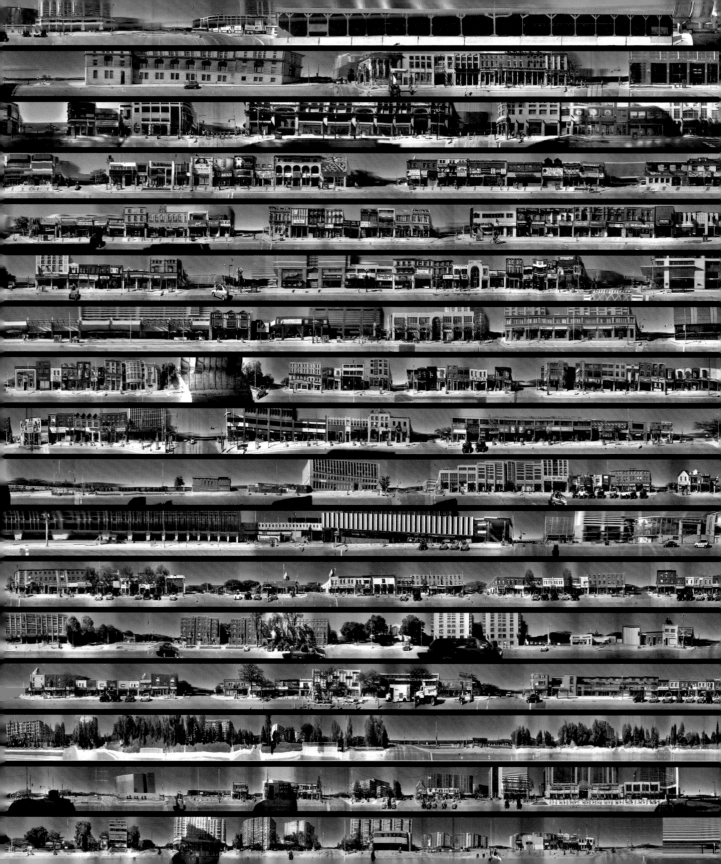

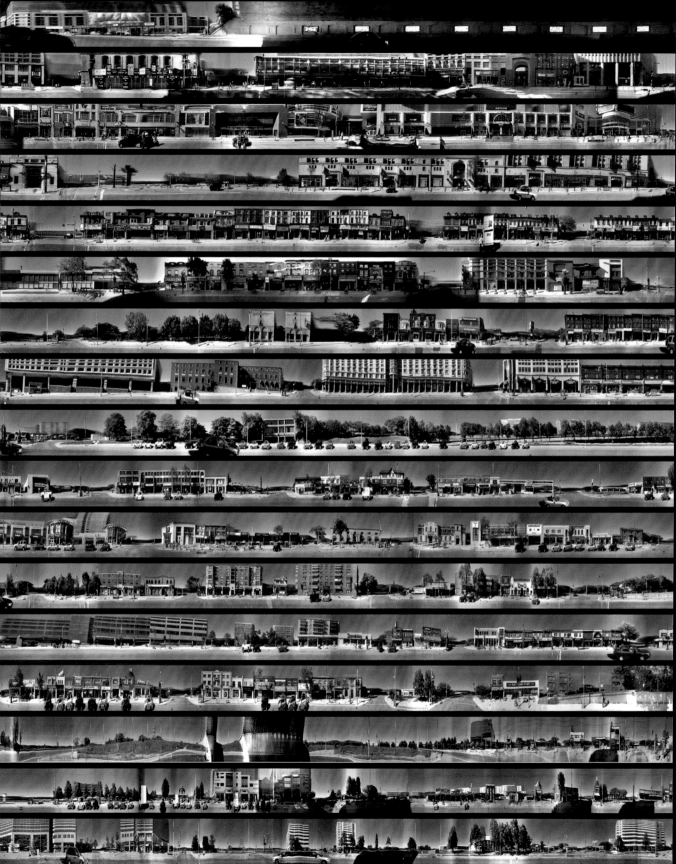

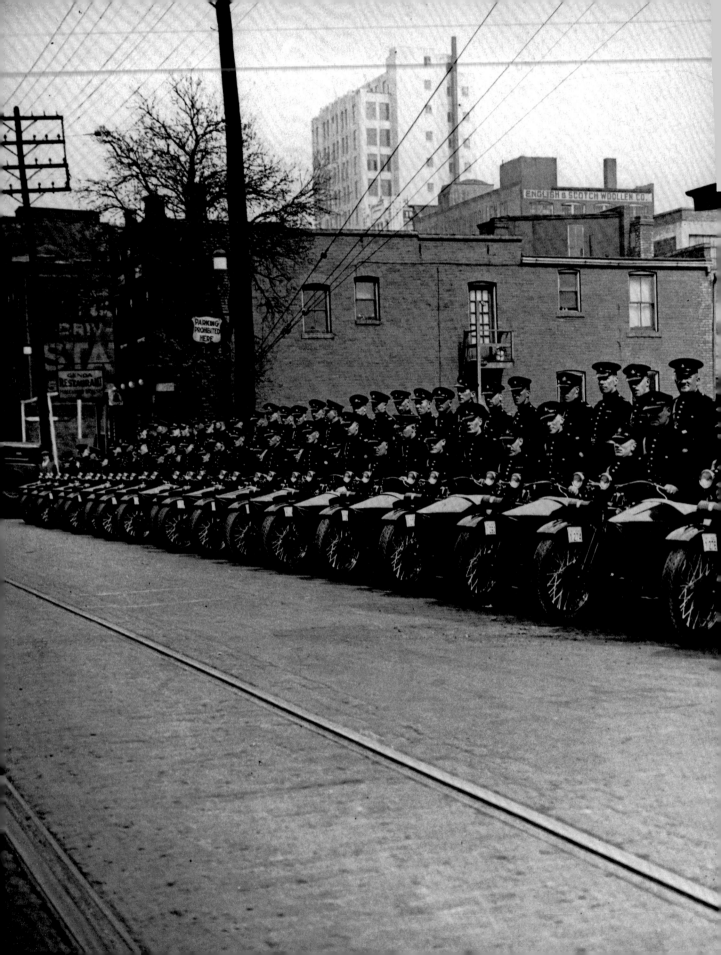

THE PRISONER
DAVID
HAYES

"I WAS SENT TO JAIL FOR THE FIRST TIME WHEN I WAS THIRTEEN. BY THE TIME I WAS TWENTY I'D SOLD CRACK, SHOT A MAN, FOUGHT IN A GANG WAR AND CONSIDERED KILLING MYSELF." ANDRE MORRISON TELLS DAVID HAYES THE STORY OF HIS LOST YEARS.

THE FIRST TIME I GOT in serious trouble with the police was a couple of weeks before Christmas, when I was thirteen. I was living with my dad and stepmom in Mississauga, and I went in the dollar store across from the Zellers at Westwood Mall and stole some cap guns and water balloons. How I got busted was I got greedy. I went over to the Zellers for one more thing, but I didn't know that the store had a lot more cameras. When they busted me they realized I had a lot of stuff from the dollar store, too.

My stepmother was very upset and she grounded me. But my father freaked. He said, "You think you're a man and you can embarrass me in public?" Then he gave it to me.

I ended up being charged and getting probation. I was supposed to work things out with my father, abide by his rules or I'd go to juvenile open custody. I tried my best to stay out of trouble, but a lot of the time he wouldn't let me out of the house. I felt like a caged animal. I'd sneak out just to piss him off.

I was supposed to be in school but I wasn't really going much then. I'd just hang around. I'd always seen these bigger guys, smoking cigarettes and weed. They was what we called the "doms," the rude boys. Nobody would say nothin' to them, nobody tried to disrespect them. I wanted to be one of them, but I wasn't bad enough.

One time the doms from our school were chillin' when a whole bunch of guys from a rival school started a big scrap. By then I wasn't really scared of catching a fist, and I had so much anger in me I just wanted to knock some-body out for the fun of it. So I jumped in and started hitting these guys from the other school. I caught a broken nose and my pinkie finger got dislocated, but I held my own and lumped up a few people. From that day on the big guys looked at me different, started giving me respect.

When I look back on those days, I know my life was getting out of control. I was knocking people down and taking from them. I'd say, "Yo, empty your pockets, give us your lunch money, gimme those sneakers or that jacket." We called it shotgun, like "I got a shotgun on that jacket." At the time, when I was doing it, it felt good. Since no one was giving me mines, I felt I was just takin' mines.

I GUESS MY STORY really starts when I was little. I was born in Jamaica, the third of four kids. My father, Neville, left for Canada when my mom was pregnant with me. Then my mother, Yvonne, left for New Jersey when I was two, leaving me to live with my older brother, Wayne. I never blamed her for leaving because she was trying to help us. She scrubbed toilets and sent whatever little money she had. The first time I saw my father was when I was three years old. He didn't come to visit me, he came to visit his friends and enjoy Jamaica but he said, since I have a son, I think I'll see what's goin' on. So he came by and stayed for ten minutes and I never saw him again until I moved to Canada nine years later.

Wayne and I lived in Tivoli Garden, a neighbourhood in Kingston. Tivoli Garden, Waterhouse, the Jungle, Rema—those are pretty much among the most dangerous places around. It wasn't much of a home, more like some boards nailed together. But wherever you rest your head is home.

School costs money down there and we really didn't have any money so half the time I was just out on the street, causing trouble. I'd climb a person's mango tree to get food. But a man's property is a man's property, so when I got caught I'd tell them I had no family, that I was living on the street, just

247

away, his friend helping him. It's a good thing those guys didn't bring any really big tools. Then there were sirens coming, so everybody scattered.

When we got back to Sean's we were scared as hell. I had that nervous, whacked-out feeling inside. I even got Sean a cup of juice and the juice was just shakin' in his hand.

I ENDED UP LEAVING the gang because I wanted to get my life together. It's not always easy to do, but Sean was a good friend and as our leader he thought I'd earned my dues. I ran into a friend who suggested we go to Hamilton because there's stuff happening there. We end up staying with this Colombian guy called Loco. He was a nice person, but a pretty dangerous guy, too. He wasn't part of a gang, but he was slingin' drugs like crazy. Crack. Heroin. Special K. You sniff Special K and after half an hour you get into something called the "K hole." You're literally paralyzed for an hour.

This was the first time I was seriously into selling drugs. I needed the money and didn't want to rob to get it. One time we arranged to sell some weed to these guys, but the idea was to rob them. Unfortunately they were a little bit smarter than we assumed. Me and Loco and a couple of friends met them at this small plaza on Hamilton's Main Street. It was dark and we moved out back. They were supposed to come put their money over here, right by me, and Loco brings the drugs over to them. But they hesitated. They're like, "Nah, nah. You first. Bring the drugs over here." Loco put his hand on his waist, because he felt like he needed to grip his tool right away. They pulled out theirs and started shooting. I got out of there, but a bullet

grazed my right side. I went to Hamilton General Hospital, but I told them somebody stabbed me.

When I left the hospital I saw a cop drive by and look at me. He must have recognized me, because there were a lot of charges against me by this time and my picture was circulating. Next thing I knew, the guy came out with a gun. You can't run when a cop has a gun on you, and I wasn't feeling 100 per cent coming out of the hospital, anyway. He took me in and at court the judge gave me two and a half years closed custody for fifteen armed robbery charges, break-and-enters, grand theft auto, and disturbing the peace, plus an additional year and a half open custody. I thought, oh my goodness, I'm not coming out until I'm twenty years old!

They sent me back to Syl Apps—this was my eighth time in jail. The first six months were very stressful. I swear, I felt like dying quite a few times because I realized that my life had come to a complete mess.

Back then I was a scrapper—I had no fear of nothing. All I did was eat, shit, and lift weights. I'd be doing 200 pounds, a hundred reps a day. I was a monster, weighed about 225. (Now I'm only 178 or 179.) One time I was playing ping-pong in the prison gym. There were these two particular guys who'd been eyeing me. Right before the gym closed, these guys rushed me from behind. The smaller one came first and I grabbed his hand and pounded him onto the ping-pong table. The other had his hand around my throat and it felt like he was breaking my neck. I slumped a bit, then rolled both of us down on that table, with me on top. He busted his head and I busted my nose.

Someone had hit the emergency button, and all you hear in the whole building is DE DE DE DE DE. About twenty staff rushed down and restrained us. They threw me in solitary—I called it the black hole. It's nasty, and all you

257

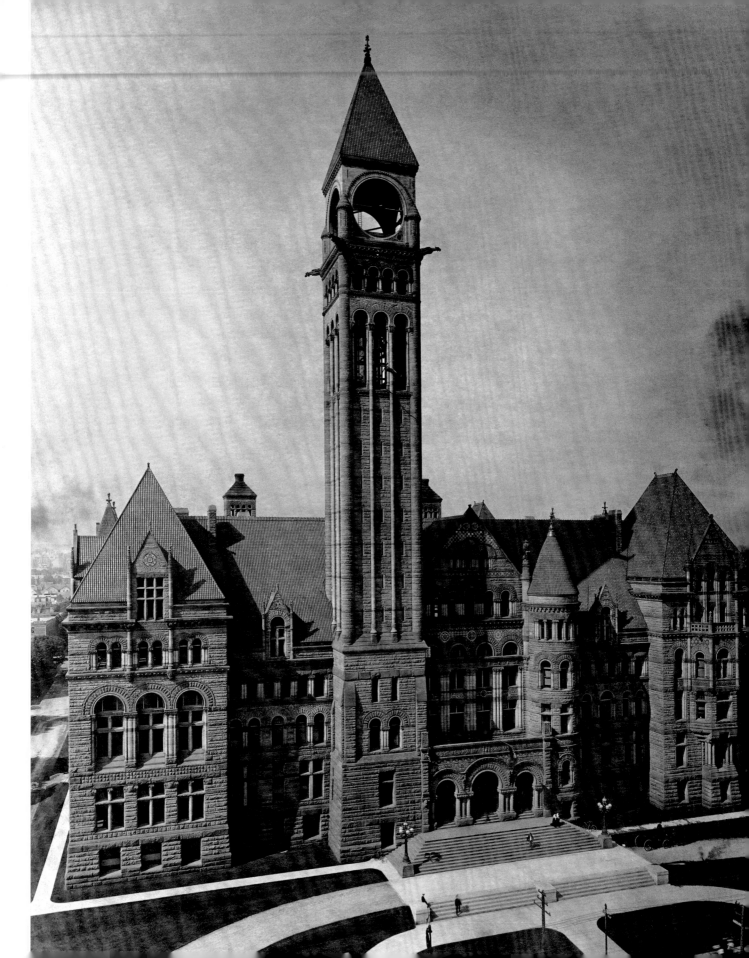

THINKING BIG
JAMES MILWAY

THROUGH THE NEW CITY OF TORONTO ACT, THE
PROVINCE HAS BESTOWED NEW POWERS ON THE CITY.
THESE CHANGES ARE GOOD ONES—THE FIRST STEPS
TOWARD THE FULFILLMENT OF TORONTO'S ENORMOUS
PROMISE. BUT THEY ARE ONLY A BEGINNING, WRITES
POLITICAL ECONOMIST JAMES MILWAY. IF TORONTO
TRULY ASPIRES TO GREATNESS, ITS GOVERNANCE
STRUCTURE MUST LEAVE ITS SMALL-TOWN
ROOTS BEHIND.

future, its governance process must include the local, the corporate, and the individual—there must be visible accountability mechanisms between citizens, elected officials, and city staff.

THE NEW SYSTEM MAKES the mayor's powers stronger than they were, but the changes don't go far enough. Toronto's mayor can appoint and remove committee chairs, but Council still has final say. As before, the system for managing city staff relies too much on good relations between Council and the mayor. The mayor should be recognized as the chief executive officer with powers to hire and fire senior public servants in municipal government with City Council perhaps having an oversight function that would allow it to ratify senior appointments. The senior leaders could function as a cabinet, advising the mayor and ensuring the effective co-ordination of policies and services. This step would make it absolutely clear to the citizens who is responsible when services are delivered well or when commitments are not met.

People are nervous about granting any one official too much power. And rightfully so. But like it or not, the municipal system in Canada is closer to a US style of government in which the executive and legislators are both elected directly and have to co-exist. (In the Canadian Westminster style of government, the legislators choose the executive and can remove them through a vote of non-confidence.) If municipalities are to work in a US type of government, then they need to have the checks and balances that make it work. Let Council keep approval of the budget—raising revenue and spending. The power of the purse strings is fundamental in a democracy and needs to be

close to the people. Give Council the right to approve the mayor's senior appointments. Create oversight committees to ensure that those who control the purse strings and who have empowered the departments to act are assessing them. On the other side, give the mayor a veto over Council legislation—with the possibility of Council overriding the veto.

Creative conflict is necessary if our municipal government is to take on much greater responsibilities. Consensus may be a virtue when the municipal government is removing snow and approving street names, but big policy decisions—should the city charge tolls on major roads? How does it support Kyoto?—require debate and, often, conflict. And the forum that most directly addresses such big policy issues is one that Toronto's municipal politicians have traditionally played down. Perhaps it's time they more openly acknowledged the elephant in the room. Perhaps it's time for the city to embrace party politics.

In Toronto, local politicians pride themselves on being in touch with the community and not needing an intermediary. It's certainly true that political parties would reduce the independence of local councillors. But consider the advantages. During municipal elections, political parties would put comprehensive agendas in front of the voters. Candidates for Council would still be able to run as independents, and many would survive. But more and more, the debate at election time must be around bigger issues than potholes. If there is serious consensus among the voters, then the mayor and the Council will be of like mind and will work smoothly to get things done. Where the voters aren't so solidified in their opinion, then it's quite possible that the mayor and the Council would represent two different views. Compromise would be necessary. But this necessity would be out in the open

rather than something to discern through reading the tea leaves the day after the election—as happens now. It would also require mayoral candidates to take a stand in ward elections. This isn't a bad thing. It would bring much-needed clarity to politicians' stands on issues.

Political parties are mechanisms for developing competing coherent agendas at election time. These agendas are also helpful between elections. Parties who are out of power have the duty to suggest alternatives and in some cases they may be persuasive.

The civility and coherence that marked the beginning of the term I watched so closely didn't last long. What looked to me like deliberative rationality as I sat in the council chambers proved to be a mirage. Council originally rejected the tax increases proposed by the mayor and his executive committee (in fact, one of the executive committee members even voted against it). In federal or provincial government, this kind of defeat would compel the executive to resign and let a new team take over—or an election would have to be called. Instead, Torontonians watched in bewilderment as the mayor instructed the city manager to cut spending to make up for the lost tax revenue and an opposing councillor brought forward a legal opinion on whether this was allowed. In the aftermath of these desperate measures, politicians and staff appeared to be flying by the seats of their budgetary pants. Angry speeches were made. Ideas were floated. But no elected official proposed a complete and coherent alternative—something that an organized opposition from a different political party would be forced to do.

A good governance system will not eliminate serious, perhaps intractable, disagreements between elected officials. But it will lead to a timely resolution of these differences through a clearly understood process.

These are exciting times in municipal politics—fitting in what is still, more than forty years after its construction, the architectural dynamism of our City Hall. Toronto has made some good first steps toward a governance structure befitting a major jurisdiction. There's more to be done and Torontonians and Ontarians should be planning those next steps now.

ONE PARTICULAR PLACE TO GO

IAN PEARSON

A FEW YEARS AGO, IT FELT TO IAN PEARSON AS IF THE ENERGY WERE LEAKING OUT OF TORONTO'S DOWNTOWN STREETS. THE GOOD BARS WERE BECOMING THE VICTIMS OF REAL ESTATE GREED. GONE, THE EMBASSY. GONE, THE MORRISSEY. GONE, THE BAMBOO. THEN—IN THE NICK OF TIME—ALONG CAME THE COMMUNIST'S DAUGHTER

A MAN WALKS INTO A BAR. At least, he thinks he is walking into a bar. The doorway does not offer certainty: it is sandwiched between Main Drug Mart and Flamingo Convenience on a dowdy stretch of Dundas Street West. The overhead sign says Nazaré Snack Bar in antique 1960s lettering and promises Coca-Cola and Farturas. But the words "The Communist's Daughter" are drawn on a chalkboard in a window, so the man enters and sits down at the counter.

He orders a Molson Stock Ale. In his youth, his right hand held hundreds of the bottles with the anchor embedded in the lovely cyan label. That youth has so long passed that the man had forgotten that Molson Stock Ale was still being bottled. The bottle sits on a counter laminated with a pastiche of maps. Vancouver and Long Island are pasted into India, the Burlington Skyway connects England with France, and a detail of Moose Jaw obliterates half of Belgium. It is a good thing, the man thinks, to have something to ponder while you drink a Molson Stock, as he traces the path of Caribou Street into Brussels.

The tiny bar holds a lunch counter and eight formica-topped tables ringed by a mishmash of kitchen chairs. Vintage crokinole boards hang on the wall—one is available for patrons to play. The walls are illuminated by strings of cheap icicle lights. The kitchen consists of an ancient fridge and dishwasher, and a toaster oven. A government permit cautions that occupancy by more than 29 people would mean something ominous.

It is 5:00 p.m. on a Tuesday and the bar is quiet. Two men sit at the bar discussing music. A trio of art students gossip at one of the tables. One of them gets up and pours coins into the imposing juke-box. The exuberant

guitar and bouncy organ of "O My Soul" by Big Star fill the room. The man hasn't thought of Big Star's uplifting power pop songs for years and he marvels at what a pleasant thing it is to be drinking a Molson Stock and listening to a half-forgotten song in a place where strangers are sharing the same happiness as the late afternoon light streams through the plate glass window. The juke-box excavates more of the man's musical bedrock: "Leah" by Roy Orbison, "Sunday Morning" by Velvet Underground, "I Still Miss Someone" by Johnny Cash, and "Crystal Frontier" by Calexico.

A few more patrons take their places around the tables. They have come for talk and music, cheap drinks and a friendly bartender. It shouldn't be a rare place, but unfortunately in downtown Toronto it is.

The man feels comfortable, even elated, and he returns to the Communist's Daughter a few times over the next few weeks. He makes it his meeting place for friends, and he also runs into acquaintances he hasn't seen in years. They are journalists, dog walkers, art teachers, filmmakers. They are drawn not only by the casual atmosphere, but also by the deliberate absence of large-screen televisions, bad music, expensive martinis, and fashion. Most of them live nearby and walk to the bar. Close to home, the man thinks.

I AM A MAN WHO has walked into a fair number of bars in his 53 years. I have sought out the various options that bars offer: camaraderie or solitude, music or silence, a slight glow after work or, occasionally, oblivion. Most of my student haunts from the 1970s are as gone as the suds of yesteryear: the Embassy, the Blind Pony, the Blue Cellar, the Silver Rail, the Tara Tavern,

the War Amps, the Beverly. None of these bars ever felt like *home* to me. They were usually someone else's idea of refuge, and as a young man I sought out those places that had the grime of experience caked over them. Scarred brown wood instead of chrome, smeared draft glasses rather than crystal.

Growing older, I lost my taste for the louche (in retrospect, the sight of this shy English major in Bukowskian dives must have looked ridiculous), but still favoured more unpretentious watering holes. Yet in Toronto—whose civic motto of "Diversity Our Strength" should read "Transience Our Weakness"—even a simple local bar is a shaky proposition.

In the early years of this century, not coincidentally the closing years of Mel Lastman's clumsy mayoralty and the first years of the megacity, the energy was leaking out of Toronto's downtown streets. Chain stores had pillaged Queen Street West; fashion obsessives in search of the latest candied martini swarmed College Street. The so-called Entertainment District was little more than a weekend gulag for suburban miscreants. The few good bars— the most compact expression of a city's soul—were becoming victims of real estate greed. The Bamboo, the city's best flowering of multicultural music and food, became an expensive supper club. The sunlight-drenched beverage rooms of the Morrissey, the best local I ever had, became a Shoppers Drug Mart. Ted's Wrecking Yard, the Blue Cellar, and the Silver Rail disappeared. It seemed, for a brief time around 2002, that Toronto was becoming anonymous and soulless. The institutions that had sprung up organically were being steamrolled by money or franchises.

Paul Emery and his wife Trish Welbourn were feeling the same disappointment around the same time. Queen Street was "done" in Paul's view. College Street was superficial. They wanted to open a bar where they

could simply hang out. Paul was a musician who worked as a runner for concert promoters; Trish was an actor with lots of experience bartending. One day, Paul walked into a bar where, to his ears, atrocious music was playing. *We won't tell you what to order*, warned a sign above the bar. *Don't ask us what to play.*

"There was no place I liked to go," recalls Emery. "We wanted our own environment, with something more active for the customers."

They started looking for a place on Dundas Street West exactly because the area was a cultural wasteland, yet close enough to the main bar and restaurant strips. "We both loved bars, and Dundas didn't have any," says Emery. "It was so obvious, a crossroads right in between Queen and College."

One day a "For Rent" sign appeared in the window of the Nazaré Snack Bar, a Portuguese diner that opened around 1970 but had slowly lost its customer base as Toronto's manufacturing sector wound down. The Nazaré had a dilapidated lunch counter and a kitchen in the front window but Paul and Trish saw not dereliction but coziness. Instead of gutting the place, they chose to use as much of it as possible, replacing the tiles and the tables and gluing the map-bedecked bar-top to the existing counter. And they found a juke-box, loading it with their favourite CDs.

The Communist's Daughter opened on Easter weekend, 2003. The name was the title of a song by the neo-psychedelic band Neutral Milk Hotel, a strange little elegy beloved by both owners ("She moves herself about her fist/ Sweet communist/ The communist daughter/ Standing on the sea-weed water/ Semen stains the mountain tops"). The disc is still on the juke-box. Within three weeks the bar was busy and has remained so ever since. Friends would tell friends with a proviso not to spread the word too recklessly so

the bar wouldn't get ruined by crowds. Musicians from then-emerging (now huge) Toronto bands such as Broken Social Scene and Metric would drop in frequently. Johnny Depp apparently paid a visit and proclaimed it his favourite Toronto bar, though Paul and Trish have never verified the story (and don't particularly seem to care).

Emery, who is now 47, found himself serving clientele his own age and a decade or two younger. "Younger people now aren't waiting for people to do something for them," he observes. "They're creating nights for themselves like Trampoline Hall and starting their own events and venues. My generation waited for things to happen. Now the kids in their 20s have taken charge of their destiny and are creating things all over the place."

It may not seem like a big deal—a small bar with a down-to-earth atmosphere and a good juke-box. But the Communist's Daughter has played an elemental role—if only as a hangout that serves cheap drinks—in lubricating the Toronto artist-run music and art scene. More importantly, it showed that you can open a space with little money and a good idea and create a community around it (compared to, say, The Spoke Club, a plush social club opened by the scion of a grocery fortune which just re-creates the establishment in a junior form—some of us would rather drink at the Communist's Daughter than the Capitalist's Son). Paul and Trish's example has been followed by a plethora of hole-in-the-wall bars: Sweaty Betty's, the Crooked Star, the Press Club, the Roxton, the Dakota, the Reposado, the Cobourg, the Comrade. The musician Brian Eno once surmised that the first Velvet Underground album sold only 10,000 copies, but each of those 10,000 listeners started a band. The Communist's Daughter holds only 29 customers, but it will possibly inspire 29 bars.

As well, the once-sleepy few blocks of Ossington around Dundas have blossomed with restaurants, bars, cafés, and stores since the opening of the Communist's Daughter. Paul Emery doesn't see this as cause-and-effect; he thinks a lot of people like him were looking at the area at the same time because it was cheap and central. But he and Trish were indisputably the first to open a hip outpost in a drab area. Whatever the Ossington organism becomes, the Communist's Daughter was its vital first breath.

THE MAN WALKS INTO the bar with his wife. They had been driving for two hours through a soggy Saturday snowstorm and the warmth of the Communist's Daughter looked irresistible in the late November twilight.

The man did not realize that the tiny bar hosted live music on weekends. Two acoustic guitarists and a standup bassist are wedged into the tiny alcove by the front window. The lead guitarist is playing dizzying fast runs of Django Reinhardt tunes, propelled by perfect swing of the rhythm players. The man adores Django Reinhardt, and grins joyfully at the dexterity and verve of Roberto Rosenman's playing.

The bartender is tall and thin, has a shaved head, and wears wire-rimmed glasses and a starched white shirt. He is impeccably polite as he takes drink orders. The band launches into "Sweet Sue." The bartender returns with two pints of Creemore and places them in front of the man and his wife. He lifts up his head, swivels his body to face the crowded little room, and begins singing in a beguilingly cracked voice: "Every little star above/ knows the one I love/ Sweet Sue, just you." He sings another verse as he lifts empty

bottles off a table. The band fills in with a few bars of improvisation as the bartender returns behind the bar. He picks up a trumpet and takes a jaunty solo, then puts it down to sing the rest of the song.

This utter surprise of the moment has made this one of the finest musical experiences of the man's life. The band plays two more sets with the singing, trumpet-playing bartender, whose name is Michael Louis Johnson. They start each song as a straight standard, and then let the guitar and trumpet explore as much as they can in their minute-long solos.

They don't have much room but they still make wild explorations. They end up somewhere completely different and unexpected from where they started. Much like the bar they're playing in.

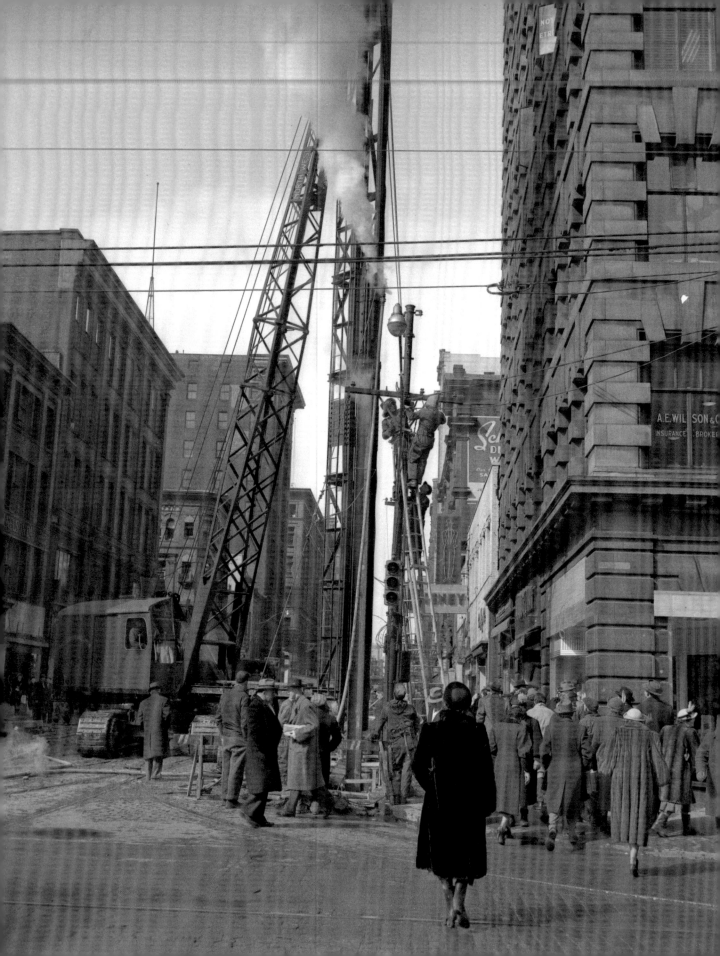

A FINE ROMANCE
SARAH MILROY

FALLING IN LOVE WITH TORONTO IS NEITHER
SUDDEN, NOR DRAMATIC, NOR EXPECTED. IT IS, AS
SARAH MILROY DISCOVERED, A STEADY ACCUMULATION
OF AFFECTION AND PERSONAL HISTORY. "I HAVE THE
IMPRESSION THAT I HAVE WATCHED THE CITY COME
OF AGE," SHE WRITES. "I THINK IT HAS
SEEN ME DO THE SAME."

LIKE MANY PEOPLE, I am an accidental Torontonian. I grew up in Vancouver, and if you grow up in the West—or the Maritimes, or the Prairies, or the North for that matter—you are pretty much raised to think of Toronto as the source of all evil; corporate greed, fast lifestyle, crime, dirty air, vacuous consumerism. Who would ever choose to live in such a place?

So I didn't. It chose me. Gradually, over the course of more than thirty years, Toronto has infiltrated my soul, its grimy brick sidewalls and littered laneways full of half-melted snow, its violently fecund ravines, its battalions of molten automobiles jammed bumper to bumper in the Friday traffic, its demure Victorian byways, leafy enclaves where people lock their bicycles to the front railing and live in peace behind their "No Junk Mail" stickers.

It was about six months ago that I realized that I had come to love Toronto. I live in the middle of the city—near Avenue Road and St. Clair—and it was spring. I was standing on my back porch at dawn, facing south to take the morning sun, which was rallying feebly after the long winter. The sky was a pale violet colour, tinged in the east with a fiery orange, and the bare trees stood out starkly against it.

Listening, I heard a few intrepid songbirds back from their southern migration. And then I heard something else: the city. It was roaring, a noise like the sound of a distant ocean, but without the surging of waves, a sound punctuated here and there by a siren, a low-flying jet, a car horn. It was the sound of millions of people heading to work, of humanity flooding into the heart of the great grinding machine of the city, its elevators probably still standing silently awaiting their human freight. It was the orchestra tuning up in the pit. It was thrilling, and I was a part of it.

This was a turning point. Up until that moment, I had heard such sounds and thought, almost scornfully, about the relative quiet of Vancouver, which is almost crystalline. But now, listening, I felt happy that Toronto has become so big and so unknowable, happy that this is a city so vast and complex now that I can never get to the bottom of it, so big that I can hide in it and never be found. Without my noticing, it had become my city.

As I have said, this has taken several decades to happen. I first came to Toronto in the mid-1970s, in my late teens, to visit my two older sisters. The eldest one, newly married to a native Torontonian, lived in an apartment building on Roehampton, near Yonge and Eglinton, and I remember how hopped and synthetic and urban that neighbourhood seemed to me after cottagey Vancouver. I also remember playing her Marvin Gaye records on the stereo in her apartment, eating Chinese take-out food out of her fridge (a novelty for me), and dancing around by myself in the living room after she and her husband had left for work. I had never spent that much time alone before.

My other sister lived in various places around the Annex and the Beaches (I made several visits) in a series of spectacularly bohemian apartments with bamboo screens and 1940s retro furniture and tumbleweeds of cat fur. She took me to Courage My Love to buy vintage clothing. We ate dinner at the Peter Pan café on Queen Street. She knew Carole Pope. She had a male friend who we visited who never got out of bed. (He wasn't sick, just wonderfully indolent.) I marvelled at how she had come to navigate this strange place with such assuredness. How could this city that I had never seen before have become her home?

The only thing I knew about Toronto before I arrived was that somewhere in it there was a collection of sculptures by the British artist Henry

Moore. I took the subway by myself (another first; we didn't have a subway in Vancouver) to find the Art Gallery of Ontario and its collection of Moore plaster maquettes. They were housed, as they still are today, in a John Parkin–designed modernist mausoleum illuminated with grey winter light, one of the few spaces in the museum that has not been overhauled in the AGO's two renovations since then. The security guard in the gallery that day described to me being in the presence of these sculptures at night, alone in the darkness, with only the city lights filtering down from overhead. He told me it was like being in a dinosaur graveyard.

I still think of his description every time I pass by this gallery, which is often. I would make my career in the art world, and the AGO—with its collection of Emily Carr paintings of the West Coast rain forest and its sublime Varley canvases of the Lynn Valley and Howe Sound—has often served as a kind of watering hole for me whenever I get homesick.

It would be seven years, though, before I would move to Toronto to live. My first university years were spent at McGill in Montreal, where I met and married my husband. Together we spent three more university years in England before returning to Canada. Toronto became our destination by default. Both of us had been born and raised in Vancouver, and both of us wanted to steer clear of our home town. Montreal, in those Oui/Non days, was a no-go zone for Anglophones. So we found an apartment in the Annex in Toronto, in a duplex that overlooked Sibelius Park, and we went to work—my husband at a law firm, I at a new visual arts magazine called *Canadian Art*.

My first job made me an aficionado of a lovely little corner of the downtown core: Church and Front. The offices of the magazine were located

in a rabbit warren infested with artists, designers, and publishing types. (Rent was cheap.) The oompa-pa music from the Organ Grinder, downstairs from our offices, was loud enough that coffee cups would migrate sideways on our desk tops as if by telekinesis. There was also no fresh air or natural light. We didn't really care. At lunch hour we sometimes went and lay on the grass beside the Flatiron Building to take the sun, eating tunafish sandwiches and potato chips.

I learned the city through its art galleries: Av Isaacs's legendary Yonge Street gallery in Yorkville (where one could see paintings by Joyce Wieland or folk art from South America) and Carmen Lamanna's gallery next door, a rather sepulchral space in which I first encountered the artist John Scott, who had just installed a gargantuan charcoal drawing of a fighter jet (or was it a rocket?) on the ceiling. I had never seen anything like it.

There was Jared Sable's underground lair at the corner of Scollard and Hazelton, with its fathomless couch and the voluptuous paintings of Tony Scherman and Harold Klunder on the walls. (I met Barbara Frum there one late afternoon during the figurative painting feeding frenzy of the mid-1980s. She was in her TV stage makeup, cruising a show of new works by the Montreal artist Betty Goodwin like a shark on a scent.)

Back in the mid-80s, the art dealer Sandra Simpson was the new kid in town. I remember first meeting her in her Queen Street gallery across the road from the Kentucky Fried Chicken, where she was typing the wall labels for an exhibition of installation art by Stephen Horne. She used to cook Italian food and serve wine to her friends (I became one of them) in the apartment over the gallery to the accompaniment of Tammy Wynette, played very loudly. As the years went by, she came to show a lot of artists from New

York and LA when it was rare for a commercial gallery to do so. It is still rare today.

Back then I also had my first encounters with the art dealer Ydessa Hendeles, whose gallery was upstairs from the Select Bistro, further east on Queen. (She now runs her own private foundation on King Street, where she stages exhibitions drawn from her remarkable collection.) Intimidated by her mystique and her ferocious intellect, I was soon able to discern that she was in fact a friendly person who seemed genuinely delighted (then as now) to have someone take an interest in what she was doing, which was usually (then as now) the most interesting thing going on in the city. I remember seeing my first exhibitions of work by John Massey at her gallery, and Jeff Wall and Liz Magor and Kim Adams, who, in one memorable exhibition, set up a kind of jerry-rigged amusement park ride in the gallery and invited me to jump aboard. (I did.)

Not far away, down Spadina Avenue, we often visited the high-ceilinged galleries on the fourth floor of 80 Spadina, a renovated garment factory brimming with light and new art. One of its denizens, the dealer Olga Korper, would become a pioneer, striking out for the city's west end in 1989, where she set up her gallery in a converted foundry on Morrow Avenue. Years before the refurbishment of the Distillery District, Korper had identified a kind of grimy, industrial soulfulness in Toronto's historical spaces and led the charge to reclaim them.

I used to visit Mercer Union when that artist-run centre was still on Mercer Street (it's now over on Lisgar Street), in an office building serviced by a clattery elevator of pre-war vintage. In those days it was run by a gangly, irrepressibly optimistic young man named Steve Pozel, who was soon promoted

to become the director of the Power Plant before skipping like a stone all the way to Australia, where he has remained.

At the Power Plant, I remember seeing exhibitions of the work of Tony Cragg and Anish Kapoor and Rosemarie Trockel—all of them rising international stars. The much bigger Art Gallery of Ontario was also in an expansive mood. I'll never forget the press opening of *The European Iceberg* there, a behemoth exhibition of Italian and German contemporary art curated by Italian impresario-curator Germano Celant—arguably the most ambitious exhibition of international art to be staged in Toronto in the past twenty-five years. It was as if the international art world, with all its pomp and hype and preposterous bombast, had suddenly crash-landed on Dundas Street. Though I was affronted by Celant's colonialist mentality toward the art scene here, I was also intrigued. This seemed like big stuff.

On the home front, things were changing too. My husband bought me two puppies. (Actually, he bought me one and then we went back together for the runt the next day.) They were Cairn terriers and after we got home from work in the evenings we ran them in Sibelius Park, in front of our apartment. After a few years, we bought a house just down the street on Wells Avenue. It was tall and skinny and attached on both sides. It was here that we had our first child, in August 1987. I remember being in labour, sitting on a bench in the park behind the Anglican church on Howland Avenue and watching the wind blow in the leaves of the trees in great gusts. I tried to think of my labour pains as gusts of wind blowing through me. It was my thirtieth birthday.

There is a turn on Davenport as it heads east after Yonge Street, and I can remember my husband navigating that curve in the road on the way to the hospital, and how the bumps in the road felt like a sledgehammer on

my cervix—the feeling of the car swaying as it made the turns, and the baby swaying inside me along with it. We had left for the hospital a little later than we should have, but it all turned out well. It was a girl, and she was perfect.

When she started walking, we took her to Sibelius Park, and I remember thinking how dangerous it was that the play area was not fenced. I remember thinking that a car could come across the sidewalk and run down the little children, that a kidnapper could run up and snatch them away. Now, when I drive by that park, I see how utterly safe it was, as safe as any place in a city can be. I was just another worried-sick new mother.

In the late 1980s we moved to New York for a few years, following my husband's work (falling in love with New York; that's another story), but we returned to Toronto just in time for the birth of our second child, in January 1991. This time it was a boy. By now, we were living in the neighbourhood known as the Republic of Rathnelly—a small enclave at the foot of Forest Hill (or at the top of the Annex, depending on your orientation), tucked in just to the west of Avenue Road.

In the depths of those first snowy nights back in Toronto, feeding my newborn son amid the packing crates, I usually sat beside the living room window and watched the street and the parking lot at the southern end of it, down beside the train tracks. Every once in a while limousines would roll in and exchanges would be made through the car windows. They were dealing drugs and I was nursing my son. It always felt like I was witnessing the tip of the city's crime-world iceberg. There it was, and then, a moment later, it was invisible again. Years later, a cab driver told me that Dupont and Sherbourne were the only streets he never picked up on after midnight. Too many wild cards.

Other than this feature, unknown to those residents who weren't routinely awake at 4:00 a.m., this was a wonderfully safe and friendly place to raise children. There were lots of kids, and there was even a geriatric maple tree with a large growth on its trunk that looked unmistakably like a large, dimpled, flabby old ass. (It's still there.) We called it the bum-bum tree. Somehow the joke never got tired.

Six months after our son was born I went back to work, now as editor and publisher of *Canadian Art*. The cover of my first issue was a detail from a painting by Joanne Tod, and inside there was an article about a prestigious international contemporary art show in Charleston, South Carolina, where Canadian artists Barbara Steinman and Liz Magor had been commissioned to make new work. It seemed like the world was suddenly opening up for Canadian artists, and these were the stories that we particularly delighted in telling.

When I wasn't editing I was selling ads like a madwoman, and I will confess that I loved every minute of it. When the magazine's 10th anniversary rolled around, we celebrated with a party and art auction that featured a martini bar, which was still a novelty at that time. We thought it was pretty swish.

Meanwhile, at home, it was endless rounds of Raffi and Cheerios and bath time—sometimes all at the same time. (Those little suckers will float.) There was a lot of Play-Doh and tipped-over containers of poster paint, often even before the newspapers had been delivered. Once every summer, on Rathnelly Avenue, we held a neighbourhood parade that was long on spirit and a little sketchy on execution (toilet paper was one of the key artistic ingredients, if I remember correctly), but the kids loved it and so did we.

Later, in the evening, all the families in the neighbourhood set up their tables and barbecues and ate dinner together outside on the street. The older women in the community—those who were well into their seventies and eighties—took turns being Queen of the Republic and there was much talk of the Republic separating from Canada. This suited us. After all, we were from BC. We know about insurrection.

We went to the park around the corner on Poplar Plains Road, a strangely solitary place set well back from the street beneath the shadow of the old brick power station. I remember digging a hole in the sandbox one early spring afternoon and vomiting into it. I was pregnant again. This child, our third, had been conceived on Valentine's Day 1993, on the night that the new architectural firm of Kuwabara Payne McKenna Blumberg unveiled its elegant redesign of Woodsworth College at the University of Toronto. The combination of chilled white wine and my failure to grasp elementary mathematics produced spectacular results: another girl, our third and last child, born nine months later after a luge-like drive down Avenue Road to Women's College Hospital.

We moved again, this time across Yonge Street into South Rosedale—my first and only time living east of Avenue Road. There, we settled on Pricefield Road in a comfortable old house with a deep garden and a lovely verandah— but only briefly. It was a different world. Everybody attended the ratepayers' meetings. There were collective concerns. Neighbours welcomed you with food baskets, subtly inquiring about your intentions to renovate. Nine months after we moved in, we left, this time for Vancouver.

We thought it would be forever, but instead it was only for three and a half years. (My husband, an investment banker, felt he had accidentally

retired, and I could see his point.) In 1999, we returned to Toronto and found the city changed. Recycling had arrived. I remember looking out my front door during my first week in our new house near Avenue Road and St. Clair and seeing the rows of blue boxes at the curb. I can recall finding the city's near universal compliance both laudable and slightly eerie. Waste management was the new religion.

There was traffic like never before. The air was dirtier. On the news, now and again, you heard about gang members being shot. But on Saturdays the entertainment section of the newspaper was dozens of pages deep with movies and plays and exhibitions. There were more food shops. There were more art galleries—way more art galleries—cropping up along Queen Street like mushrooms after rain, and, as the art critic for the *Globe and Mail* (my new job, starting in 2001) I had the idea that I would see them all. Soon I realized this was impossible. The scene was just too deep.

Amid all this gallery visiting, I had developed a few favoured pit stops. Most beloved of all was Vienna Home Bakery on the north side of Queen Street near Tecumseth Street, which closed just this year. A relic from the 1950s, it still had the original white carved wooden trim decorating the shelves and faded floral murals on the walls. The bread was baked in coffee cans, and came out round. They made lentil soup and the best apple pie I have ever eaten in my life. It was a good place to be alone, but I sometimes took my children. However, my love of the place only seemed to mystify them. It seems you can't be nostalgic for an era you never knew.

These days, the rate of change has become cyclonic. Down with the old AGO, up with the new. An intergalactic spacecraft has landed on the Royal Ontario Museum, morphing it unrecognizably from its appealingly frumpy

original conception. (A fond nod, here, to the shoddy old bat cave, the site of many a foolishly optimistic parental outing—a rite of passage that I understand is still enacted by young parents in the city.) A new opera house has risen on the banks of University Avenue, shedding its blonde light onto the flowing night traffic. Yorkville is convulsing with condo towers, and the divey little Cake Master café has gone the way of the Vienna. HMVs and Starbucks proliferate. At the upper reaches of the city, new communities are spilling across the farmland in a relentless tide of raw plywood and gyprock. The city won't be held back.

Perhaps it will not always be so. Perhaps this is the big push and then there will be a halt, and then a pause and then, perhaps, a gentle atrophy as the fine dust of an evolved culture settles over it. But I have the impression that I have watched the city come of age. I think it has seen me do the same.

For all that I have come to love Toronto, I could still leave it. The difference now is that I would have to leave a piece of my soul behind with it. The place is impregnated with a thousand memories. Stalled in the traffic on John Street below Queen, I am always reminded of the old Orso restaurant and the first night that my husband took me out to dinner after the birth of our first child, twenty years ago. (I cried when he gave me a beautiful bracelet to commemorate the occasion and the waiter discreetly provided a pile of wetted table napkins.)

And every time I stop at the top of St. George Street, where it meets Dupont, I see a busted-down diner called People's Foods, which presides over the busy intersection with a kind of blank, exhausted gaze. It was here, about four years later, that I once sat alone, nursing a cup of tea, when it seemed possible that this same husband would not forgive me for some idiocy I had

committed. Like so many places in the city—the North Toronto hockey arena (with its clammy, locker room smell), My Favorite Ice Cream shop at the corner of Macpherson and Yonge, the high plateau of the Winston Churchill Park reservoir, which looks out over the tree tops toward the southern skies— it has a place in my heart that was forged in the furnace of experience.

How can you love People's Foods? Because it was there at just the right moment. It makes me smile every time I turn that corner. There's a history there.

PHOTO CREDITS

JACKET AND TITLE PAGES: Michael Awad, *Queen Street, Toronto*. 2005 [detail]

FACING TABLE OF CONTENTS: David Kaufman, *Gooderham-Worts Distillery Storage Warehouse, June 1984*; The warehouse loading doors were freshly painted, and the tree newly planted, when I photographed it in 1984. The warehouse was one of more than forty buildings on a thirteen-acre industrial site which operated for 130 years before closing down in 1990. The site reopened as an artistic and cultural venue in 2003.

PAGE 6: City of Toronto Archives, Series 372, Sub-series 52, Item 54; Queen's Park [detail], July 21, 1913

PAGE 32: City of Toronto Archives, Series 376, File 1, Item 16; Bellmouth, Northwest Branch, Garrison Creek sewer, 189?

PAGE 38: City of Toronto Archives, Fonds 1244, Item 296; North Toronto Book-Store, 1922

PAGE 44: City of Toronto Archives, Fonds 1244, Item 370; Front of Comique movie theatre, 1910–1911

PAGE 61: Scott Johnston, *17 Unconvinced Chairs*, 2006

PAGE 62: Scott Johnston, *Room to Live in Your Living Room*, 2006

PAGE 63: Scott Johnston, *Hammock*, 2006

PAGE 64: Scott Johnston, *Go Fish*, 2006

PAGE 65: Scott Johnston, *Everything on the Line*, 2006

PAGE 153: David Kaufman, *Don Valley Brick Works, December 2003*; The brick works were created in 1889 to take advantage of local clay deposits and were in operation for almost a century. The abandoned site, with its kiln ovens and rusting machinery, was a favourite location for photographers of derelict industry, until placed off-limits by redevelopment.

PAGE 154: David Kaufman, *McMurtry Furniture Factory, August 1996*; The furniture factory was one of dozens of large and small industrial enterprises that lined Dupont Street from Davenport Road to Landsdowne Avenue. The de-industrialization of Dupont was almost complete in May, 1999, when the McMurtry factory burned down as it was being converted to condominium lofts.

PAGE 155: David Kaufman, *R.C. Harris Filtration Plant, Pumping Station, May 2001*; The water treatment facility was begun as a Depression-era project in 1937 by public works commissioner Rowland Caldwell Harris. It's an architectural landmark, an Art Deco palace of marble and tile and stainless steel, which still pumps almost half of the city's water.

PAGE 156: City of Toronto Archives, Series 1057, Item 1881; Traffic policeman

PAGE 160: City of Toronto Archives, Series 1057, Item 8114; Acrobats at the Royal Alexandra Theatre, 196?

PAGE 168: City of Toronto Archives, Fonds 1244, Item 3061; Gooderham and Worts Distillery, ca. 1917

PAGE 188: City of Toronto Archives, Fonds 1244, Item 1113; Noon hour traffic, Yonge Street looking north from King Street, December 24, 1924

PAGE 194: City of Toronto Archives, Fonds 1244, Item 1967; Elm Park, Woodbridge, 1933

PAGE 204: City of Toronto Archives, Series 71, Item 3742; Dupont and Christie Loop, looking southwest, 1925

PAGE 222: City of Toronto Archives, Series 376, File 3, Item 84; Corner of Queen Street and Spadina Avenue, public lavatory, 189?

PAGE 232–243: Michael Awad; *Chinatown #1, Toronto*. 2001; *Escalator, Toronto.* 2006; *Carabana Parade #2, Toronto.* 2005; *Canadian National Exhibition, The Zipper.* 2005; *Pride Day Parade, Toronto.* 2006; *Yonge Street, Toronto.* 2005 [detail]; *Yonge Street, Toronto.* 2005

PAGE 244: City of Toronto Archives, Fonds 1244, Item 1014; Police motorcyle division, between 1926 and 1930

PAGE 262: City of Toronto Archives, Series 376, File 3, Item 1A; City Hall, clock not yet installed, 1900?

PAGE 274: City of Toronto Archives, Fonds 1244, Item 128; Five bartenders behind St. Charles Hotel bar, 1911?

PAGE 284: Archives of Ontario. C 3-1-0-0-676 (9508-15005). Construction of Yonge Street subway (at Yonge and Adelaide streets), November 8, 1949. Copyright David Milne

PAGE 298: City of Toronto Archives, Fonds 1244, Item 8156; Cycling beside Don River, between Don Mills Road and Leaside, ca. 1912

Library and Archives Canada Cataloguing in Publication

Toronto : a city becoming / David Macfarlane, general editor.

ISBN 978-1-55263-949-8

1. Toronto (Ont.)—History. 2. Social change—Ontario—Toronto.
3. Toronto (Ont.)—Social conditions. 4. Toronto (Ont.)—Population.
I. Macfarlane, David, 1952-
FC3097.3.T553 2008 971.3'541 C2007-902302-9

ONTARIO ARTS COUNCIL
CONSEIL DES ARTS DE L'ONTARIO

The publisher gratefully acknowledges the support of the Canada Council for the Arts and the Ontario Arts Council
for its publishing program. We acknowledge the support of the Government of Ontario through the Ontario Media
Development Corporation's Ontario Book Initiative.

We acknowledge the financial support of the Government of Canada through the Book Publishing Industry
Development Program (BPIDP) for our publishing activities.

Page 157: Tabatha Southey's "Toronto, The Outlaw" originally appeared in *Elle*.

Page: 205: A version of Philip Preville's "Stop and Go" was published in the Fall 2006 issue of *Maisonneuve*.

Page 245: David Haye's "The Prisoner" was originally published in *Toronto Life*, April 2006, as "The Prisoner: I was
sent to jail for the first time when I was 13. By the time I was 20, I'd sold crack, fought in a gang war and shot a man.
This is the story of my lost years." by Andre Morrison, as told to David Hayes.

Key Porter Books Limited
Six Adelaide Street East, Tenth Floor
Toronto, Ontario
Canada M5C 1H6

www.keyporter.com

Design: Marijke Friesen

Printed and bound in Canada

08 09 10 11 12 6 5 4 3 2 1